ESSAYS ON ART, TECHNOLOGY, AND CULTURAL RESISTANCE

MINING THE MEDIA ARCHIVE

DOT TUER

Canada Cataloguing in Publication Data
Tuer, Dot
Mining the media archive: essays on art,
technology, and cultural resistance
Includes bibliographical references.

ISBN 0-920397-35-2

1. Art, Canadian – 20th century. 2. Art,
Canadian – 21st century. 3. Art – Political
aspects – Canada. 4. Art – Political aspects
– Argentina. I. Title.

N7442.2.T84 2006 709'.71
C2005-905894-3

The publisher would like to thank the
following magazines and galleries for
permission to reprint the essays selected
for this volume: National Gallery of
Canada, Ottawa Art Gallery, Walter
Phillips Gallery, Presentation House,
Blackwood Gallery, St. Norbert Arts
Centre, Arton's Publishing, Parachute,
C Magazine, Bay Press Inc., and
Nina Felshin. Full citations are listed at
the end of each essay.

Design: Sarah Robayo Sheridan
Managing Editors: Robert Labossiere,
Sally McKay
Copy Editor: Lorissa Sengara
Proofreaders: Milada Kovacova, Scott Sørli

Printed in Canada by Friesens
Distributed by the Literary Press Group
of Canada www.lpg.ca

YYZBOOKS

401 Richmond Street West, Suite 140
Toronto, ON M5V 3A8 Canada
www.yyzartistsoutlet.org

YYZ Books is an alternative press
dedicated to publishing critical
writings on Canadian art and culture.
YYZ Books is associated with YYZ
Artists' Outlet, an artist-run centre
that presents challenging programs of
visual art, film, video, performance,
lectures, and publications.

YYZ Artists' Outlet is supported by its
members, the Canada Council for the
Arts, the Ontario Arts Council, and
the City of Toronto through the
Toronto Arts Council.

YYZ Artists' Outlet and YYZ Books
gratefully acknowledge the support of
the Canada Council for the Arts and
the Government of Canada through
the Book Publishing Industry
Development Program (BPDIP).

Canada Council Conseil des Arts
for the Arts du Canada

Canadian Patrimoine
Heritage canadien

for
los desaparecidos

CONTENTS

III. Testimony

ACKNOWLEDGEMENTS

Mining the Media Archive has been a collaborative effort from its inception. A number of people generously read the manuscript and contributed to its making, including Susan Crean, Lynne Fernie, Alberto Gomez, Sally McKay, David McIntosh, Kym Pruesse, Deborah Root, and Margaret Tuer. Lorissa Sengara provided an invaluable copy-edit. Milada Kovacova and Scott Sørli generously volunteered to proofread. Sally McKay, the former Managing Editor at YYZ, offered encouragement and support in the first stages of the project, and Robert Labossiere, the current Managing Editor, oversaw the book's production. I want especially to thank Sarah Robayo Sheridan for her wonderful design and dedication to the project.

I would like to acknowledge the support of the Canada Council, Ontario Arts Council, and Toronto Arts Council in funding my writing over the years, the members of the YYZ Publishing Committee for their support of this book project, and the Canada Council for providing publishing assistance. I want to extend a special thanks to Sara Diamond, President, and Sarah McKinnon, Vice-President Academic, of the Ontario College of Art and Design for their institution's support of the project.

At its most creative, writing is always a reciprocal process and I would like to thank the artists I write about for their work and insights. My study of history, which forms the backbone of my writing on art, owes its genesis and development to Tim Brook's inspiration as a professor and his unwavering support. My friends have listened patiently as I have talked about the big ideas and small details of publishing this book and I want to thank them profusely. They include Carol Condé and Karl Beveridge, Lynne Fernie, Vera Frenkel, Rebecca Garrett, Johanna Householder, David McIntosh, and Deborah Root. Most of all, I want to thank Alberto Gomez for sharing his life and his ideas with me, and for being there.

—Dot Tuer, September 2005.

PREFACE

History decomposes into images, not into narratives.
—Walter Benjamin

In the history of the Americas and its contact zones—those spaces
where European and indigenous belief systems first collided and
overlapped—unexpected encounters between cultures made possible
new ways of thinking about the world and its representations. The
essays gathered in this book address the legacy of such encounters,
weaving together testimony, theory, and history to unsettle the concep-
tual boundaries of art and technology. The stories I recount here have
been shaped by my experiences living in Canada and Argentina, and by
my passion for the history and art of these places as portals to a shared
social imagination. The archives I mine are image repositories of the
global media and of local remembrance that straddle both chronologi-
cal time and a north/south divide. From these stories and excavations
emerges the central focus of this book: an exploration of how the body,
as a cipher of memory, and storytelling, as a witness to history, are inte-
gral to making artistic practice a site of social intervention and cultural
resistance.

When I first began writing on art in Toronto in the mid–1980s, the
Canadian art scene was awash in postmodern theory and cultural
activism, ranging from visual strategies of appropriation and decon-
struction to feminist debates and identity politics. It was a heady mix of
discursive duelling and on-the-ground struggles for representational
power. My writing at the time, which focused on feminism and media
art, and my interest in Latin American politics reflected the exuberance
and urgency of that historical moment. In 1989, the Berlin Wall fell and
the Cold War paradigm of rival superpowers and ideological polarity
began to unravel. As transnational corporate capitalism extended its

tentacles to encircle the globe, I turned to the study of colonial history, seeking in however provisional a manner to map a genealogy of global-ization's fractious terrain. Tracing the roots of what postcolonial theo-rist Cornel West has termed the "new cultural politics of difference" back to the European conquest of the Americas in the 1500s, I took to heart his imperative "to reject the abstract, general, and universal in light of the concrete, specific and particular; to historicize, contextualize and pluralize."[1]

The essays selected for this book, which with one exception were written after 1991, reflect my ongoing commitment to West's "politics of difference" and the influence of my historical studies on conquest and colonialism. Whether discussing hybrid subjectivity in virtual reality or the memory traces of the body in documentary photography, I am interested in illuminating how colonial legacies and modernist frame-works influence contemporary image production and reception. The first section of the book, "New Media," draws together my critical writ-ing on a number of Canada's new-media artists. Primarily interpretative monographs, the essays explore how the dialectics of nature and culture, art and science, history and memory are manifested in interactive video and computer technology. The second section, "History," presents case studies on political art, community, and cultural funding in Canada. This section includes the one essay in the collection written in the 1980s, "The CEAC was banned in Canada," a history of a controversial Toronto artist-run centre of the 1970s. The third section, "Testimony," features essays on art, memory, and cultural resistance in Canada and Latin America. It most clearly reflects my interest in colonial history and includes several autobiographical essays. "Cultures in Conquest/Culture in Context" examines issues of identity and location in the context of the global paradigm shift that took place in the early 1990s. "Anatomy of an Insurrection," written ten years later, recounts my personal involve-ment in the political upheavals and cultural memory of Argentina, a country I have been travelling to since the mid-1990s.

Besides the common threads of cultural politics and historical con-text that bind the essays in this book, what also links them is a theoretical concern with how the mimetic function of technology in art produces an unsettling mirroring of identity and memory. In his essay "On the Mimetic Faculty," philosopher Walter Benjamin describes mimesis as an imitative power according to which "the gift of seeing resemblances is nothing other than a rudiment of the powerful compulsion in former times to become and behave like something else."[2] Following upon Benjamin's definition, cultural anthropologist Michael Taussig argues that the "fundamental move of the mimetic faculty taking us bodily into

alterity is very much the task of the storyteller too. For the storyteller embodied that situation of stasis and movement in which the far-away was brought to the here-and-now."[3] Drawing upon Benjamin and Taussig, I explore how the mimetic enactment of the body in new technologies has the transformative power to remake the boundaries between the material and virtual worlds. Conversely, I bring my own role as a storyteller to reflect on how the colonial legacy of becoming other through conquest finds its residue in shrines to Argentina's "disappeared" bodies and First Nations' testimonies of cultural resistance.

Also central to this collection of essays is the reconceptualization of history as circular and fluid, rather than chronological and fixed. Through the juxtapositions and collisions of simulation and bodies, mimesis and memory that structure the conceptual framework of my writing, I am interested in transforming the media archives I mine. It is my contention, and hope, that the decomposition of history into images is recomposed in these essays as a narrative of cultural resistance, one in which the disjunctures of storytelling and affirmation of memory create a collective archive. In its imagined form, this archive houses local and translocal conversations about the importance of art as a reflection of social reality and struggle. Far from being dusty and archaic, the archive becomes a dynamic montage of the past and present: a repository for the steady trickle of utopian interchanges between life and art that lies beneath the surface of the simulacrum, and a talisman against the historical amnesia of global corporate culture.

Notes

1. Cornel West, "The New Cultural Politics of Difference," in *Out There: Marginalization and Contemporary Cultures*, eds. Russell Ferguson, Martha Gever, Trinh T. Minh-ha, and Cornel West (New York and Cambridge, MA: New Museum of Contemporary Art and MIT Press, 1990), 19.

2. Walter Benjamin, "On the Mimetic Faculty" (1933), in *Reflections*, trans. Edmund Jephcott (New York: Schocken Books, 1978), 333.

3. Michael Taussig, *Mimesis and Alterity: A Particular History of the Senses* (New York: Routledge, 1993), 40.

pallid grace quick-witted scatter carrot

carrot powdered quick-witted scatter green

sweet yellow yellow courtier

bright blue yellow ink

dunce's cap green

orange yellow Under spectral colour saturation

frenchman rustle

screech Naples yellow dishonour

over hammer ash

drooping screak rapturous broadcast

draw a blank chandelier

middle blow up skriech

usually terra-verde powderiness most

sylphlike breathless torpor

creaky fluorescent ghastly scrupulo

between wan vermil

Buirdly brimful

pumpkin Bengal light sheerin

remote spectral wan bone ash

light-win wax

naranjila topsided [inaugurate]

loftily awkward faun in color electric harp

[fuse] rrator upright since contr knocker pruden

husk supple deign

alert sore luscous Dane

fuse protect pot

screaming ballyhoo artist

[fuse] able alert maturation spiritu keep up transmitting aerial

lustrallidness small-grained lean lean

courage to feel

pallid grace lienformer Mosco

us carrot house quick-witted scatter carrot

powdered yellow green

sweet yellow very

dunce's cap unshakable

bright blue yellow ink

orange yellow Under eyelid eso spectral colour courtier

frenchman saturation

screech over hammer Naples yellow dishonour

drooping ash

screak rapturous broadcast

middle draw a blank chandelier

blow up [light-blue] swatch

usually terra-verde skriech

sylphlike breathless powderiness most

torpor

creaky fluorescent ghastly scrupulo

NEW MEDIA

EMBODYING THE VIRTUAL

HYBRID SUBJECTIVITY AND NEW TECHNOLOGIES

Key Words

mouse	space	conquest
monster	multiple	colonization
flesh	memory	capitalism
fake	proliferation	platonic
simulation	doubling	spirit
longing	identity	dimension
desiring	body	self
transfiguration	accretion	subjectivity
purity	virtual	code
contamination	threshold	encoded
hybridity	material	reality
earth	mutation	

a few definitions …

inter: to bury / to inhume *net:* mesh / clear profit

Internet: to bury clear profit

utopia: no place

cyberspace: a virtual place

code: that which organizes information for secrecy / programming text

the body: the physical structure of a person / a genetic code /
a sensory organ / a dream machine / a mother tongue

memory: a technology of information storage and retrieval /
an encoding of bodily traces / a residue of consciousness

cyborg: a human body that aspires to technological fusion

artificial life: a machine that aspires to human consciousness

reality: what underlies appearances / resemblance to an original

virtual: being so in essence or effect, but not in form or fact /
not physically existing as such but made by software to do so

4 *material:* corporeal / not spiritual

objectivity: that which pertains to the experiential cognition or
deductive logic of a reality external to the self

subjectivity: that which pertains to the internal and perceptual cognition
of self

hybrid: heterogeneous / incongruent / crossbred

In this essay, I perform a hypertext exercise that moves through historical time and space to explore issues that arise from the encounter of the body and its virtual apparatus. In relation to where we are here and now—one hand clutching the mouse, eyes on the screen, feet still mired in the earth, images raining down upon us—I frame this exercise in terms of a hybrid subjectivity: an apprehension of the self that is struggling to bridge the natural and artificial, the sensory and the constructed. By invoking the concept of hybrid subjectivity, I am not arguing for something specific to new technologies, but for a condition that occurs whenever there is a meeting of material and virtual worlds. I imagine the cyborg—that fabulous indeterminate creature described by Donna Haraway—with one foot planted in the material sediment of history and the other in the virtual architecture of cyberspace.[1] The cyborg straddles embodied and disembodied realms of cognition; it carries with it the imprints of conquest, colonialism, capitalism. Out of the oscillation between these two places, there arises the potential for the conceptualization of a hybrid subjectivity anchored in the specificity of historical legacies as well as in the technological projections of the future. How we embody this hybrid subjectivity is a pressing issue, one that determines our interaction with the virtual worlds that envelop us in synthetic and often imperceptible simulations.

Several years ago, I participated in a roundtable discussion on the Internet and issues of identity. During the discussion, certain members of the audience spoke of the potential of new technologies to create a realm of higher consciousness. Their enthusiasm reached a particularly heightened pitch when they spoke about leaving their bodies behind and becoming whatever one wrote into existence as code, offering up cyberspace as a panacea for global discord and a virtual infrastructure for collective social harmony. In response to this utopian embrace of cyberspace, I felt compelled to remind one particularly fervent programmer-turned-apostle that the material world—with its inequities and wars and hunger and class divisions and racism and gendered identities—still shaped people's lives, whether they did or did not surf the Internet. He turned to give me a look that was at once wounded and outraged. He insisted, with vehemence out of character for what was until that moment a polite and typically Canadian exchange of ideas, that in cyberspace we float above capitalism, and that those who think otherwise destroy its imaginative potential. While it seemed to me that he had missed the point I was trying to make in suggesting the two worlds are indivisible, I was both fascinated and taken aback by his passionate belief that linking the two would, like an avenging angel, destroy all hope of redemption. This psychological investment in a cyberspace

where imagination is unfettered by the constraints of a bodily existence is widespread. It is adopted by anarchist Web artists and appropriated by corporate interests alike, deflecting our attention away from the collapsing boundaries between material and virtual economies.

The computer and the cybernetic future it promises are the products of a late capitalism that has fuelled the global economy during the last quarter century, creating new classes of workers and workspaces including electronic sweatshops where bit chips are made, computers assembled, and Web pages designed. Computer interfaces—the mouse, the glove, the keyboard, the webcam—depend on the physical presence of the body and its access to technology. In order to have an avatar (a digitally generated incarnation of oneself in cyberspace), one must first have the economic infrastructure to create it. The virtual apparatus promises us freedom from the material world yet pins down our bodies in a web of surveillance; the virtual commons of the Internet heralding unfettered communication is being rapidly privatized. No matter how many times one changes sex or age or race or identity in a virtual world, this cannot alter how one embodies a material universe weighed down with history and philosophy and belief systems and economics. Rather than dispensing with the material world, cyberspace masks and mimics social relations within a realm of simulation.

All of this leaves us with a paradoxical site of interrogation. The rupture envisioned between the physical self and its virtual other is one of pure projection; at the same time, projections do impact upon our consciousness. Simulations have the power to shift our perceptions of worlds that we cannot necessarily change, and to create imaginary ones that allow us to dream a different future and sometimes act upon it. Utopian projection as collective will is a little-understood phenomenon, whether it results in millenarian movements and insurrections or rituals summoning spirit realms and virtual communities. It can serve as a nodal point for resistance to institutionalized power; it is also linked to delusion and oppression. Given the collapsing and contested relationship between the material and the virtual, it seems imperative to think about cyberspace as both a product of human labour and a projection of human consciousness that demands a rethinking of the boundaries between the two.

The schism between dystopic views of cyberspace and utopian projections of a brave new universe has tended to polarize discussions about new technologies. There are the true believers and the naysayers and both think the others the rearguard of reactionary thought. Consider the futuristic sound-bite discourse of Arthur and Marilouise Kroker as delivered in a recent lecture in Toronto. In one breath, they

denounced genetic engineering (the latest breakthroughs being stem-cell cloning and mutated monkeys) and artificial life (HAL from *2001: A Space Odyssey* is poised to take over) as a social and economic disaster spiralling out of control, one that could create a genetically designed elite and a vast underclass of unmodified human beings. In the next breath, they pronounced that new technologies are beyond our ethical and social grasp and urged us to embrace the post-human condition as inevitable.

While the Krokers are astute in their assessment of the dramatic impact of cybernetics and biotechnology on the new global economy, their doomsday-and-revelation paradigm constructs a circular vortex of hopelessness. There is no conceptual opening in their paradigm to envision a dialectic relationship between human beings and their cybernetic creations, no possibility of interacting with and acting upon the technologies that are reshaping the apprehension of the self. Rather than acquiescing to the Krokers' nihilistic vision of the future, I am interested in understanding how the past has shaped the polarization found in contemporary debates about new technologies. What philosophical and historical legacies have created the investment in a virtual world that floats above the material one, or, conversely, the belief that computers are leading us to certain extinction? What models can enable us to strategize a hybrid subjectivity that accounts for the ways in which our bodies and technologies intertwine?

One of new technology's most pervasive philosophical legacies is Platonic thinking. In an article entitled "The Erotic Ontology of Cyberspace," Michael Heim articulates the unacknowledged philosophical assumptions that underlie the utopian embrace of cyberspace as a realm of higher consciousness, locating in the virtual representations produced by computers the potential realization of Plato's ideal forms. In his assessment, cybernetics' increasing capacity to produce artificial intelligence and virtual infrastructures enables us to discard an imperfect material world.[2] Through cybernetics, we can finally escape the shackles that tie us to the shadowy realm of appearances in Plato's cave and be able to apprehend ideal forms as patterns of information.[3] What Plato envisioned as a model of philosophical enlightenment linked to the internal mental processes of human beings, Heim transposes wholesale to the mathematical logic of machines.

Given the Western influence in the development of cybernetics, it is not surprising that Platonism has been evoked when philosophically describing computer-generated simulations. Yet in the application of ideal Platonic forms to the binary clarity of cybernetic code, a closed feedback loop is enforced. To achieve pure knowledge is to be one with

the matrix; to resist its logic is to refuse to leave the shadowy recesses of the cave. Either way, the distinction between the material as false and the virtual as true is absolute, negating the potentially contaminating effect of a hybrid subject who moves between cognitive realms, straddling the sensory and the cerebral, the concrete and the abstract, the natural and the artificial. Arenas of contamination have always been fruitful places of exchange, and ones that the state and the church have fought hard to exorcise. Plato, clearly, was no enemy of Western civilization.

In contradistinction to Heim's use of Plato to think through the collapsing boundaries between the material and the virtual, I want to argue for the importance of grounding our understanding of new technologies in a materialist history of place and colonization. Rather than linking the philosophical roots of cyberspace to an idealist Platonic tradition, I would like to draw an analogy between cybernetics and the conquest of the New World in the 1500s. In so doing, I want to propose a conceptual model for the body and its virtual apparatus that parallels the encounter of Europeans with the indigenous beliefs of the New World: a meeting described by the Mexican writer Octavio Paz as the collision of radically different world-views.[4] From this collision emerged an imperial order and a zone of instability that provides historical insight into the current rash of Platonic idealizations, utopian projections, and doomsday scenarios.

On this topic, Uruguayan cultural theorist Angel Rama's analysis of Spanish colonialism is instructive. In Rama's posthumously published book *The Lettered City*, he argues that the Spanish conquest of the indigenous peoples in the Americas was achieved through the imposition of an idealized urban design linked to an independent order of signs. While medieval cities grew organically in relationship to human labour and social interaction, the Americas presented the opportunity —in confluence with the humanistic models of the Renaissance—to map an idealized city grid upon a *terra incognita*. This mapping of cities in advance provided the spatial design for a symbolic ordering of reality. In turn, the idealized grid was serviced by *letrados*, functionaries of the Spanish king, who as the only literate subjects of the empire, wrote the edicts and laws that reinforced this order.[5]

The *letrados*, in effect, were the programmers of a new world order, producing a linguistic framework that linked the writing of code to the architecture of colonialism. For those who could neither write nor read the code, the church provided a visual interface through the dizzying splendour of the baroque. In the lands between the ordered spaces of the city, there lay a vast spatial and linguistic heterogeneity, an indigenous reality that presented an indecipherable chaos to the colonizers.

The *letrados* could not order this chaos, and so they sought instead to impose an independent system of signs that would mask its existence. Like the programmer's fervent belief in a cyberspace that floats above capitalism, the *letrados* created a symbolic order that appeared to float above the colonial reality of oppression. By analogy, computer programmers who write code are the equivalent of modern-day *letrados*, linking an independent order of signs to a virtual architecture. Like those who lived in the colonial era, we are part of the *letrado* elite, or those who engage with their technological interfaces, or among those who inhabit the heterogeneous spaces that lie outside the architectonic structures of social engineering.

In the colonial era, one of the groups that occupied the spaces in between the grid of ideal cities were the Guaraní, a semi-nomadic indigenous people whose territories at the time of the Spanish conquest stretched from the coast of Brazil inland to Argentina and Paraguay. Today, although decimated in numbers through disease, war, and enslavement, a few surviving Guaraní in eastern Paraguay and the Brazilian Pantanal have preserved their cultural traditions and their belief systems. In relation to the collapsing boundaries between the material and the virtual that we are experiencing through cybernetics, what is most striking about the Guaraní is the way in which their cosmology conceives of a virtual world that mirrors their material existence.

Just as Michael Heim imagines that cyberspace will lead to perfected virtual forms of which their material counterparts are shadowy imitations, so the Guaraní believe their virtual world more complete than the one they can perceive through their everyday senses. They reach this virtual world through a series of ritual chants, invoking what they call "the beautiful words." The beautiful words belong to the sacred realm of language and transform the material into the virtual through metaphor. In the shamanistic order of the Guaraní, the entire community has access to the virtual realm through ritual chants; a few very powerful shamans preside over specific ceremonies and have a highly developed and nuanced language of metaphor that facilitates movement back and forth between the two realities.[6]

Since their first encounters with the Guaraní, Europeans have been fascinated by their abstract metaphysical system. For most Western observers, the Guaraní's virtual world appears to correspond to a Neoplatonic framework in which a spiritual architecture houses ideal forms.[7] I would argue, however, that to inscribe their shamanistic realm with Platonic values is to misinterpret its fundamental attributes; this same misrecognition shapes contemporary perceptions of what cyberspace is or could become. In the Guaraní's world-view, the virtual is not

separate from material existence, but on the contrary is contingent upon embodied experience. Through the Guaraní's use of metaphor, the phenomenological and spiritual dimensions of the self are grounded in an encounter between the material body and its virtual other; language becomes a connective tissue that facilitates movement between cognitive realms; and access to codes is a social and communal function, shared and not individualized.

In bringing the Guaraní's apprehension of the virtual to a discussion of new technologies, I want to consider how new media artists are shaping metaphors and contexts for the encounter of the body with its virtual apparatus. In so doing, I want to argue for a role for the artist that is like that of the Guaraní shaman, one of a guide between material and virtual worlds. In Canada, there are a number of artists—Thecla Schiphorst, Nell Tenhaaf, and David Rokeby, to cite just a few—producing computer-integrated works that explore how new technologies are shaping hybrid subjectivity. Creating interfaces that straddle cognitive realms, they counter the idealization of cyberspace by locating in the virtual apparatus an apprehension of the self through bodily experience. In the process, their artworks critically examine and reflect upon the phenomenological and social implications for our entanglement in a realm of simulation.

Thecla Schiphorst, an artist with an interdisciplinary background in dance, choreography, and computer science, is concerned in her work with engaging the mimetic boundaries of virtual and material worlds through the body's skin, privileging touch over sight in the creation of her computer interfaces. In *Bodymaps: artifacts of touch* (1996), the viewer enters a darkened space to encounter an empty table covered with a white velvet cloth. When the viewer strokes the soft velvet, a video image of a sleeping woman and a young boy mysteriously appears. As the sound of water fills the room, the phantom sleepers restlessly turn and toss in response to the viewer's touch, producing an uncomfortable sensation of transgressing another's privacy and vulnerability. Technically, the work uses motion sensors embedded in the table to activate the video image. Metaphorically, it engages with the boundaries of intimacy and proximity, inverting the distance between the body and virtual representation into a primal meeting of physical touch and simulated presence. From the sensory amplification that occurs in this encounter, a hybrid subjectivity emerges, one in which the viewer occupies a contradictory site of immersion and disjuncture, apprehending the virtual through material gesture as he or she reaches out to touch an imaginary other.

Nell Tenhaaf's work, like Schiphorst's, is concerned with boundaries of intimacy and proximity. Through her use of virtual imaging, Tenhaaf

explores the cultural narratives underlying scientific objectivity, fore-grounding subjectivities latent in computer-generated simulations. In a series of digital photographs, *Machines for Evolving* (1995), Tenhaaf links the virtual modelling of the body's genetic memory to a historical legacy of gendered representation. In 1968, when James D. Watson and Francis Crick described unravelling the mystery of DNA in *The Double Helix*, they proclaimed that they were convinced of their discovery because the double helix was so beautiful, so perfect, so simple: in effect, the realiza-tion of Plato's ideal forms.[8] Tenhaaf takes laboratory images of the dou-ble helix's perfect strands and inscribes upon them barely perceptible traces of hand-drawn female bodies. Her ghostly figures, arrayed in abject and overtly sexual poses, contaminate the binary purity of DNA with the historical legacies of female objectification and voyeuristic structures of looking and identification. Through this aesthetic reconfig-uration, Tenhaaf points to the body's colonization as "pure" information within the architecture of genetic coding: one that strips it of sensory and psychic dimensions. Infecting Crick and Watson's symbolic ordering of the double helix with the heterogeneity of feminine desire, she posits a hybrid subjectivity in which the material sediment of history and the virtual imaging of evolution overlap.

In *UCBM (you could be me)* (1999), an interactive video installation, Tenhaaf extends her exploration of virtual imaging to encompass the voyeurism of webcam culture and genetic algorithms. Entering the gallery, the viewer encounters a video projection of a woman in a labo-ratory setting who delivers a speculative and convoluted discourse that draws upon psychoanalytical theory. She then entices the viewer to interact with a computer screen embedded in the wall, on which cam-corder footage of Tenhaaf's activities in her bedroom appears. The viewer is asked to respond with a yes or a no to a series of questions designed to assess the degree of empathy with which he or she reacts to the images of the artist's private space. The viewer's answers are then processed by an algorithmic formula that evaluates his or her viability for an empathy gene pool, which is created from the responses of nine consecutive viewers. Depending on the viewer's responses and their relationship to previous responses in the nine-person grouping, the viewer's adaptive offspring either enter the gene pool or are eliminated. After completing the empathy quiz, the viewer is informed by the female scientist of his or her genetic fitness. Simultaneously, light pat-terns on an LED panel representing recombinant gene strings flash on and off and a graphic interface appears on the video screen, translating these patterns into an abstract swirl of exploding colour and form.

Through the layers of encoding built into *UCBM*, Tenhaaf entangles virtual models of the body and memory with issues of intimacy and identification. On one hand, the viewer is reduced to string patterns of genetic information; on the other, this genetic sequencing is calculated through the viewer's subjective responses to the artist's intimate domestic space. The viewer's relationship to the webcam images pivots on unpredictable and unquantifiable structures of voyeurism and desire; the genetic modelling pivots on precise and quantifiable computation of data. As in *Machines for Evolving*, the discordance between the two cognitive realms contaminates "pure" information with subjectivity. Tenhaaf's adaptive empathy test becomes a metaphor for the ways in which computer simulation is inextricable from a process of identification and projection embedded in the material world.

In David Rokeby's work, similar issues are addressed through the creation of artificial perception systems that incorporate the viewer within the computer's cognitive mechanisms. From his first computer integrated installation, *Very Nervous System* (1986–90), which envelops the viewer in a feedback loop of gesture and sound, to more recent works such as *Watch* (1995) and *The Giver of Names* (1991–), which use image and text, Rokeby has been interested in the disjuncture between how computers see us and our experience of this perception. In *Watch*, the viewer enters a darkened room to encounter a large double-screen projection of black-and-white video images that fill one wall of the gallery space. The images are fed from a surveillance camera located on the street outside the gallery to a computer that monitors them for stillness and motion, and then reprocesses them as inverted mirror images of each other. On one side of the double projection, only static objects are discernable, such as pedestrians or cars waiting for a streetlight to turn green. All else blurs or disappears. On the other side, the only visible objects are things in motion: cars driving by or people walking or snow gently falling. As ghostly figures appear and disappear within a shimmering background, the viewer hears the sounds of a watch, a heartbeat, and soft breathing.

Enveloping the viewer in a sensory realm of image and sound, *Watch* resonates with the conventions of early daguerreotype photography, whereby the camera could only capture that which remained still, to create a virtual dissimilitude. How the computer processes the image and what we perceive are distinct but entangled: our apprehension oscillating between the mimetic desire to identify with the eye of the camera and an eerie sensation of physical displacement. The image, split apart, no longer confirms the world as we see it, but reveals how

the computer processes it as information. The viewer is incorporated into an algorithmic architecture, while his or her relationship to its visible interface is conditioned by the schism between the way the computer watches the world and the viewer's perception of this process. Caught in between two cognitive realms, the viewer becomes a witness to hybrid subjectivity shaped by a heterogeneous and incongruent apprehension of the computer's visual register of doubling and its disturbance.

In *The Giver of Names,* the most complex of Rokeby's computer-integrated installations, the viewer enters the gallery space to encounter an unassuming configuration of a computer monitor, a video camera pointing at an empty pedestal with a small screen above it, and an odd collection of small plastic toys and everyday objects piled on the ground beside it. When the viewer places objects on the pedestal, the computer performs a series of cognitive functions. First, the computer analyzes the objects by delineating recognizable components such as colour, texture, and outline, rendered visible on the video screen located above the pedestal. Then the computer radiates this information through an associative database of language that enables it to describe the objects in full sentences that appear on the screen above the image of the object. On the computer monitor, the algorithmic architecture of this linguistic function is represented as constantly shifting clusters of words the computer has retrieved from its memory bank of language. Simultaneously, the computer speaks aloud its endearing and often humorous, but ultimately nonsensical, strings of word associations.

As a computer that not only sees but also describes, *The Giver of Names* corresponds to what makes us human: the ability to communicate and interpret the world through language. At the same time, the work's idiosyncratic output reveals the gap between the subjectivity of language we experience as humans and the logic of binary code. As humans, we enter the symbolic register of language through the acquisition of a mother tongue and an unconscious internalization of self and other. The computer, on the other hand, acquires language through building blocks of information and a cognitive process stripped of cultural and social relations. Through *The Giver of Names'* outpouring of grammatically correct nonsense, the gap between naming and comprehension lays bare the differences between the mathematical logic of machines and the nuances of meaning and metaphor. What creates the appearance of the computer's discursive intelligence is not its capacity to describe, but the projection of it as a higher realm of consciousness, evoking the fantasy of mastery inherent in Plato's ideal forms and the *letrados'* symbolic ordering of a colonial reality.

In the 1950s, León Cadogan, a Paraguayan ethnographer whose writings on the Guaraní are key sources of information on their belief system and rituals, published a small pamphlet on the subject of nomenclature and nature.[9] In his text, Cadogan examines how the ethno-botanical vocabulary of the Guaraní reflects a fluid and hybrid process of naming that encompasses a multiplicity of dimensions: folkloric and spiritual, material and virtual. He ends his text with the story of a forestry engineer named Hutchison, who, in documenting the flora of the region, found that his Guaraní informants would refuse to divulge the names of certain trees whose branches and leaves he asked them to identify. One day, frustrated at an informant's refusal to provide him with names for his specimens, Hutchison pointed to a tree known in Guaraní as *kyrypyne* and asked the Guaraní man what its name was. In response, the informant went up to the tree, embraced it, caressed it, whispered to it, and then caressed himself, in the same manner that two Guaraní would greet each other in order to demonstrate their friendship. Based on Cadogan's research of Guaraní cosmology, in which trees share a common origin with humans and speak to them from time to time of the virtual realm, Cadogan surmised that the hug symbolized an intimate and fraternal relationship with the tree. What the Guaraní man whispered to the tree Cadogan could never know, but he imagined the following words:

> Brother *kyrypyne*, everything is over. Those who possess the thunder
> have started to show me branches and leaves of your brothers, who are
> also my brothers. But why? Undoubtedly, in order to tell me that they
> intend to destroy you, like they have destroyed our palms, our subsis-
> tence; the herb trees whose fruit feed so many birds; the cedars whose
> scent is refreshing and who offer cones to the monkeys...[10]

By greeting the tree as his brother, the Guaraní crosses a boundary between the objective ordering of the natural world and the subjective realm of human emotions, effectively changing a story about naming and science to one of naming and culture. In turn, Cadogan's interpretation of his caress changes a story about naming and culture into one of naming and power. Juxtaposing the Guaraní's acute sense of the connection between material and virtual realms with the engineer's classificatory system, Cadogan offers a cautionary tale that speaks to the contemporary desire to sever the body and culture from the cybernetic realm of simulation. The computer, like the forestry engineer, deploys a linguistic model that is unambiguous and universalizing,

stripping language of its cultural and historical associations. By surrendering to the computer's symbolic ordering of reality, we end up abdicating the power of metaphor to facilitate movement back and forth between cognitive realms.

In Schiphorst's, Tenhaaf's and Rokeby's works, it is the Guaraní's rather than the engineer's ordering of reality that is privileged. Creating metaphors for hybrid subjectivity, they point to the ways in which embodied experience is the connective tissue that straddles cognitive realms. They serve as guides rather than as dissimulators, rendering explicit the gaps between idealization and a historical materialism that utopian projections of cyberspace disguise. In their works, they ground the sticky residue of our technological projections in the subjective differences between the material and virtual worlds we inhabit. Locating in the imaginative potential of cybernetics a hybrid subjectivity that is reflexive, radical, and crossbred, they transform the phantasmagorical terror of a devouring matrix or the utopian ecstasy of cyberspace into a fluid apprehension of the self that interacts with simulation without being dominated by it.

Notes

1. Donna Haraway, "A Cyborg Manifesto," in *Simians, Cyborgs and Women: The Reinvention of Nature* (New York: Routledge, 1991), 149-186.

2. Michael Heim, "The Erotic Ontology of Cyberspace," in *Cyberspace: First Steps*, ed. Michael Benedikt (Cambridge, MA and London: MIT Press, 1991), 59-80.

3. Plato's "Allegory of the Cave" addresses the philosophical stages of enlightenment by describing prisoners living in a cave, whose perceptions of the world are limited to shadowy images of objects on the cave wall. Plato contrasts this apprehension of external appearances to the experience of one of the prisoners who escapes the cave and is able to see the objects as they truly are in sunlight. See *The Republic of Plato*, ed. Francis Macdonald Cornford (London: Oxford University Press, 1941), 227-231.

4. Octavio Paz, "The Art of Mexico: Material and Meaning," in *Essays on Mexican Art*, trans. Helen Lane (New York: Harcourt Brace and Company, 1993), 29-43.

5. Angel Rama, *The Lettered City*, ed. and trans. John Charles Chasteen (Durham and London: Duke University Press, 1996).

6. For further discussion of the Guaraní see Dot Tuer, "Old Bones and Beautiful Works" in *Colonial Saints: Discovering the Holy in the Americas 1500-1800*, eds. Allan Greer and Jodi Bilinkoff (New York: Routledge, 2003); Hélène Clastres, *The Land-Without-Evil: Tupí-Guaraní Prophetism*, trans. Jacqueline Grenez Brovender (Urbana and Chicago: University of Illinois Press, 1995); and León Cadogan, *Ayvu Rapyta: Textos Míticos de los Mbyá-Guaraní del Guairá* (Asunción: Biblioteca Paraguaya de Antropología, 1997).

7. Two recent studies with conflicting interpretations of Guaraní cosmology both attribute to their spirituality a Platonic structure. See Bartomeu Melià, *El Guaraní, experiencia religiosa* (Asunción: Biblioteca Paraguaya de Antropología, 1991) and Alfredo Vara, *La Construcción Guaraní de la Realidad* (Asunción: Universidad Católica, 1984).

8. James D. Watson, *The Double Helix: A Personal Account of the Discovery and Structure of DNA* (New York: Atheneum, 1968).

9. León Cadogan, *Ta-ngy puku: aportes a la etnobotánica guaraní* (Asunción: Universidad Católica, 1973).

10. Ibid., 42.

This essay first appeared in *The Multiple and Mutable Subject*, edited by Vera Lemecha and Reva Stone. Winnipeg: St. Norberts Arts Centre, 2001.

THE SECOND NATURE OF SIMULATION

MIRRORING THE ORGANIC IN THE VIRTUAL WORLD OF CHAR DAVIES'S *EPHÉMÈRE*

Long after unstrapping the harness and shedding the helmet that immersed my body in Char Davies's *Ephémère*, I retain a memory of her computer-rendered environment that is absolutely visceral. Etched in my mind is the sensation of floating downwards into a wintery scene of a flowing river and stark silhouettes of trees stripped of their foliage to an underground world of entangled roots and strangely animate seeds; then sinking deeper to a place where flesh and earth mingle, rivers become veins, seeds give birth to eggs, rocks evolve into organs, and bones turn to dust; and finally surging upwards again to encounter a kaleidoscopic burst of verdant greenery. Like a vivid dream, the memory of this sensation has a clairvoyant, surrealist quality. It hovers between the cognitive realm of consciousness (I was there, I experienced it) and the extrasensory realm of the unconscious (it seemed so real that it must have happened, yet the fluid shifts in time and space and seamless transformations of matter mean it must have been a dream).

At the dawn of the Enlightenment, Descartes struggled to find a method of philosophy to anchor thought in the apprehension of the self and to banish dreams from invading our waking perceptions of the natural world.[1] At the twilight of the twentieth century, immersive virtual environments such as Char Davies's loosen the moorings of Cartesian logic, setting the self adrift in an uncharted realm of perception where the demarcation between what is an illusion and what is not is no longer easily ascertained. In part, the unsettling blurring of boundaries between reality and its technological replication occurs on a sensory and physiological level. By donning a stereoscopic headset that envelops perception in a computer-rendered realm of images, we voluntarily blind ourselves to the exterior world. Unlike cinema, in which the audience sits in a darkened theatre, their bodies grounded in the physical

world, and watches flickering projections of light on a screen, in Davies's work our enclosure of the self in a simulacrum is complete. Enveloped by images and sounds, one loses a perception of one's body as separate from the artificial environment it inhabits.

On a metaphysical plane, the implications of this entanglement of body and machine are far more indeterminate and paradoxical. The experience of virtual reality is not only a technical process, but also an imaginative and conceptual act of giving oneself over to a mimetic universe of human design. In the 1930s, Walter Benjamin, writing on the revolutionary potential of cinema to penetrate, like a surgeon's hand, deep into our optical unconscious, noted that a critic hostile to film complained, "I can no longer think what I want to think. My thoughts have been replaced by moving images."[2] In virtual reality, this sensation of technology remodeling consciousness is amplified. Dziga Vertov once wrote that in cinema one flies.[3] In virtual reality, one becomes the cameraperson, the viewer, the set, the landscape. There is no chance to flee the theatre, as audiences did when they first experienced Lumières' train arriving at the station. Another strategy of interacting with the mimetic image must be found to avoid a psychic collision with the technological doubling of reality.

A poetic and meditative exploration of the ways in which perception and the apprehension of self are reconfigured by virtual reality, Davies's *Ephémère* is a search for such a strategy. Her innovative use of the technological apparatus of VR to create an artificial environment that mirrors the organic world reveals a twofold process of linking the technical to the metaphysical, matter to illusion. On a physical plane, the blindfolding effect of the standard VR helmet is countered by the use of a body harness, which intimately connects the corporeal act of breathing to immersion of the self within a technological realm. Whereas most virtual environments deploy a glove wired to computer sensors to create a relationship between the motion of the hand and the perception of movement in virtual space, in *Ephémère* the subtle and involuntary life force of the body interacts with computer code. Rather than experiencing the sensation of penetrating a mimetic realm (a literal enactment of cinematic projection analogous to Benjamin's metaphor of the surgeon's hand), one is gently suspended, floating and sinking to the rhythmic inhales and exhales of one's own breath.

While this link between the physicality of the body and its immersion in virtual space is an essential element of Davies's work, the content of the artificial environment we temporarily inhabit is equally salient. It is not only how we move but also what we see in virtual space that produces a critical awareness of how our apprehension of self is

altered within a mimetic universe. To experience a computer-generated reality of hard-edged grids and futuristic architecture, as is common in most VR environments, is to engage with a cultural paradigm that reinforces a technological will to power over nature. In contrast, *Ephémère* draws upon the natural world and the artist's background as a painter for inspiration, with hard-edged grids giving way to muted transparencies and an atmospheric translucence.

There is a moment in *Ephémère* when, sinking deep below the red-tinged earth, one encounters a technological doubling of the organic and the virtual. Passing through indeterminate layers of alluvial sediment, one finds oneself inside a highly symbolic and abstracted replication of nature that feels, but does not appear, real. The disorientation that occurs in virtual space and time is suddenly compounded by the realization that one has entered a mimetic image in which one's body has fused with simulation. What ensues from this flash of recognition is an uncanny sensation of seeing oneself as both flesh and machine. As if in a dream, the self is both embodied and disembodied, matter and illusion. Distinctions between mind and body melt away to reveal a place where consciousness is no longer grounded solely in the natural world nor in its technological double, but in a dialectic between organic and synthetic realms. Instead of being able to give ourselves over to cybernetic fantasies of technological control and eternal replication, we come face to face with our own mortality.

Curiously, the most controversial aspect of Davies's work is precisely the mirroring of the organic within virtual space. When Davies speaks publicly about her immersive virtual environments, there is inevitably one person in the audience who asks her why she makes virtual replicas of nature when she could simply take a walk in the woods. The contrast that this question evokes, between the mediated experience of viewing an artificial rendering of an old-growth forest and the first-hand experience of smelling fragrant pine needles overhead and feeling dank earth underfoot, cuts to the heart of Davies's artistic intervention in the realm of new technologies. Embedded in the question is an assumption of an opposition between culture and nature, yet the urge to copy nature—that is to create a second nature through mimesis—is central to an understanding of our existence and the world we live in.

The human impulse to mimic nature finds its genesis in the earliest immersive environments, caves, in which wall paintings animated the experience of hunting animals for survival. It carries forward into shamanistic realms, in which medicine men create models of the natural world through chants or herbal potions or crudely fashioned sculptures calling forth the invisible spirit world of dreams and visions. Like

the return of the repressed, the mimetic urge finds its modern roots in the capacity of photography and cinema to seize hold of nature through images. Between the animistic magic of the shaman and the secular lens of the camera lies a legacy of classical Western thought extending from the Hellenistic era to the Enlightenment, in which both God and humanity were artisans tending gardens, creating from the chaos of the cosmos a neat and ordered relationship of nature to culture predicated upon divine design.

In Char Davies's virtual environments, the historical progression from the "primitive" cognition of a spiritually infused nature to the ascendancy of modern science, which classified, secularized, and demystified the material universe, is disrupted. As in that moment of early modernism when Louis Aragon sensed that technology's advances had unleashed a mythic flow of spirits, something of an ancient animism seeps through the modern lens.[4] In the second nature of simulation that is experienced through *Ephémère* there emerges a sense of the mysterious and the marvellous. While it is tempting to attribute this impression to the transcendent role of technology, the opposite has occurred. The experience of otherworldliness in *Ephémère* is dependent on our capacity to relate the reduced space of virtual reality, with its defined set of computer coordinates, to the infinite complexity of the natural world. For as Davies reminds us in the dialectic she constructs between the organic and the synthetic, the earth is a fertile site of reverie and regeneration. In contrast, virtual reality is a sterile environment that, at best, can offer us a glimpse of the mimetic residue of nature's vast chaos. To imagine otherwise is to risk mistaking technology for divine design.

Raised on a mass-culture diet of video games, Gulf War precision bombings, and Hollywood blockbuster spectacles, we have ingested a series of paradigms framing virtual reality that reinforce the role of technology as the trumpeting warrior, waging battle against real and perceived enemies ranging from space aliens and DNA mutations to the cataclysmic forces of natural disasters. Yet despite the Manichaean fantasies that underlie the harsh, clean grids of computer animation, virtual reality has become, in the popular imagination, a parallel universe in which we can bridge the escalating schism between nature and culture. The appeal of this phantasmic universe, with its potential to extinguish desire for the messy and unpredictable reality of everyday existence, is both the utopian promise and the sinister endgame of new technologies. In response, Davies creates a virtual environment that disturbs the ingrained attitudes in contemporary Western society of nature as separate from culture, and of illusion and matter as irreconcilable. To

immerse the self in *Ephémère* is not to evade a psychic collision with a technological double, but to reflect upon the implications that such a collision poses for how we choose to imagine and to inhabit a second nature of simulation.

Notes

1. René Descartes, *Discourse on Method and Meditations on First Philosophy*, ed. David Weissman (New Haven and London: Yale University Press, 1996).

2. George Duhamel quoted by Walter Benjamin, "The Work of Art in the Age of Mechanical Reproduction," in *Illuminations*, ed. Hannah Arendt, trans. Harry Zohn (New York: Schocken Books, 1969), 238.

3. Dziga Vertov's description of cinematic experience is quoted in Paul Virilio, *War and Cinema: The Logistics of Perception*, trans. Patrick Camiller (London: Verso, 1989), 11.

4. Louis Aragon, "A Preface to a Modern Mythology," in *Paris Peasant*, trans. Simon Watson Taylor (London: Picador Books, 1980).

This essay first appeared in *Char Davies: Ephémère*. Ottawa: National Gallery of Canada, 1998.

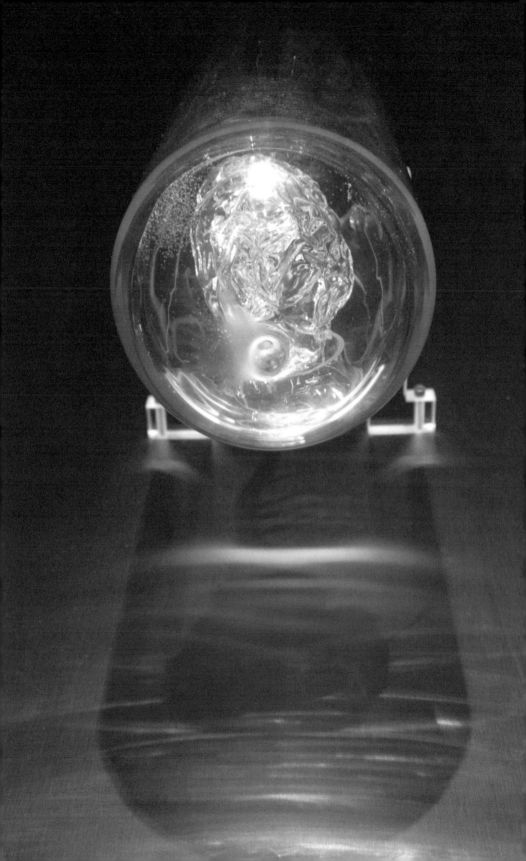

THE HEART OF MATTER

THE MEDIATION OF SCIENCE IN THE ART OF CATHERINE RICHARDS

The almost fashionable success of anatomy cannot be attributed solely to scientific curiosity. It is not hard to understand; it corresponds to certain ill-defined things at the outer limits of life and death, sexuality and pain.

—Philippe Ariès, *The Hour of Our Death*

The body is an extraordinarily complex system that creates language from information and noise, with as many mediations as there are integrating levels, with as many changes in sign for the function which just occupied our attention. I know who the final observer is, the receiver at the chain's end: precisely he who utters language. But I do not know who the initial dispatcher is at the other end…. The observer as object, the subject as the observed, are affected by a division more stable and more potent than their antique separation: they are both order and disorder. From this moment on, I do not need to know who or what the first dispatcher is: whatever it is, it is an island in an ocean of noise, just like me, no matter where I am.

—Michel Serres, *Hermes*

When I was a small child, my grandfather, a retired physics professor who had studied electromagnetic fields and thermodynamics, used to gather his grandchildren together in his cottage teahouse for impromptu science lessons. He was a tiny, unassuming man, overshadowed by my more voluminous and voluble grandmother. In the early August mornings, the ground heavy with dew, he would become animated and expansive, chalk in hand, as he drew for us the workings of the internal combustion engine on a makeshift blackboard. I don't remember much from these lessons, except a vague image of complicated

diagrams. I do remember that I was barely interested in the subject at hand, and kept looking through the screened gazebo at the lake I loved to swim in, my body enveloped by dark blue waters that became a terrifying black as I dove downwards towards the untouchable bottom.

In the afternoon, my grandmother would hold court in the main cottage, which was heated by a propane stove on even the hottest days of summer. She lectured us sternly about the greatness of literature and handed us books off the shelf to read—Charles Dickens, Jane Austen, Robbie Burns. I absorbed even less from these lessons, distracted by my grandfather's innumerable science experiments, which cluttered every surface of the room: odd bits of wood and wires, and elastic bands, and vacuum-sealed jars that made sparks fire and alternating currents ring tiny bells.

The ritual of the summer cottage continued into my teenage years, long after my grandparents died. The chair by the stove where my grandmother held forth was now occupied by my mother; my grandfather's experiments were piled into boxes and stored in the attic with the board games and dress-up clothes. My father, who, like my grandfather, was quiet and introspective, was recovering from a brain aneurism at the time. In the late afternoons, he would wander the woods, returning in a philosophical mood to share his thoughts with his children. One hazy August afternoon, he confided in me his thoughts about the brain that had so betrayed him. He told me that despite modern medicine, the brain was still a mystery. Scientists knew very little about how it functioned, yet it controlled and animated our bodies. He was sure that in twenty years—too late for his lifetime—science would begin to understand the brain's internal workings, bringing cures for an unimaginable range of ailments.

Twenty years later, my stepson is now the age I was when my father and I had that conversation. The human genome has been decoded, cloning has begun, and newspapers print daily reports of predictions and speculations about the body's transformation through science. One day I read an article about the potential to harness the gene that controls aging and slows the process of dying. My partner and I, half believers and half sceptics, tell my stepson that while it is too late for us, he is lucky to be young enough to have the chance to live a hundred and fifty years. His response surprises us. He tells us he doesn't want to live that long, by that time the world won't be worth living in. While we see the body as a discrete object purified by science, he envisions it as a hybrid object compromised by social forces.

In Bruno Latour's philosophical meditation on the history of science, *We Have Never Been Modern*, he argues that modernity as the

foundation of contemporary Western science is based in two contradictory and distinct practices—translation and purification:

> The first set of practices, by "translation," creates mixtures between entirely new types of beings, hybrids of nature and culture. The second, by "purification," creates two entirely distinct ontological zones: that of human beings on the one hand; that of nonhumans on the other. Without the first, practices of purification would be fruitless or pointless. Without the second, the work of translation would be slowed down, limited or even ruled out.[1]

In order to keep these two indivisible practices distinct, we subscribe to what Latour calls the "modern Constitution," a system of knowledge that organizes the "Great Divide" between the representation of things and subjects, nature and culture. While hybrids—what Latour names "quasi-objects"—proliferate, we patrol the boundaries of knowledge to enforce the separation of empirical reality and social constructions. Although non-humans and humans form networks that are at once "simultaneously real, like nature, narrated, like discourse, and collective, like society,"[2] we rigorously deny zones of contamination. Yet the ways we conceptualize and negotiate the world, argues Latour, are dependent upon the very networks we are busily negating. In our everyday lives, nature is both thing and being; science is both myth and reality; culture is both biology and belief. Yet in our system of knowledge, we assign such confusions to the "primitive" realm of the pre-modern, non-Western mind.

By clinging to an epistemological purification that cordons off the laws of nature from the social fabric, Latour proposes that we respond to the profusion of hybrids in our lives by assuming one of several stances. Disillusioned by the failure of emancipatory politics in the social arena, we become anti-modern, turning our backs on the present and seeking solace in an archaic past. Alternatively, disillusioned by science's domination over nature we become postmodern, turning our backs on empirical objectivity and suspending belief in the future. For the most part, however, we remain resolutely modern, continuing "to believe in the promises of the sciences, or in those of emancipation, or both."[3] Yet, Latour observes, this "faith in modernization no longer rings quite true in art, or economics, or politics, or science, or technology. In art galleries and concert halls, along with the façades of apartment buildings and inside international organizations, you can feel that the heart is gone."[4]

In relationship to this faltering will to be modern, with its troubled boundaries of knowledge, Latour argues for a symmetrical anthropology in which all societies, not just "primitive" ones, are understood as collectives that mobilize natures and cultures. He stresses the importance of granting historicity—contingent, non-temporal, and associative—to all actors in the networks, both human and non-human. Otherwise, we can neither recognize nor regulate the hybrids we produce. In contrast to the modern Constitution, with its categorical purity, he proposes a non-modern Constitution in which we commit to "providing representation for quasi-objects."[5] Here, "the work of mediation becomes the very centre of the double power, natural and social. The networks come out of hiding."[6] The result of such an epistemological shift is the comprehension that:

> there is indeed a nature that we have not made, and a society we are free to change; there are indisputable facts, and free citizens, but once they are viewed in a non-modern light they become the double consequence of a practice now visible in its continuity, instead of being, as for the moderns, the remote and opposing causes of an invisible practice that contradicts them.[7]

Catherine Richards, an artist whose new-media practice explores the intersection between art and science, functions as Latour's symmetrical anthropologist, rendering visible the quasi-objects he theorizes. In her art pieces, the classical elements of the scientific laboratory are present —observable phenomena, experimental proofs, and vacuum-sealed tubes; so are memories and subjectivities, embedded in the cultural dimensions of the objects she has fashioned by roaming across a historical horizon from Renaissance curiosity cabinets to rococo chambers to virtual reality environments. Linking this historicity to a nineteenth-century scientific vocabulary, she entangles us as viewers in a process of mediation between nature and culture where we can no longer cling to the edges of either empiricism or subjectivity, but must instead contemplate their indivisibility.

In Richards's material conjuring of hybrids, the concept of the body as a quasi-object and the role of the viewer as observer are central. In her earliest works, *Spectral Bodies* (1991) and *Virtual Body* (1993), she explores how a proprioceptive reaction (the sensation of a phantom limb) can be triggered through the viewer's interaction with computer simulations. In *Curiosity Cabinet, at the End of the Millennium* (1995), the viewer enters a copper cabinet, which shields his or her body from

electromagnetic fields that saturate our environment; in *Shroud/Chrysalis I* (2000), the viewer's body is wrapped in a copper shroud. In *Charged Hearts* (1997) and *I was scared to death; I could have died of joy* (2000), exquisitely crafted blown-glass models of hearts and brains respond to the viewer's proximity and touch. All of these works are rich in associations and contingencies that position the viewer in recombinant systems of cognition; all deploy a circuitry that connects the body as an object of scientific inquiry to the cultural relativity of the observer. Within the broad conceptual model of Richards's artistic practice, two pieces—*Charged Hearts* and *I was scared to death; I could have died of joy*—are also distinct in their use of anatomy to lay bare the projections and perceptions of our bodies as simultaneously scientific phenomena and social narratives.

For *I was scared to death; I could have died of joy*, Richards creates a sepulchral atmosphere in which glass models of halves of a brain and spinal cord, sealed in vacuum tubes, lie in wait for the viewer. In the darkened gallery space, the two models are located in opposite ends of the room on surgical steel tables, illuminated by tiny spotlights that bathe the brains in a halo-like glow. As the viewer approaches, the spotlight goes out and a shimmering luminescence flickers along the spinal cord and the brain, giving the impression that the two halves are communicating. By reaching out to touch the glass tube filled with phosphorous gases, the viewer appears to excite the organ. However, the viewer does not interact with the work in any direct way. The pulsating patterns—created by the plasma flow of electrons and modeled on the electromagnetic impulses of the brain—are generated independently of external stimuli. Rather, cultural narratives and the viewer's emotional reactions connect him or her to composite halves of the model brain.

My first experience of this work was empirical and relational. There were a number of people in the gallery, and as we circled the model halves of the brain we began to exchange questions. What happens, we asked each other, when we stand near the tables, or far away? What is the relationship of our touch to the plasma flowing through the tube? Is it our body heat that triggers the brain's iridescent patterns, or is it the electricity flowing through our bodies? Is there a way to predict and manipulate the brain's response to our presence, or is there something mysterious and random about the behaviour of these blown-glass body organs? Like Serres's final observer, we were receivers in a network of information and noise, sorting out meaning through language. We were both "observer as object, subject as the observed" in relation to each other and the non-human agent in the room: that delicate anatomical

replica of the brain charged with electromagnetic energy. Through our interactions, the body as "simultaneously real, like nature, narrated, like discourse, and collective, like society" became visible as the quasi-object of a hybrid epistemology.

The second time I saw the work, I was alone after closing time; an attendant opened the gallery for me and left me in the darkened hush of the room. As I approached the model halves of the brain, their phosphorescent gases silently flickering like nerve impulses, I had a strange sensation of intimacy. It was as if the blown-glass vacuum tubes, scientific models responding to quantifiable data, had become beings in their own right—not part of me, not like me, but nevertheless imbued with emotional vulnerability. As I stroked one half of the brain, watching the plasma surge, it was as if I had invoked a magical incantation and the brain had come alive, an animate mesh woven from the technological precision of the work itself and my memories of my grandfather's experiments. It was months later when I realized that another memory had woven its way into my caress. Thinking back to my impression of connectivity in the gallery, a sensation of empathy but also of something intangible, I realized that in stroking the brain I had relived a feeling of absolute difference and sameness—an impossible hybrid of emotions—which I had experienced after my father died. The day before my father's burial, his body was placed in an open coffin at the funeral parlour. During visitation hours, there was a moment when I found myself alone with his immaculately embalmed corpse. I reached over to stroke his head, and in that gesture, I experienced—just as I would with Richards's brain so many years later—an object that was deathly other and yet deathly familiar.

In his book on the history of dissection, *The Body Emblazoned*, Jonathan Sawday traces a genealogy of anatomy back to the early modern world of the Renaissance, when cadavers were plucked from the gallows by surgeon/barbers and ferreted to the public arena of the dissection theatre. Through this display of the body's interior as a discrete entity to be observed and analyzed, the foundations of modern medicine were laid. In parallel fashion, the social division between pathology and normalcy was established: sinners were no longer returned to the fold of the body politic after death but dragged off to the dissection table. Echoing Bruno Latour's argument that modernity is based on a division between things and subjects, Sawday locates in the dissection theatre a separation between the mind as Cartesian consciousness and the body as an observable phenomenon of the natural world.[8]

Whereas previously the body had provided metaphors for political organisms, and our relation to it was one of mystical affinity rather

than anatomical partition, henceforth, the interior of the body was understood as a vast continent to be mapped by intrepid explorers, and a corporeal mechanism whose malfunctions could be corrected by scientific tinkering.[9] Paradoxically, this view of the body as a mechanism to be dissected and studied produced an inverse effect on the capacity for self-understanding. While we could learn about other bodies through empirical methods, we could only know ourselves through divination or introspection. The objectivity/subjectivity split, which would propel the rise of science and harness nature to empiricism, found its parallel in the binary division between self and other, mind and body. From the seventeenth-century ordering of spirituality that envisioned God as a watchmaker and the body as his perfect automaton, to the ungodly evolution of the nineteenth-century that viewed the body as an engine converting energy into labour, science claimed to be an empirical domain untainted by cultural relativism, despite its obvious narration of the body as a social construct.

In the medieval world of martyrs and religious miracles, the body was a profoundly hybrid object. As in the realm of "primitive" belief, the boundaries between materiality and immateriality, what was visible and what was invisible, were leaky and indeterminate. Hearts continued to beat after death, suggesting heavenly visions and hellish retribution; souls nestled in the brain, producing visceral stigmata. The modern era swept away this unnerving circuitry of natures and cultures, banishing the mediating power of the priest or shaman to "see" inside the body and interpret its external signs as visible manifestations of a mesh of natural and social relations. In the contemporary context, as our bodies and technologies become increasingly entangled, the boundaries between nature and culture are unravelling. The convergence of biological and artificial life, genetic manipulation, and ubiquitous computing produce a system of networks in which the modern concept of the Great Divide becomes as absurd as the medieval belief in miracles. Yet mastery, rather than connectivity, continues to drive the ethos of our social relations.

As an artist who crosses the Great Divide between scientific objectivity and artistic subjectivity, Richards foregrounds connectivity as an intimate experience in her visualization of the leaky boundaries between body and technology. In *Charged Hearts*, an earlier companion piece to *I was scared to death; I could have died of joy*, the vulnerability of our relationship with technology converges in the image of the heart. Chosen by Richards for its emotional symbolism and its physical function as "one of the body's better known electromagnetic fields,"[10] the heart becomes the interface between the viewer and natural phenomena.

In her installation, Richards places two glass replicas of the human heart, vacuum-sealed in bell jars, on pedestals. A terrella—a scientific model of the electromagnetic field that envelops the earth and produces the northern lights—is placed between them on a third pedestal. The hearts and the terrella are activated when a viewer approaches one of the pedestals and lifts up the one of the bell jars. As the viewer holds the glass heart in his or her hands, phosphorescent gases illuminate its interior, appearing to pulsate in time with the viewer's own heartbeat. When two viewers lift the hearts, it seems as if a mysterious connection has been made between the artificial heartbeats and the viewers' pulses, while in the middle between them the terrella begins to glow with a magical incandescence.

In relation to this work, Richards speaks of the linguistic slippage involved in the act of holding a heart in our hand. The glass models are fragile replicas that, if dropped, would shatter, with shards scattering in all directions, like the shattered heart of someone scorned in love. She also speaks of the physical slippage between the glassed-in models and the electromagnetic fields that envelop us. "The real object in this piece," writes Richards, "is electromagnetic activity and its play between the material and the virtual. The hearts and the terrella are containers for these electrons. They are windows which frame the activity."[11] As the site of the viewer's interaction with the work, the glass heart becomes a quasi-object, a visual cipher of a field of electromagnetic signals that connects the electrons of our bodies to those of televisions, computers, and voltage lines; and connects the cognition of these invisible fields of energy to cultural narratives of intimacy. In Richards's work, the interiority and the exteriority of the body are transposed; we literally wear our heart on our sleeve; we hold a representation of our emotions in our hand. In so doing, we immerse our bodies inside a scientific modelling of natural phenomena in which we become Serres's island in an ocean of electronic noise.

In the fields of psychoanalysis and psychology, which lay claim to the interiority of consciousness, dissociation is a term for an individual's capacity to cordon off a traumatic experience by separating or disconnecting component parts of his or her personality. The result limits the individual's potential to achieve self-knowledge and intimacy in social relationships. Extending this concept, by way of analogy, from the troubled boundaries of the individual mind to the troubled boundaries of our collective environment, the dissociation underlying modernity's Great Divide prevents us from forging connections with the quasi-objects that shape our social fabric; it prohibits intimacy between the cultural and scientific dimensions of our knowledge systems. For Latour,

the ability to recognize that we have always lived in a world where associations of observation and imagination mediate our existence is of paramount importance to an understanding of contemporary science. Similarly, Sawday argues that the mystical affinity of the body and consciousness remains with us, repressed, unacknowledged, yet deeply operative in our social relations. In Richards's work, these insights are coupled to a conceptual strategy that enables the viewer to "see" these associations and affinities through an experiential relationship to the art object. By blurring the boundaries between representations and extensions of the body and revealing the repressed intimacy between human and non-human agents, she provides a conceptual model that allows us to "feel the heart" of networks that modernity extinguished.

Notes

The epigraphs are taken from Philippe Ariès, *The Hour of Our Death*, trans. Helen Weaver (New York: Alfred A. Knopf, 1981), 369; and Michel Serres, "The Origin of Language," in *Hermes: Literature, Science, Philosophy* (Baltimore and London: John Hopkins University Press, 1982), 82.

1. Bruno Latour, *We Have Never Been Modern*, trans. Catherine Porter (Cambridge, MA: Harvard University Press, 1993), 10.

2. Ibid., 6.

3. Ibid., 9.

4. Ibid., 9.

5. Ibid., 139.

6. Ibid., 139.

7. Ibid., 140.

8. Jonathon Sawday, *The Body Emblazoned: Dissection and the Human Body in Renaissance Culture* (New York and London: Routledge, 1995), 27.

9. Ibid., 25.

10. Catherine Richards, artist's notes for *Charged Hearts*, 1.

11. Ibid., 2.

This essay first appeared in *Excitable Tissues*. Ottawa: Ottawa Art Gallery, 2003.

THREADS OF MEMORY AND EXILE

VERA FRENKEL'S ART OF ARTIFICE

It is a testament to the simultaneously ephemeral and tangible quality of Vera Frenkel's artistic practice that years after I first viewed her videotape *Her Room in Paris*, I retain a vivid image of the room in which the central character of the work, Cornelia Lumsden, a little-known Canadian writer, wrote a great novel in exile before mysteriously disappearing. The room, as I remember it, is small and cluttered, with loose papers strewn about and faded flowered wallpaper peeling off the walls. A diffuse grey light filters through lace-covered windows that open onto a mournful Paris sky. A stately oak desk dwarfs a threadbare couch, over which a shawl is carelessly thrown. The memory is flawless, except for one troubling detail. I am convinced that a video monitor is present amongst the room's piles of papers and worn objects. This, however, is impossible, since Cornelia wrote her novel in the period between the two world wars before the invention of television.

Watching the videotape again, I discover that the room I imagined in all its detail does not exist. More precisely, the videotape is not about the material evidence of Lumsden's life and her writing sanctuary, but about its absence. The viewer never actually sees an image of the room; although it is true that one blurry black-and-white photograph is momentarily displayed before the camera. Instead, one is witness to the conflicting testimonies of an expert, a rival, a confidant, and a reporter (all played by Frenkel); as well as a lover and a friend (played by Tim Whiten), who all proffer information and speculation concerning Lumsden's life and the mysterious circumstances of her death. I discover that what I have retained all these years are the traces of an after-image, a fictional reconstruction of a room in Paris stitched together from the scattered clues and artifice of Frenkel's narratives. I harbour a memory that, similar to Frenkel's work, is shaped by the indeterminacy between the act of seeing and the act of remembering.

In Frenkel's videos, this illumination of memory as simultaneously real and fabricated weaves together themes of exile and displacement, loss and longing into a rich tapestry of work spanning several decades. From her early experimentation with live-feed video and performance, *String Games: Improvisation for Inter-City Video* (1974), to her *Body Missing* website (1996–ongoing), Frenkel engages the viewer in an active process of piecing together meaning from fractured points of view. From her two-channel work *No Solution — A Suspense Thriller, #2, Introduction to Some of the Players,* made in 1979, to her 1992 videodisc installation *…from the Transit Bar,* she is concerned with a model of interactivity and with how remembering and forgetting are cast into flux by new technologies.

While each of Frenkel's individual works offers the viewer distinctive pathways into an entangled web of memory and technology, what is also remarkable is the way in which the works interconnect. On a formal level, the migration of images, characters, and themes from one tape to another multiplies potential interpretations and meanings. On a conceptual level, the destabilization of narrative conventions such as detective or romance formats leads to a profusion of possible truths and fictions. Through the ancient ritual of storytelling, Frenkel creates a representational realm that finds a parallel in the hypertext junctures and chimerical online identities of the World Wide Web. But while the electronic landscape of the Web holds out the lure of redemption by blurring boundaries between consciousness and simulation, Frenkel's work cautions against false messiahs preaching technological salvation.

On the World Wide Web, the computer screen serves as a window that opens onto a seemingly endless expanse of information. This vast, labyrinthine network of archives and Web pages, chat lines and databases, reconfigures how and what we know. Surrogate personalities, in the form of online identities, promise the freedom to discard our bodies and forget our histories. In contrast, the video and computer screens of Frenkel's artworks are filled with elusive ghosts and discordant memories. The intimate disclosures and deceptions in her storytelling link disparate fragments of evidence and testimony to call into question how and what we remember. Rather than promising an illusion of freedom, her fictional identities disclose the existence of missing bodies and forgotten histories. Through her electronic tales, Frenkel creates a technological horizon in which it is the structure of memory, rather than the structure of information, that is reconfigured.

Take, for example, the mysterious identity of Cornelia Lumsden, the obscure but brilliant Canadian novelist who is first conjured by Frenkel in *Her Room in Paris.* In a strange turn of events, a chance encounter

between Frenkel and a woman claiming to be from the Lumsden family unsettles a delicate ecology of fabrication. While giving a lecture in Montreal, Frenkel was confronted by a member in the audience, who rose from her seat and demanded to know by what right the artist was using the Lumsden name in a work of art. A reenactment of this confrontation forms the underpinning of Frenkel's subsequent videotape "...*And Now, the Truth,*" *(A Parenthesis)*. In this work, the story of the "real" Lumsden as told by the audience member (who is also a novelist named Cornelia) builds upon the testimonies of *Her Room in Paris* to create another layer of memory and dissimulation.

In "...*And Now, the Truth,*" *(A Parenthesis)*, an interview takes place between the woman from the Montreal audience and Frenkel on the secret life and work of the mysterious novelist. The juxtaposition of Frenkel's knowledge, accumulated during years of careful study, and the stories that the woman divulges about the Lumsden past, replete with snapshots of the family castle, deepen the enigma of the missing novelist. It seems plausible, although improbable, that the encounter in Montreal between Frenkel and the woman that led to the making of the videotape did occur. Yet the tall tales the latter tells of the family's genealogy and the curious similarities that emerge between her mother's life and Frenkel's fictional novelist heighten our suspicion that not only Cornelia, but also the family member, are fabricated by the artist's hand. At the same time, the more intricate and entangled the web of memories becomes, the more tangible Cornelia Lumsden seems.

With the same ease that the Lumsden family member appears to slip in and out of Frenkel's fictional life of Cornelia Lumsden, the viewer begins to slip in and out of a belief in the novelist's existence. She seems so familiar that I am sure I have stumbled upon a reference to her writings in one of those voluminous tomes on Canadian literature that I occasionally pull at random from the library shelf. What makes Cornelia Lumsden so real in the viewer's mind is not only a confusing interplay of truth and fiction, but also the emotions that memories of exile evoke. Through her enigmatic absence, Cornelia Lumsden becomes a cipher for the feelings of alienation and dreams of belonging that mark the experience of exile; the inconsistencies of her story become a repository for the elisions and ellipses of history.

When Cornelia Lumsden wrote her novel *The Alleged Grace of Fat People* in 1934, Paris was still an artistic Mecca for the avant-garde; in Berlin, the National Socialists had just come to power. As Canadian writers and artists looked to Europe for the freedom to reinvent cultural boundaries and expression, the first refugees were fleeing Hitler's fascist regime. When Frenkel made the Cornelia Lumsden tapes in 1979/80,

exile as a form of creative alienation was already a modernist myth, called by Frenkel herself at the time "Canada's favourite fairy-tale." Mass media images and instantaneous satellite transmissions now promised the reinvention of cultural boundaries and expression; the ideological divisions and geographical barriers of the Cold War dominated economics and politics. Of the massive displacements of peoples and histories wrought by the ravages of fascism and the Second World War, barely a whisper was heard.

Hemmed in by television signals and ideological silences, artists in the 1970s sought to bridge the alienation of self from technology by turning the lens of the video camera back upon themselves. Using the grainy images, awkward close-up framing, and feedback capabilities of primitive portapak video to enact an intimate mirroring of body and machine, they created an aesthetics of narcissism. Frenkel chose instead to record the fragmentation of memory and of narrative. Holding up the video camera as witness to the alienation of self from history, she became a detective in an electronic surface of appearances, questioning what was forgotten and unspoken in the impending ascendancy of the simulacrum.

In Frenkel's earliest video work, *String Games: Improvisations for Inter-City Video,* she orchestrated a live teleconferencing transmission of two groups of people playing a game of cat's cradle between Montreal and Toronto. Although the technology of telepresence offered the illusion that the participants could reach out and touch one another, what the viewer sees in the video documentation of the event are their disjointed and incongruous gestures. Seeking to string together a seamless pattern of interaction, the players reveal instead a disorientation of body and place, the imaginary thread that they are passing back and forth alluding to what is lost in electronic transmission.

In subsequent works, such as *Introduction to Some of the Players* and *Signs of a Plot: A Text, True Story & Work of Art,* the game of cat's cradle becomes a mystery puzzle; in *Stories from the Front (& the Back)* and *The Last Screening Room: A Valentine* it becomes a true-blue romance. Frenkel's cast of players becomes increasingly complex, and the imaginary thread that connects their actions increasingly entangled. Missing bodies, banned storytellers, and state censors populate her narratives. Memory emerges as an antidote to the fracturing of communication. Yet the poignancy of the participants' gestures in *String Games: Improvisations for Inter-City Video* remains a constant, their desire to reach across time and space to one another central to the exploration of new technologies in Frenkel's work.

When *String Games: Improvisations for Inter-City Video* was made in the 1970s, the World Wide Web was in its infancy, born of and carefully nurtured by a military-industrial complex. The materialization of a

virtual interconnectivity was a distant mirage on the technological horizon. By the 1990s, the Web had become a household word and the divisions of the Cold War had given way to a global embrace of instant communication. As the counterpoint to an increasingly totalizing vision of a technologically engineered simulacrum, Frenkel's *…from the Transit Bar* restages the disorientation of body and place first enacted in *String Games* as a deterritorialization of memory and space. Exile as a metaphor for alienation and displacement, first conjured by the enigmatic absence of Cornelia Lumsden, is evoked in *…from the Transit Bar* through testimonies shaped by war, trauma, and dislocation.

 …from the Transit Bar, first commissioned as an installation piece for Documenta IX in Kassel, Germany, is a functioning piano bar contained within a gallery setting. The walls of the bar are slightly skewed, and false windows open onto still life tableaux of fake palm trees, suitcases, and raincoats. As viewers meet to sip drinks, or perhaps talk to the bartender, music filters through the air. At times, a piano-player is present; on other occasions, a computerized system inside the piano enables it to play itself. Six video monitors, placed in the walls and on the bar and piano, fill the space with the voices of fourteen Canadians, all friends of the artist, who address the patrons in the bar as if they are strangers encountered by chance. Speaking of their experiences as immigrants and exiles, they recount memories of loss and longing, anonymity and discrimination.

 Like conspirators speaking in a secret code, their disclosures are fragmentary and partial. Voice-overs in Yiddish and Polish supplant the original spoken English. Sub-titles interpret the voice-overs in German, French, and English. Each monitor functions independently, with different testimonials playing at different moments. Sometimes, cadences of repetition occur on two or three monitors simultaneously. In isolation, each testimony is tentative and personal; together as a discordant chorus, they transform the instability of remembrance into a collective unsettling of the past. The viewer, straining to piece together the fragments of the stories, literally inhabits the space between image transmissions. From this embodied site of dislocation, the viewer experiences the gathering of memory as the thread that links disparate bodies and histories across time and space.

 Similar to the way in which *…from the Transit Bar* turns the conceptual premise of *String Games* inside out, Frenkel's *Body Missing* intertwines the detective genre—explored in her early single-channel tapes, *Introduction to Some of the Players* and *Signs of a Plot: A Text, True Story & Work of Art*—and the archival task of history. In the early works, the mystery revolves around the missing corpse of Sam Art Broom. Although

there is a crime scene, the body cannot be found and the mystery of its disappearance never solved. In its absence, Frenkel, the narrator turned detective, gathers scattered clues and a trail of evidence to knit together an open-ended plot with an unexpected twist.

In *Body Missing*, first exhibited as a multiple-channel video installation in the Offenes Kulturhaus in Linz, Austria, in 1994, the mystery revolves around the art-theft policies of the Third Reich and the lost artworks that Hitler stored in a salt mine near Linz towards the end of the Second World War. Returning to the era when Lumsden was writing her novel in exile, Frenkel gathers a body of evidence from archival lists and photographs, conversations overheard in cafés, and the memories of witnesses. Constructing from the findings of her investigation photographic montages housed in packing crates and a six-part videotape played on separate monitors scattered throughout the gallery space, Frenkel becomes part detective, part storyteller, and part archaeologist, excavating from fragments of history and memory a genealogy of culture and politics.

In her subsequent adaptation of *Body Missing* as a website, Frenkel's work comes full circle. The tools of new technology deepen the enigma of the missing artworks in the same way that the video screen intensified the enigma of Cornelia Lumsden. Integrating storytelling with the connective possibilities of hypertext, Frenkel links her investigation of the Third Reich art thefts to narrative fragments culled from stories told to the bartender in *…from the Transit Bar*; and to the Web pages of artists who have been invited by Frenkel to mount their own inquiries into lost artworks. Continuing her quest to reconfigure the structure of memory, she unveils a complex mapping of representation in which the act of remembering is now dispersed across both historical time and electronic space.

While Frenkel has chosen to locate her strategies of narrative fragmentation and her interplay of real and fabricated evidence within the virtual architecture of the World Wide Web, her work also cautions the viewer against abandoning our bodies to the realm of simulation and our histories to a technocratic vision of the future. In *Censored: Or the Making of a Pornographer*, the sexual habits of fleas come under the magnifying glass of the censor to warn us of the power of the state to control our images and our narratives. *The Last Screening Room: A Valentine*, a story about a time when storytelling is banned and memory is considered a highly flawed form of data, presents the viewer with a dystopic and ironic version of exile as a form of alienation from our own culture.

In *The Last Screening Room: A Valentine*, the protagonist is an imprisoned storyteller from the future found wandering a country road with no documentation in her possession. Without a passport or Social Insurance Number, there exists no evidence of her identity. All that remains is her incomplete and fragmented tale told to a Privacy Guarantor from the Ministry of Health, whose job is to listen to prisoners' stories when the surveillance equipment is turned off, and then forget them. Convinced by the imprisoned storyteller to break the law and remember her story, the Privacy Guarantor uses the opportunity provided by the state on St. Valentine's Day—the one day of the year citizens are permitted to retrieve and re-enact the past in the form of an electronic valentine—to reconstruct the prisoner's tale. Building a replica of a screening room described by the prisoner where stories were once told and recorded, the Privacy Guarantor pieces together the storyteller's past.

Through the Privacy Guarantor's electronic valentine, the viewer learns of a time in Canada before the rain and memory were outlawed, when storytellers crossed the country weaving commentaries about what they heard and saw. On the west coast of Canada, where the rain fell thickly and luxuriously, artists were "the reporters on their own lives," telling stories to each other in search of the true-blue romance: a cluster of narratives in which memory was circular and partial, and collectively voiced. At the end of the video, the Privacy Guarantor reveals that when the imprisoned storyteller was found wandering the country road, she had in her possession a scarf embroidered with the initials C.L. Although she dismisses speculations that the storyteller might have been the enigmatic Cornelia Lumsden, the initials serve as a material residue of the convictions that underlie all of Frenkel's work: a belief in the subversive power of memory to give shape to the incorporeal, and the potency of storytelling to breathe life into art.

In *"…And Now, the Truth," (A Parenthesis),* this belief is manifested in images of Japanese Bunraku puppeteers practicing their craft of animating nearly life size marionettes. As ancient as storytelling itself, Bunraku puppetry involves a lifetime apprenticeship devoted to perfecting the movements that render inert matter lifelike. Revealing the hand that lies behind this mimicry of life, Frenkel offers a metaphor for the mechanics of new technologies. As viewers, we can accept the marionettes as real, or we can begin to search for the threads that animate their gestures. Through her artworks, Frenkel invites the viewer to engage in the latter, to find our own pathways through her interwoven narratives of exile and history, and to create our own memories from her interplay of truths and fictions.

This essay first appeared in *Images Festival of Independent Film and Video*, Toronto, 1997.

MINING THE MEDIA ARCHIVE

WHEN HISTORY MEETS SIMULATION IN THE WORK OF DARA BIRNBAUM AND STAN DOUGLAS

As the millennium draws to a close, we confront an entanglement of lived and simulated experience that daily grows more complex. Seeking to comprehend this relationship between the everyday world we embody and the manufactured realm of images that envelops us, we stumble upon both familiar and unfamiliar terrain. The contemporary enthusiasm for refashioning the self through technology echoes the early-modernist embrace of machine over humanity. The ubiquity of images in the contemporary field of vision, described by Paul Virilio as "the handling of simultaneous data in a global but unstable environment where the image is the most concentrated but also the most instable form of information,"[1] finds a resonance in the Futurist's celebration of "simultaneous states of mind."[2] From the dematerialization of identity taking place in Internet chatrooms to the destabilization of experience occurring through the headsets of virtual reality, Charles Baudelaire's poetic vision of modernity as "the transient, the fleeting, the contingent"[3] seems as apt a description for life and art in 1997 as it did in 1863.

At the same time, it is also possible that our desire to harness consciousness to the luminous emissions of image machines renders these modernist echoes obsolete. During the emergence of modernity, railroads, telegraphs, and standard time cut a swath of grids across a heterogeneous landscape to reconfigure spatial and temporal boundaries. Now the feverish construction of information highways and the global swirl of data threaten to dissolve these boundaries altogether. With the invention of X-rays, photography, and cinema, an image of the body was frozen in time and cast into motion. With the advent of nanotechnology and virtual reality, both body and image are caught within a cybernetic feedback loop. At the beginning of the twentieth century, an exponential expansion of knowledge in fields such as biology and

physics mapped a comprehension of the self within a scientific sphere and cast it adrift in relativity. At its end, we meet with a conception of the self that is subject to genetic manipulations, artificial intelligence, and image phantasms.

Given the changes that new technologies have wrought, perhaps Baudelaire's vision of modernity is not so appropriate after all. Instead of a world in flux, perhaps we have been plunged into a world of fusion and mutation, confusion and contamination. Marshall McLuhan, writing a hundred years after Baudelaire, envisions the world being reshaped by technology as the "extension of our central nervous system itself into a global embrace."[4] Jean Baudrillard, expanding upon McLuhan's prophecy of a global nervous system, proposes that we have left behind a world in flux and have entered the realm of the simulacrum. According to Baudrillard's opaque description of the universe we now inhabit, "simulation is no longer that of a territory, a referential being or a substance. It is the generation by models of the real without origin or reality: a hyperreal."[5] The image now precedes reality; the copy supersedes the original. Henceforth, argues Baudrillard, "it is the map that engenders the territory."[6]

Baudrillard's encapsulation of the simulacrum as a hyperreal offers a seductive, albeit slightly incomprehensible, theorization for the increasing convergence of lived and simulated experience. His acquiescence to a technologically engineered reality is also uncannily familiar, a dystopic echo of the modernist enthusiasm for the machine age. In contrast to Baudrillard's theorization of the hyperreal, Gilles Deleuze offers a philosophical reading of the simulacrum that counters the mastery of technology over consciousness. Tracing the idea of the simulacrum back to its genealogical origins in Plato's hostility to mimesis, Deleuze identifies an ancient site of contestation over images and copies. What is at stake in the simulacrum, argues Deleuze, is an archaic struggle between representational purity and promiscuity that challenges a Platonic order of representation in Western culture that privileges sameness over difference.[7]

In Deleuze's reading of Plato's hostility to mimesis, he notes that Plato distinguishes between good copies (such as mathematical models) and bad copies (image phantasms). Good copies are good to the degree to which their representation of appearances resembles ideal forms or ideas. Bad copies, on the other hand, appear to mimic reality perfectly, yet, upon close inspection they do not even remotely resemble the originals they profess to represent. For Plato, these bad copies are the simulacra, giving rise to a false representation that challenges the truth-value of ideal forms and privileges the imitation of appearances

over the geometrical purity of the model. Accordingly, Plato seeks to repress the simulacra in his search for knowledge that enlightens rather than deceives, purifies rather than contaminates.[8]

In turn, argues Deleuze, Plato's decision to exorcise the simulacra from the order of representation constructs a legacy in Western culture of repressing difference in favour of sameness. Banished from the Platonic tradition of thought is the power of mimesis to conjure indeterminacy and the power of the copy to affect the original. What is lost in the process, writes Deleuze, "is the state of free, oceanic differences, of nomadic distributions, and crowned anarchy."[9] To assert the primacy of the simulacrum is not to give into a reality lost in a shuffle of degraded copies, but to "render the order of participation, the fixity of distribution, the determination of hierarchy impossible."[10]

In recent multimedia works by Dara Birnbaum and Stan Douglas, it is this ordered hierarchy of representation that is called into question. Instead of surrendering to the spectre of the hyperreal in which the map precedes the territory, these artists examine what issues emerge when simulation meets a territory of bodies and histories. Mining the media archive to isolate historical moments in which ideological confrontation plays out through a proliferation of images, they excavate sites of contestation between good copies and bad copies. Using multiple video projections, their installations mimic a global nervous system of television screens and instantaneous news transmissions. Reconceptualizing the flow of information through visual strategies of juxtaposition and montage, they position the viewer as an active participant in deciphering the entanglement of simulated and lived experience. In the process, they locate in the simulacrum the potential to pry loose the fixed categories of gender and race from their representational moorings, to conjure the ghosts of difference that history represses.

In Dara Birnbaum's *Hostage*, a six-channel video installation with an interactive laser beam, an interrogation of the global nervous system as its most nervous ensues. First exhibited at Paula Cooper Gallery in 1994, *Hostage* takes as its subject matter the controversial kidnapping of the German industrialist Hanns-Martin Schleyer by the West German left-wing urban guerrillas, the Baader-Meinhof Group, in 1977; and the supposed suicides of three Baader-Meinhof members who were in Stammheim prison during the hostage-taking crisis. Holding up a mirror up to the simulacrum, Birnbaum reflects back a deadly game of mimicry in which the Baader-Meinhof kidnappers and the state engaged in a constant escalation of violence. As a witness to this game, the viewer sifts through archival data to decipher how an image map bled over into the body politic to entangle image and response, terror and repression.

In *Hostage*, six video monitors span the gallery space diagonally. Four of the monitors are suspended from the ceiling at the height of television sets found in airport waiting lounges. The other two monitors are mounted in opposite corners of the gallery at eye-level. The four ceiling monitors display video-loops running about five minutes in length. In each, a rapid-fire montage of television footage from the period of the kidnapping, mug shots of the guerrillas, and drawings of the high-security wing built at Stammheim to contain members of the Baader-Meinhof Group create a perceptible chaos from archival documentation.

At the far corner of the gallery, the fifth monitor features clandestine footage of Schleyer that was shot by the kidnappers, and then rebroadcast on television by the West German state to demonstrate that Schleyer was still alive. At the other corner, the sixth monitor plays a twelve-minute montage of clippings from various American newspaper sources on the hostage-taking crisis and the Baader-Meinhof Group. Between the two corner monitors runs a laser beam, with sender and receiver signals located just below the screens. When the viewer stands in front of the red thin beam of light, the news clips on the sixth monitor freeze for as long as the viewer continues to interrupt the laser's signals.

In Birnbaum's installation, only the most determined viewer can piece together a coherent narrative from the disparate images on the six monitors. Fragmented and disjointed, the flow of information escalates to the point where the screen becomes a death space in which the simulacra stare each other down. It is as if the interface has gone awry, no longer conveying control but instead producing anarchy. Similar to the German public at the time of the kidnapping, the viewer is held hostage by an image machine, positioned in a place where information collapses into a ubiquitous field of vision. Here, the convergence of simulation and experience is manifested in the shock of finding oneself a target of the simulacrum.

The positioning of the viewer as a target is reinforced by Plexiglas silhouettes of human figures that are placed in front of each of the four ceiling monitors. Resembling firing-range targets, these silhouettes are marked with elongated circles that approximate fingerprints. This added layer of simulation alludes to how the state, through the imprint of the body, entangles identity with classification as well as with the flow information, presaging the use of DNA testing and fingerprint passport controls. At the beginning of each video playing on the ceiling monitors, an image of the Plexiglas target appears. It is superimposed on top of an electronic identification countdown for the broadcast transmission of United Press International, which is keyed with the

words "roving reporter," a code name for an independent newsgathering service. It was from this news service that Birnbaum was finally able to obtain documentary evidence after all the major mass-media sources and German television refused to release their archival footage. As the electronic countdown on each tape reaches zero, the target is riddled with bullet holes, adding to the noise and confusion of the viewing experience.

In making a concerted effort to view each of the videotapes individually, the viewer becomes aware of the way in which the German state used television as a means of social and political control. Through the filtering of information, television became an arena of simulated negotiation with the kidnappers that masked the lack of political will to achieve a resolution to the crisis. Transmitting clandestine images of Schleyer pleading for his life, the television screen served to sensationalize the drama of the situation rather than delineate the issues that lay behind the kidnapping. After Schleyer's murder by the guerrillas and the recovery of his body by the police in October of 1977, television resurrected him as a martyr to the temporary collapse of social order. The *New York Times* reported that during Schleyer's funeral West German "television canceled programs and substituted funeral music," while the *Chicago Tribune* described how "the ceremony was televised live into the factories of Daimer-Benz, of which Schleyer had been a director."[11]

In contrast to the spectacle that television created out of Schleyer, there was no media access to the Baader-Meinhof members in prison. Inside Stammheim, the television screen served as a tool of hidden surveillance witnessed only by the guards. As a result, the guerrillas' motives for embracing terrorism and their supposed suicides were enveloped in a media wrapping of pseudo-psychology. Reports on the Baader-Meinhof Group in the print medium filled in the image gaps of television, constructing a narrative in which gender became the dividing line between normalcy and monstrosity. The sixth monitor in *Hostage* is the archival focus of these image gaps, with news flashes on the hostage-taking crisis interspersed with reports from American papers and magazines that construct a psychology of West German terrorism based upon women's participation in the urban guerrilla movement.

Newsweek attributes the phenomenon of women joining the Baader-Meinhof Group "to the typical emotional fervour of the female," quoting a German female politician who declares, "these women negate everything that is part of the established feminine character." The *Chicago Tribune* quotes a German police official in saying "women's participation [in terrorism] is the dark side of women's emancipation." A *Los Angeles Times* headline reading "A new generation of deadly

young women" is accompanied by the assessment of a German crimi-
nologist, who links their feminine pathology to "the influence of domi-
neering mothers" and fathers who were "often described as dictatorial
and absent." Perhaps the most succinct commentary is proffered by a
neighbour of a certain Baader-Meinhof member, who describes for the
L.A. Times how her infamous neighbour "sang communist songs all
night and never cleaned the stairs."

By reordering the data of a historical moment, Birnbaum reveals
how the flow of information manipulates the signification of gender.
What also becomes apparent through her assemblage of news reports
was the inability of the mass media to provide an explanation for the
global nervous system's sudden nervousness (beyond an analysis of
women guerrillas as the unfortunate byproduct of female emancipa-
tion). *Time* and *Newsweek* reports displayed on the monitors provide
"no ready explanation for the terrorist movement except that it grew
out of the Vietnam War," noting that the "emergence of a fanatical
minority has baffled analysts." Such bafflement was not ingenuous.
Attempts by leading European theorists in *Semiotext(e)*'s 1982 German
Issue to disentangle the ideological and technological strands that led to
escalating violence in West Germany in the 1970s are characterized by a
sense of uneasiness and confusion. The visual design of the journal
reinforces this unease by dividing each of the pages in half to mimic the
division created by the Berlin Wall. It was here that Virilio first devel-
oped his analysis of image ubiquity and Baudrillard began his slippery
theoretical slide towards a hyperreal of models without origins.[12]

When Virilio published *L'Espace Critique* several years later, he con-
textualized his initial analysis by arguing that the image architecture of
the global system was generated as a response to the Euro-terrorism of
the late 1970s. For Virilio, the lived experiences of ideological con-
frontation preceded a blueprint of simulation. The collapse of the nerv-
ous system upon itself had produced a shift in the deployment of new
technologies, whereby "the screen interface of computers, television,
and teleconferences, the surface of inscriptions, hitherto devoid of
depth, becomes a kind of 'distance,' a depth of field of a new kind of
representation, a visibility without any face-to-face encounter."[13]

In Stan Douglas's video installation *Evening*, it is the conjunction
of ideological confrontation with a shift in the architecture of image
proliferation that is examined. Commissioned as a site-specific piece
for Chicago's Renaissance Society in 1994, *Evening* combines archival
footage with actors playing news anchors to simulate three newscasts
broadcast by three fictional local television stations on January 1, 1969,
and January 1, 1970. The three newscasts are screened side by side on

ten-foot screens, so that the viewer can choose to listen to one or all three at the same time. Through a carefully orchestrated chorus of gesture and speech, *Evening* explores a formal shift in the delivery of televised information, from editorial news reporting to the "happy-talk" format of sound-bite journalism and informal chatter that has become the prototype for today's entertainment and personality-driven news.

As a glimpse backwards in time, *Evening* is as fascinating in its evocation of image phantasms as is *Hostage*. Similar in strategy to Birnbaum's installation, *Evening* amplifies a flow of information to leave the viewer disoriented, shifting between viewpoints and copies. While *Hostage* identifies a historical moment in which television was unable to contain a political crisis, *Evening* examines how a transition in image delivery successfully defused an escalating ideological confrontation. Making the headlines in *Evening* are the Black Panthers, the My Lai massacre in Vietnam, the FLQ crisis in Quebec, the Yippies, the Chicago Seven Conspiracy Trial, Ross Perot's failed attempt to deliver Christmas hampers to prisoners of war in Hanoi, and the escalation of the space race between the US and the USSR. Fear of Soviet technological superiority is propagated by a report on the launch of a Russian supersonic aircraft, then assuaged by NASA photographs of the moon's landscape. The monitoring and suspicion of the Black Panthers by the American internal security services is mirrored by the media framing of the Black Panthers as preachers of riot and revolution.

In Douglas's archeology of television newscasts from 1969 and 1970, the stories making the headlines and images of conflict do not change substantially in the intervening year. What does change is the analysis of ideological confrontation, altered by the shift in styles of journalism. In 1969, the newscasts present the Black Panther and the student activist movement as credible challenges to an ailing political system. By 1970, they have become one-dimensional stereotypes of a fringe revolutionary menace to an otherwise stable democracy. Through excavating and reordering archival footage, Douglas points to the way in which racial and social conflicts are reshaped by the mass media. Reflecting an ongoing concern in his work "to understand what kind of reality has been effaced by something else, because a particular kind of representation supposes a kind of understanding of the world,"[14] *Evening* pries the viewer away from a fascination with media spectacle to consider, in his words, "the fragmentation of interrelated events and atomization of historical processes."[15] A critique of how representations of anti-racist and anti-imperialist struggles are excised from technology's web of mediation, *Evening* mimics the simulacrum in order to render visible the invisible repressions of difference.

The historical moment that Douglas conjures in *Evening* was also a moment at which media activists sought to open a window on the world through the self-determination of community-television and cable initiatives. Heated discussions were taking place at UNESCO around the McBride Report, in which the non-aligned movement of post-colonial states called for the establishment a New World Information and Communication Order to rein in the open-sky access to communication technologies enjoyed and deployed by the United States of America. In an ideologically polarized world, freedom and access were clearly dependent on one's political and economic resources in a global system of centres and peripheries, of post-industrial and non-industrialized nations.

Today, we stand at a crucial crossroads in negotiating the relationship between the world we embody and the manufactured realm of images we inhabit. The ideological bipolarity revealed in *Evening* and *Hostage* has collapsed into a diffuse embrace of technology as a tool for the enhancement of the human race. The Internet, conceived as an infrastructure for the dissemination of classified military information, has become a site of global exchange. Yet if the Internet and the promise of global harmony are not to fall prey to the same dystopic fate as television—collapsing meaning into infotainment and ideological manipulation—it is paramount that issues of access and resources, of historical legacies and cultural differences, are taken into account. In Birnbaum's and Douglas's multimedia works, these issues are central to their excavations of the media archive. Constructing artistic interventions from the simulacra of the past, they create a blueprint for future in which it is not the television or computer screen that dematerializes identity and destabilizes experience, but the lived experiences of ideological confrontation that haunt an ordered hierarchy of representation.

50

Notes

1. Paul Virilio, *War and Cinema: The Logistics of Perception,* trans. Patrick Camiller (New York: Verso, 1989), 71.

2. Umberto Boccioni quoted in Marjorie Perloff, *The Futurist Moment: Avant-Garde, Avant Guerre, and the Language of Rupture* (Chicago: Chicago University Press, 1986), 6.

3. Charles Baudelaire, "The Painter of Modern Life" (1863), in *Selected Writings on Art and Artists,* trans. P. F. Charvet (New York: Penguin Books, 1972), 403.

4. Marshall McLuhan, *Understanding Media: The Extensions of Man* (Toronto: McGraw-Hill, 1964), 3.

5. Jean Baudrillard, "The Precession of Simulacra," in *Simulations,* trans. Paul Foss, Paul Patton, and Philip Beitchman (New York: Semiotext(e), 1983), 2.

6. Ibid., 2.

7. Gilles Deleuze, *Difference and Repetition*, trans. Paul Patton (London: Athlone Press, 1994).

8. For a synthesis of Gilles Deleuze's critique of Plato and Plato's formulation of the simulacrum, see Paul Patton, "Anti-Platonism and Art," in *Gilles Deleuze and the Theatre of Philosophy*, eds. Constantin V. Boundas and Dorothea Olkowski (New York: Routledge, 1994); and Seth Benardete, *Plato's Sophist* (Chicago: University of Chicago Press, 1984).

9. Gilles Deleuze, *Difference and Repetition*, 265.

10. Cited by Paul Patton in "Anti-Platonism and Art," 152.

11. All newspaper quotes are taken from text appearing on the sixth monitor in *Hostage*.

12. *Semiotext(e)* 4:2 (1982).

13. Paul Virilio, *The Lost Dimension* (originally published as *L'Espace Critique* in 1984), trans. Daniel Moshenberg (New York: Semiotext(e), 1991), 12.

14. Interview with Stan Douglas by Jean-Christophe Royoux. *Galleries Magazine* (February–March, 1994), 46.

15. From Stan Douglas's proposal for *Evening*, unpublished.

This essay first appeared in *Fuse Magazine* 20:5 (1997).

HISTORY

STRIKE

ART COMMUNICATION EDITION, VOL. 2, No. 2, MAY, 1978

CANADA $ U.S...$.50
FRANCEF5
GERMANYDM2
ITALYLIT500
UNITED KINGDOM 50p

TORTURE
POST-MARXISM
RED BRIGADES

"THE CEAC WAS BANNED IN CANADA"

PROGRAM NOTES FOR A TRAGICOMIC OPERA IN THREE ACTS

Epilogue

We wanted to be famous, glamorous and rich. That is to say, we wanted to be artists and we knew that if we were famous and glamorous we could say we were artists and we would be. We never felt we had to produce great art to be great artists. We knew great art did not bring glamour and fame. We knew we had to keep a foot in the door of art and we were conscious of the importance of berets and paintbrushes.
—General Idea, "Glamour" 1975.

What perpetuates the reactionary mystification of the role of the artist is the "world of scarcity" and the "incapacity to survive" in a capitalist society. The artist defends the privilege and the entrenchment he/she holds in a capitalist society. Also symptomatic, even and not less so among the vanguard, alternative and co-op artists groups, is the sense of hopelessness for social change, as these same groups mimic those repressive methods of economical capitalization adopted by the art world.
—Amerigo Marras, "On Organization" 1978.

In 1975, General Idea, an art collective comprised of AA Bronson, Felix Partz, and Jorge Zontal, published a tongue-in-cheek manifesto proclaiming that "in order to be glamorous we had to become plagiarists, intellectual parasites. We moved in on history and occupied images, emptying them of meaning, reducing them to shells. We then filled these shells with glamour, the creampuff innocence of idiots, the naughty silence of shark fins slicing oily waters."[1] Taking up the challenge of New York's cultural dominance and divesting it of its social, economic, and political ramifications through a mocking semiotic mirror, General Idea was instrumental in shaping a context for Toronto's vanguard art scene in the 1970s. Under their aegis, parody and the simulation of media referents became the framework for a local discourse

that was slim in substance and big on self-promotion. Thus, ten years later, Philip Monk concluded that we suffered from "a lack of history, and so we repeat one from elsewhere, or from Western history, but without the grounding of history or context."[2] This configuration of appropriation and lack is in itself a context, one that identifies dominant ideology as the sole ideology and constructs a mythology of subversion.

At the same time as we have inherited the vanguard legacy and creampuff shells of General Idea as a materialist base for history, we are, as writers and artists, involved in an extensive cultural bureaucracy. Our intellectual and aesthetic autonomy comes from our collaboration with state-funded artist-run centres and magazines; the production and dissemination of alternative artistic practices are dependent upon art councils' support. Given the existence of this clearly materialist base for a local art practice, one that bears little relation to General Idea's capitalist, media-saturated paradigm, it seems improbable that we suffer from a lack of history. Perhaps, instead, we suffer from the lack of a history constructed outside the confines of an institutionalized and state-funded art system. Perhaps it is not history we lack, but an acknowledgment of and interest in the history of art practices and politics that stray too far from the cultural mandate of the status quo.

Prologue

It is December 1985…January…February 1986. In search of history, I travel to the north of the city to work in the archives of York University. The journey is numbing. The subway pulls out of its subterranean passage to reveal an endless landscape of high-rise apartments and urban townhouses; the bus winds through an abandoned army base and along avenues lined with strip malls. As I look through the windows of the crowded bus, the downtown arts neighbourhood of Queen Street seems both psychologically and topographically distant. From the bus stop, I walk through a maze of buildings and down a labyrinth staircase to the York archives. Entering the archives feels like approaching a military bunker, requesting entrance to a sterile tomb. The door is locked at all times; there is a hushed, brittle feel to the atmosphere. It is here, tossed unsorted into seventy-odd boxes, that I find the documentation of a Toronto artist-run organization that existed as the Kensington Arts Association (KAA) from 1973 to 1978, and which in 1976 opened a large multimedia space, the Centre for Experimental Art and Communication (CEAC).

Dedicated to "a continuous collective experiment in living and in sociological infiltrations with practical demonstrations,"[3] the KAA, located at 4 Kensington Avenue, grew into CEAC, an artist-run centre located at 15 Duncan Street in the Queen Street district that housed a library and archives, a video production studio, a performance space, a film theatre, and a punk-music venue. Between October 1975, when KAA sponsored the *Women in Society Festival*, and April / May 1978, when CEAC held a lecture series entitled *Five Polemics to the Notion of Anthropology*, the activities of this "collective experiment" were prolific. In a few brief years, KAA / CEAC published catalogues, nine issues of *Art Communication Edition* (*A.C.E.*), and three issues of *STRIKE* magazine; it organized exhibitions, conferences, international tours, workshops, performances, film and video screenings, and music events. During 1976 and 1977, there was literally an event held at CEAC every night of the week. Yet a decade and a generation later, it is only through talking to individual artists involved with CEAC that I learn of its existence, two years after moving to Toronto. And it is only through archival research that I am able to uncover, in a fragmented and hieroglyphic form, evidence of its activities and copies of its publications, all of which seem to have vanished without a trace from the Toronto art community's historical record.

After emerging from the archive bunker, engaged in a necrophiliac piecing-together of documentation, have I uncovered a history? Only remnants survive: photographs, lists, letters, files, posters, clippings, catalogues, and books. From these I have gleaned less a history than impressions: impressions of an artist-run centre whose philosophy, politics, and ideals seem very remote from the city's current infatuations. Or are they? In one of the boxes, I find a description of British artists Lorraine Lesson and Peter Dunn's *Docklands Project*, sent to CEAC in 1976. Ten years later a poster version of the project is featured in an A Space billboard exhibition. International artists who performed at CEAC are included in Art Metropole's books *Performance by Artists* and *Video by Artists*. Amerigo Marras's analysis, in *STRIKE* magazine, of the relationship of artists to state funding and his call for a guaranteed minimum income echo similar demands formulated by the recently organized Independent Artists Union. While Philip Monk argues that Toronto lacks a history, what the archives reveal are traces of a very specific and local history: one in which artists' political ideals and cultural practices were realized through and subverted by a state-funded cultural bureaucracy.

In researching CEAC, I was left with the impression that I had excavated but one layer of a 1970s local context for art as a political and

social practice. The early years of A Space, *Body Politic*, and *Centrefold* (which became *Fuse Magazine*) are also part of CEAC's story. While it is beyond the scope of this article to trace the interconnections between them, I invite the reader to bring his or her own knowledge of Toronto's art community to bear upon my history of CEAC. History as personal memory, as collective amnesia, as constructed ideology, as sexual politics, as fiction, as myth, as self-preservation, as rumour, as fact, as eternal return: take your pick. Each of you has a position from which to find in this text continuity, aberration, or lack. It is not my intention to present here an authoritative reconstruction or definitive history of CEAC. Rather, through a description of some of CEAC's activities and theoretical positions that can be reconstituted from written and visual documentation, I hope to encourage speculation about and reflection on the nature of art, ideology, and local context.

Program Notes for a Tragicomic Opera in Three Acts

Overture

In 1970, Suber Corley, Amerigo Marras, and Jearld Moldenhauer formed the Art and Communication group and founded *Body Politic*, which became the voice of the gay movement in Toronto. Out of these initiatives, described by Marras as "clearly negativist and neo-Marxist in ideology,"[4] grew a loose organization of individuals, based at 4 Kensington Avenue, who were interested in challenging capitalism's "specialization of roles and its homophobic sexism."[5] By 1973, *Body Politic*, Glad Day Bookstore, and Toronto Gay Action were operating from this address. In the same year, Marras and Corley became interested in formulating a relationship between art and social practice and incorporated as the Kensington Arts Association, while Moldenhauer continued to concentrate on gay liberation movement. With the opening of an exhibition space in September 1973, the Kensington Arts Association became identified with the writings and programs of Marras, who envisioned the gallery as an environmental structure that would facilitate and exhibit non-commercial and demystified approaches to art and language. The KAA quickly became implicated in the theoretical intrigues of the conceptual-art movement of the time, which sought to establish a currency of non-objects through philosophical manifestos and linguistic interventions. Its exhibition of non-material art practices and simultaneous objective of developing a theoretical

platform that would provide an overarching framework for these practices would become one of the defining parameters that shaped the history of CEAC's rise and fall within Canada's artist-run centre movement.

An Intervention from the Audience

You promised us a history of CEAC. We may not know much, but we have heard that they were gun-toting terrorists, lurking behind every art-ghetto corner to kneecap innocent, fresh-faced bureaucrats. We've also heard rumours. Didn't Amerigo abscond to New York with thousands of dollars worth of video equipment? We want to know the real history of CEAC. DIDN'T THEY SUPPORT THE RED BRIDGADES!

If this is the history that fascinates you, turn in your program notes to the Finale. It is all there in black-and-white, compiled from the archives. But before you turn the page, consider the legacy of General Idea's "shell" of history. In Toronto's collective memory and common currency, that is all that remains of CEAC's years of exhibitions, workshops, and publications. It makes for great rumours, provides a little notoriety, and effectively dismisses a local history. When CEAC went down in flames amid recrimination and government shuffling, the art community's silence supported a state-sanctioned version of the past by default. Yet the events that CEAC sponsored and the theoretical platforms it articulated were the impetus for the ideas behind the development of other artists' collectives and centres that followed. The events surrounding CEAC's demise, not nearly as sordid or interesting as rumour would have it, provided a smokescreen that reduced issues of art and politics to a media one-liner.

The Leading Roles and Supporting Cast

Karl Marx, with ensuing revisionist squabbles, plays a large behind-the-scenes role. Theodor Adorno, Herbert Marcuse, R. D. Laing, Ivan Illich, and Marshall McLuhan feature in the formulation of the plot. The theoretical work of the Italian *Autonomia* movement and the writings of Toni Negri contribute to the operatic finale. Guest stars include Yona Friedman, Joseph Kosuth, and Joseph Beuys. Guest spokespersons for art movements of the time include Hervé Fischer of France's Collectif d'Art Sociologique, Jan Swidzinski from the contextual-art movement

in Poland, and Reindeer Werk, a performance collective from England. Philip Glass and Steve Reich provide an intermittent musical score. Local talent is featured in most of the major scenarios. Amerigo Marras, an émigré from Italy, brings a background in experimental architecture and the ferment of post-war Italian politics to his role as the director of the opera. Suber Corley, an American draft dodger, brings extensive administrative expertise to his role as the manager. Beth Learn's interest in language art adds a dimension of semiotics and structuralism to the libretto. Lily Eng and Peter Dudar of Missing Associates offer a theory and radical practice of experimental dance. John Faichney, also an experimental dancer, becomes the librarian of the opera, building a large collection of contemporary-art documentation, including numerous artists' books. Ron Gillespie and the OCA students who formed SHITBANDIT promote an extremist performance style. Michaele Berman advocates the return of ritual, and then becomes a punk singer in The Poles. Bruce Eves, who subsequently became involved with *The New York Native*, infuses performance art with a gay aesthetic and sado-masochism. Miss General Idea hangs around centre-right stage for much of the action. Ross McLaren, a local filmmaker, programs a large selection of experimental cinema. Noel Harding involves video students at OCA in the chorus of the opera, while the punk venue Crash'N'Burn adds the excitement of a local musical scene. An improvised production, based on the ideas and collaboration of all of the players, the CEAC opera was sponsored by the Canada Council for the Arts, the Ontario Arts Council, and Wintario, and supported by the private donations of individuals.

Act One: The Formative Years

Scene One: Radical Design

In October 1973, with the opening of Yona Friedman's exhibition *Self-Design* at a newly renovated gallery space at 4 Kensington Avenue, the curtain rose to reveal a rehearsal for an opera in progress. Friedman, a French architect, had created a manual instructing children on the possibility of conceptualizing an architecture that would translate their needs directly into structure. Marras identified the manual as a political tool with interventionist possibilities, and situated its importance in the gallery setting as an example of environmental adaptation based on self-determination and the existence of multiple, self-directing communities. The stance adopted by Friedman, suggested Marras, "rejects the

utopistic nuclear (single) mini-society which some thinkers proposed in the 1960s. It also rejects the totalitarianism of much left-wing doctrinary approach to society."[6] Friedman's goal of altering the language of architecture and its specialized application, documented in the magazine *Supervision*, also encompassed the possibility of translating architectural language into user-friendly, computerized design, and an analysis of the relationship of architectural imperialism to conditions in the Third World.[7]

After Friedman's initial exhibition, presented by Marras as a synthesis of language, environment, and technology—a theme that will recur in CEAC's investigative platform—there is little information about the gallery's activities during 1974. A letter sent to supporters of the gallery by Corley and Marras in January 1975, however, gives some indication of the gallery's direction and the conflicts it had experienced during this year. Quoting from the KAA's first written statement of its philosophy and objectives, they remind participants that the gallery encourages "the showing of…propositions for non-marketable environments, demountable or temporary objects, illustrated ideas, programmes and manifestos."[8] Corley and Marras go on to state that these basic objectives have not been supported by the majority of participants. According to their letter, artists interested in producing static objects had usurped the gallery space after Friedman's exhibition, and were utilizing the KAA as a stepping stone to the commercial arena. In response, Corley and Marras announced the cancellation of all shows scheduled after May 1975, stating an intention to program events and shorter exhibitions on a more spontaneous basis. Thus *Works in Progress*, a series of installations exhibited from February to May 1975, belongs to this first, uncertain era of CEAC's development. The works in this series—Gary Greenwood's sound performance *Table Talk*, Don Mabie's *Second Annual Correspondence and Junk Mail Art Show*, and Angelo Sagbellone's *Monolithic Intervals*, an audience-participation environment piece—were part of a rehearsal for an opera whose stage set was not yet developed. When the curtain rose again to reveal the full production, CEAC would be an opera of manifestos, rhetorical stances, and orchestrated exhibitions that persisted in addressing the political and social dimensions of the art world.

Scene Two: Language and Structure in North America

With the stage set proving inadequate, there was a desire on the part of the cast to reinvent the principles of set design. Beth Learn's proposal for a comprehensive exhibition of language art suggested the means for

this reinvention. With the opening in the late fall of 1975 of *Language and Structure in North America*, a sprawling exhibition of wall/book art, poetry, sound pieces, environmental investigations, film, video, and performance, the conjunction of theory and practice that would become CEAC's trademark coalesced. The exhibition, envisioned as a travelling visual and literary manifesto on aspects of language, art, and structuralism, was coordinated by Learn, who was working at KAA at the time, and curated by Richard Kostelanetz, a language artist and cultural historian living in the United States. Learn, who was interested in the margins of communication and the "strategraphic" variance of language as it is mapped through visual, literary, and sound sources, coined the term "contexturalism" to describe the deep structure (in Noam Chomsky's sense of linguistics) of language and technology that the exhibition addressed. In the catalogue accompanying the exhibition, Kostelanetz compiled a lengthy enumeration of artists working with language as an aspect of their production, while KAA featured portable pieces that were available for showing in a gallery setting.

As part of the exhibition, a performance series entitled *Language Art* was held between November 4 and November 30, 1975. Featuring Richard Kostelanetz, Yvonne Rainer, Vito Acconci, Vera Frenkel, the Four Horsemen, bill bissett, sound artists, experimental poets, structuralist cinema, and radical theatre, it offered a survey of conceptual, structural, and process-oriented approaches to the remapping of language's functions and systems. In an article written by Learn published in *Queen Street* magazine, her use of a quote from Roland Barthes to describe the exhibition—"Exhaustion through catalysis is the impetus by which art constantly re-generates itself"[9]—suggests both the ambitious spirit of the project and its drain on the resources of the gallery. Where catalysis overreached its proportions to the point of exhaustion was in the plans to tour the show. With insufficient funds and a lack of time and resources, *Language and Structure in North America* began to fragment at the same incremental rate as the investigations it presented. Conflicts arose between Learn and Marras, between Marras and Kostelanetz, and between KAA and the participating artists. As a result, Learn left KAA in 1976, with debt and recrimination ensuing. Although the opera would never again attempt such a grandiose scenario for the presentation of an art manifesto, Marras and those surrounding him began to utilize the ideas articulated in this exhibition to construct a theoretical platform for CEAC that linked art to the politicization of language, technology, and culture.

By 1976, Marras and Corley had built an elaborate stage set to present their operatic vision. The cast, however, had been assembled in a minimalist tradition. With the rearticulation of their non-commercial and investigative goals and the impact of *Language and Structure in North America* on the local art scene, a number of Toronto artists, many of whom had graduated from OCA in the wake of Roy Ascott's experimental directorship and ensuing shake-up, began to focus their activities at the KAA.[10] As more cast members were added to the chorus, the conceptualization of a multimedia space to house their opera came into being. Marras and Corley moved KAA to a temporary location at 86 John Street where a number of diverse art practices could share the stage. With $55,000 in funding from a Wintario grant received the same year, KAA became the first artist-run organization in Toronto to buy a building and effectively establish a large multimedia centre. Relocating from John Street to their newly acquired premises at 15 Duncan Street in September 1976, KAA launched CEAC: the Centre for Experimental Art and Communication.

In anticipation of the full production of the CEAC opera, KAA organized an exhibition entitled *Body Art* that opened in January 1976. Influenced in part by the Vienna Body School and the extremist work of Hermann Nitsch, the exhibition explored the mapping of the body through the investigation of its architecture, transmutation, and social behaviour. Proposing to redefine the functions of violence, actions, and structures of the body's political, social, and sexual dimensions, *Body Art* established a platform for performance and non-object art that countered the strategies of parody and appropriation promoted by General Idea, and the phenomenological investigations prevalent in the United States. The exhibition featured Suzy Lake's photographic transformations; Darryl Tonkin's film *Cantilever Tales*, which introduced the aesthetics of black humour and sadomasochism; Peter Dudar and Lily Eng's structural dance performances; and the collaborative performances of SHITBANDIT. In April 1976, Bruce Eves organized another performance series, *BOUND, BENT, AND DETERMINED*, which elaborated on the theme of sadomasochism introduced in *Body Art*. Included in this series were Wendy Knox-Leet, Ron Gillespie, Heather MacDonald, Darryl Tonkin, Blast-Bloom, Bruce Eves, Andy Fabo, and Paul Dempsey.

Parallel to KAA's programming of performance art was its interest in showcasing experimental cinema and video. As the theoretical catalyst of the organization, Marras had been influenced by his studies with

McLuhan, and by the contacts he subsequently made while attending an international video symposium held in Buenos Aires in November 1975. It was here that Marras met a collective of thirteen video artists working out of Argentina who called for the gallery system to be replaced by a system of workshops that would encourage a wide range of multidisciplinary activities. Within this system of workshops, the artists envisioned the video medium as a tool to diversify the hierarchies of information and media, to foment political unrest and promote revolutionary aims.[11] The radical impetus of their aesthetic, intent upon challenging the repressive regime of Argentina as well as the broader concept of alternative information networks, influenced KAA's theoretical approach to video. With the opening of CEAC in September of 1976, KAA sponsored the production and collection of local and international tapes and placed an emphasis on the documentation of events at the centre. Toronto artists involved with CEAC's video program included Noel Harding, David Clarkson, Elizabeth MacKenzie, Susan Britton, Peter Dudar, John Massey, Ian Murray, Ross McLaren, and members of the Development Education Centre and Trinity Square Video.

Concurrent with its political commitment to the accessibility and "new television" aspects of video, KAA began to program experimental cinema, with a particular emphasis on super 8 production. Marras, strongly influenced by Michael Snow's *Rameau's Nephew* and the films presented during *Language and Structure in North America,* including Vito Acconci's 8mm films and Yvonne Rainer's *Film About a Woman Who*, organized an initial *Art Film* series in March 1976. Working with Diane Boadway, Marras programmed works by Michael Snow, Ross McLaren, Lorne Marin, Rick Hancox, Vito Acconci, and David Rimmer, among others. Marras and Boadway then approached Ross McLaren to coordinate super 8 open screenings. These weekly screenings, which began in October 1976, were a regular programming feature of CEAC, with documentation published in CEAC's in-house magazine, *Art Communication Edition*. Providing a focus for local filmmakers, these screenings led to the formation of an experimental cinema collective The Funnel in September 1977. Canadian experimental filmmakers exhibiting at CEAC during this period included Ross McLaren (who also programmed a large selection of British, Austrian, Australian, and American films), Michael Snow, Keith Locke, Jim Anderson, Peter Dudar, Eldon Garnet, David Rimmer, Rick Hancox, Ron Gillespie, Noel Harding, Raphael Bendahan, Al Razutis, Holly Dale and Janice Cole, and Chris Gallagher.

While more local filmmakers congregated around CEAC than artists involved in video production, Marras's theoretical interest lay in the political application of video as a cultural practice that would challenge power hierarchies and normative ideologies perpetuated by the mass media. As a result, little theoretical speculation was engaged in on the subject of super 8 and experimental filmmaking at CEAC. With the exception of descriptive program notes and an essay by Roy Pelletier in the final issue of *Art Communication Edition* entitled "Creativity by Default: The Potential of Super 8," writing on time-based media in CEAC's publications concentrated on the revolutionary nature of video production. In an unpublished text on the political potential of video networks, Marras posited that the manipulation of the television medium leads to a condition of simulation in which the viewer is "completely dependent upon 'mediation' in order to watch their own reality."[12] The result of this dependency, Marras goes on to state, is the elimination of critical judgment and political consciousness, whereby politics do not disappear but rather "become invisible."[13] Marras's analysis closely foreshadowed Jean Baudrillard's theories of the simulacrum in his text "In the Shadow of the Silent Majorities." In this text, Baudrillard asserts that the saturation of information in the mass media produces a simulacrum in which representation constructs reality, or, as he terms it, the hyperreal.[14] Marras, however, was more optimistic than Baudrillard in his assessment of the possibility of combating the political fallout of simulation. While Baudrillard argued that the hyperreal signals the futility of oppositional politics and the neutralization of the masses, Marras speculated on the emergence of a new, hybrid form of reception in which independent video production would intersect with television's network-communication systems. Terming this hybrid reception "telemedia," Marras concluded that the technological infrastructure of mass media could be revolutionized through "an ideological programme for a new condition of a self-managed culture."[15]

Through the acquisition of equipment and the establishment of CEAC as a multimedia space, KAA's initiatives for video production and dissemination reflected Marras's stated objective. In March of 1976, the organization began the ambitious construction of a video-production studio emphasizing broadcast quality and colour technology. Artists associated with KAA, which became synonymous with CEAC after the centre opened in 1976, were active in a number of international video exchanges. As one of a number of groups attending these encounters (others included CAYC of Buenos Aires, NTV + KB of Berlin, the Museum of Modern Art of Ferrara, and World Video Association), CEAC emphasized a global perspective for the medium, leading to their

acquisition of a North American-European transfer system that enabled video artists in Toronto to trade tapes and information with European producers. At the same time as CEAC's vision for its video programming and production was international and ambitious in scope, the centre lacked support from the larger video community, which did not necessarily support its ideology or goals.

Competitive divisions developed between CEAC and other artist-run organizations, most notably A Space, the other major artist-run centre in the city promoting the production and dissemination of video. The intensity of this animosity became clear in the aftermath of the *STRIKE* scandal that led to CEAC's demise. In a 1978 letter to CEAC from Renee Baert, the Video Officer for the Canada Council, Baert states that:

> [The] Council had received numerous written and verbal complaints about the lack of access to the CEAC facility, an alleged censorship of projects in the selection process, the disdainful manner in which many artists either using or requesting the use of facilities were treated.

Furthermore, she adds, since the last meeting between CEAC and members of the Canada Council

> The Council has received a telegram signed by every Toronto video or video-related organization receiving funding from the Canada Council, as well as by a number of individuals. That telegram reads as follows:

> "As members of the video community and/or administrators of publicly accessible production facilities, we are concerned that the video equipment loaned by or purchased with funds from the Canada Council is being appropriated by the trustees of the Kensington Arts Association for purposes other than those for which it was granted. We are particularly concerned that said equipment may be lost forever to this community for the intended access to artists. We request that the Canada Council ascertain that the said equipment will remain in Toronto and accessible to the community of artists for which it was intended."

> This is a very clear indication of a lack of support for, or of confidence in the CEAC from the very community which it was funded to serve, and gives rise to questions about CEAC's use of public funds.[16]

While the cast for the full production of the CEAC opera was assembled by 1976, it was a cast that stood in opposition to other artist-run

centres. In the ensuring arias, some audience members would prove hostile, while others would simply boycott the production.

Act Two: Cultural Revolution

*WHAT IS A/THE CENTRE FOR EXPERIMENTAL ART AND
COMMUNICATION?*
*It is the working ground where the forces of intellectual production, cultur-
al consumption, as well as the exchange and the distribution of culture are
managed in accordance to the need of art and communication while
affecting art forms.*

WHAT IS ART AND COMMUNICATION?
*It is the interface impact conductive within social forms as frames, struc-
tures, behaviours. Art as materialist practice and communication as
dialectics in juxtaposition along contextual layerings produce revolution-
ary effects. Art and Communication is basically this: dialectical material-
ism practiced as ideology.*[17]

Scene One: The Grand Opening

For CEAC's grand opening of its new space at 15 Duncan Street, a week-long extravaganza of events was presented under the rubric, *CANNIBALISM*, which secured CEAC's controversial reputation. In keeping with KAA's proclivity to program well-known composers of experimental music, CEAC opened its doors on September 18, 1976, with a concert featuring Michael Snow on piano and Larry Dubin on drums. KAA's sponsorship of Steve Reich's *Music for 18 Musicians* at Convocation Hall in May 1976 and Philip Glass's *Einstein on the Beach* in March 1977 presented Toronto audiences with Canadian premieres by musicians whose work had received international recognition, but who were relatively unknown in Canada. In the case of Reich, the audi-ence was small and hostile; in the case of Glass, the audience was also small but more receptive. For Snow and Dubin's concert, however, the audience proved quite large, and most stayed to experience Ron Gillespie's *Katchibatta* performance, featured the same night.

Documented on film by Ross McLaren, Gillespie's performance situ-ated the audience as the aggressor and featured performers enacting rit-ual definitions of territory. The performance began with Gillespie crawling naked on his knees into the gallery space, his thighs and ankles bound together with leather, and carrying a staff with horns mounted

at the top. SHITBANDIT members Glen James, Lily Y, Marlene X, and Debbie Pollovey followed behind him, faithful disciples of the guru. Circling one another like animals in heat, they engaged in mating gestures, alternately challenging each other and the audience. The climax came when the performers began to throw lighted matches at the audience members, who responded by hurling beer bottles back. At this point, SHITBANDIT disbanded, retreating in the face of audience outrage, and the opening night of CEAC came to a close.

Also featured during CEAC's opening week was Wendy Knox-Leet's performance *Bringing in the Harvest*, which engaged the same elements of alchemy, shamanism, and mysticism as Gillespie's *Katchibatta*. A review in *Art Communication Edition* describes Knox-Leet's performance as a twenty-minute ritual based upon her investigations of megalithic monuments and burial grounds. Knox-Leet entered the gallery with a six-foot-high bundle of corn stalks attached to a wood frame, a canvas dog effigy, her body greased, chestnuts wrapped around her neck and ankles, and horsetails strung around her waist. She proceeded to

> withdraw metal and plastic icons from the entrails [of the dog] and stitch together the stomach opening. These ornaments were attached to the bundle of corn stalks, and then the whole structure was suspended from her forehead by a natural linen strap. With increasing speed, Knox-Leet traced the pattern of the double and triple spirals, the squared circle, and the three-four-five triangle. The whirling motion of the body, corn stalks, and horsetails flying through space transmits elemental connection with forces of the universe, instinctual creation, and of fertility and initiation.[18]

Bringing in the Harvest was conceived in relation to Knox-Leet and Michaele Berman's manifesto "Ritual Performance," which was published in *Art Communication Edition*. In this manifesto, Knox-Leet and Berman describe the visual elements of ritual performance as "conductors of spiritual power," the sculptural elements as "a ritualistic preparation and initiation into the time-space continuum," the sound elements as "piercing the core of the audience," and the movements as gestural, shamanistic, and primeval. Ritual performance, they conclude, is a "revolutionary form which takes this limited and predefined structure [perception], and EXPLODES it. As it shatters into fragments, we see the key to survival."[19] Both Knox-Leet's and Berman's ritual performances, and Gillespie's exploration of behaviour, violence, and sexuality would influence CEAC's subsequent formulation of Behavioural Art.

Although Missing Associates did not perform during the opening week of CEAC, their structural dance experiments also informed CEAC's theoretical platform. Comprised of Peter Dudar, a choreographer and filmmaker, and Lily Eng, a dancer trained in the martial arts, Missing Associates pursued a style of dance that was diametrically opposed to the Martha Graham modernist school prevalent in Toronto in the 1970s. The duo published broadsheets that both self-aggrandized their productions and criticized those of their contemporaries, and were an important, if alienating, component of Toronto's experimental dance scene. Their dance performances were structural and minimalist in concept, and aggressive in execution. *Running in O and R, Getting the Jumps, Crash Points 2*, as well films made by Dudar recording their performances, sought to challenge the definitions of movement and poise current in dance terminology by exploring behaviour patterns and "ordinary" actions. They situated their work in the context of structural film and ritual aspects of body art, while their polemic referenced futurism, Marxism, anarchism, and the opposing ideologies of Bruce Lee and Mao Zedong. Describing a performance intervention at the Art Gallery of Ontario in 1977, Dudar indicates the degree to which their collaborations were shocking to the general public:

> As Lily entered to do her solo number, I reminded her to make it at least 15 minutes. A security guard approached the two martial artists in one of my pieces and asked what was wrong. Derek and Henry said 'Nothing.' The guard then asked what THAT WOMAN was doing. 'Performing' they answered. 'No, she's not!' he responded, and stormed into Lily's performance area. She was lying on her back at the time. He said something and tried to grab her arm. She pulled back, her lips moving. All I could make out was 'Get the fuck out of my performing space!' He drew back (he seemed to be contemplating charging in), noticed the 150 people or so staring at him, then exited, so to speak. Lily went on a bit, then laughed maniacally a couple of times.... She then addressed the audience: 'Every time I come into this fucking place the fucking security guards harass me. Well if you want to get me out you'll have to fucking come and drag me out!'... When she was set I roundhoused Lily quite loudly in both ribcages, moving her a couple of feet to each side in each instance, then side-kicked her in the small of the back where it really hurts. The steel pieces in the brace took most of the shock, and the leather binding helped emphasize the sound.[20]

While the programming of concerts and performances during opening week expressed CEAC's commitment to a multidisciplinary approach to

art and communication, Heather MacDonald's environmental installation *Rain Room* was the focal point of the Duncan Street launch. Built by the CEAC collective, *Rain Room* was an eight-by-eighty-foot enclosed room with white sand on the floor, white walls, a grid of copper piping on the ceiling, heat lights, and speakers. Inside the room, it rained for two days, then heat lamps switched on for two days, causing a cycle of humidity that became dry heat and initiated the rain cycle again. The accompanying audio track juxtaposed the climatic changes with opposing sounds. When MacDonald committed suicide in late 1976, *Rain Room* also became a symbol of tragedy for the active members of CEAC. Together with MacDonald's friends, they viewed her suicide as related to the lack of funding for her work, and to her eviction, along with other artists, from a building at 89 Niagara Street due to land speculation. For Marras, her suicide was a political issue, emblematic of her struggle as an artist "under the brutality of capitalizations with eviction from her work place without a just cause, under the weight of paralytic institutions and of armoured funding agencies."[21] In the aftermath of MacDonald's suicide, her friends approached the Art Gallery of Ontario with a request to install *Rain Room* and documents leading to her "action" as a permanent commemoration of her death. In the ensuing and failed negotiations with the AGO, and in Marras's criticism in *Art Communication Edition* of an institution that would only validate work after an artist's death, *Rain Room* became a flashpoint for issues over the politics of suicide and the politics of state-funded art.

In an unsigned article "The Lumpen and the Lumpen Eaters," published in *Art Communication Edition*, the anonymous author denounced the "unyielding institutionalizing patronage of reactionary minds that make up the government funding agencies" in the "let's not cause a scene land of the beavers."[22] The article defined the lumpen artist as one who experiences a series of "perverse art crimes," from the romanticization of the autonomous artist promulgated through art colleges to the "brick wall of near impossibility of receiving financial or moral support"[23] from older artists co-opted by the grant system and funding agencies who support a "safe, reactionary, institutionalized art…exemplified by the representatives to the Venice Biennale…the most recent example being Greg Curnoe in 1976 with his 1964 pop art style.[24] This characterization of Canada's state-funding system as an institution that places itself "into the pie-in-the-sky ivory-tower framework of producing endless streams of useless objects pandering to the tastes of the bourgeoisie,"[25] and the simultaneous positioning of CEAC as the sole artist-run centre in Canada "maintaining a direct interest in political and artistic activity"[26] affirmed CEAC's confrontational stance and ensured its alienation from much of Toronto's art community.

Here we have the grandfather of conceptual art, and we have the pro-
moters of contextual art, and we're all going to battle it out and see
who's going to run off with the art trophy.[27]

The atmosphere was banal while charged with defensiveness, combat-
iveness, and constraints parading as *noblesse oblige*. As I often do under
the weight of bad faith, I absented myself—until near the end the situ-
ation seemed so silly that black humour seemed a viable respite. In
short, I think this transcript is fairly worthless. Except perhaps as a
workshop on alienation.[28]

In February 1976, a number of artists from KAA, including John
Faichney, Lily Eng, Peter Dudar, Ron Gillespie, and Amerigo Marras,
were travelling in Europe when they discovered a pamphlet written by a
Polish artist, Jan Swidzinski, expounding a theory of contextual art.
Published in English translation in 1977, Swidzinski's *Art as Contextual
Art* sought to dislodge conceptual art from its vanguard throne by argu-
ing for "art not as the syntactic proposition of conventional art or as the
analytical proposition of conceptualism, but as the indexical proposi-
tion / the occasional sentence / of naturally contextual meanings."[29]
Describing the logic which rules art as epistemological, and contextual
art as "signs whose meaning is described by the actual pragmatic con-
text" where there occurs "the continuous process of the decomposition
of meanings which do not correspond to reality and in creating of new
and actual meanings,"[30] Swidzinski arrived at the paradigm:

REALITY INFORMATION ART NEW OPEN MEANINGS REALITY.

The thrust of this statement, which comprised part of the "Sixteen
Points of the Contextual Art Manifesto" outlined by Swidzinski, was to
situate contextual art as a dialectical praxis in which "truth" was subject
to the context of the ever-changing flux of reality. In Swidzinski's search
for a paradigm that could describe the relationship of art to a modern
condition of knowledge, he identified three models of visual semiotics
that coexisted in current art practices. The first, the universal model of
classical art, assumed that the "signs with which civilization shows reali-
ty are transparent for art,"[31] and arose from a belief that language
expresses a reality of recognition rather than structure. The second, orig-
inating in Romanticism, was relativistic. In this model, a direct and
homogeneous image of the world depends upon the tools with which we

learn about it. Swidzinski suggested that a problem arises in this model between the relationship of the signifier and the signified, whereby the relativism of modernism creates uncertainty about whether art produces a "true" reality, or a reality that only expresses knowledge about art. Citing Ad Reinhardt's proclamation—"permanent revolution in art as a negation of the use of art for some other purpose than its own"—as emblematic of contemporary relativism, Swidzinski posited this declaration of art for art's sake as the "last expression of this tendency."[32]

For Swidzinski, the consequences of relativism were related to the philosophical problem of neo-positivism, from which he traced the origins of a third model, conceptualism. This third model was identified by Swidzinski with the platform articulated in Joseph Kosuth's *Art after Philosophy* and in the publications of the Art and Language group, founded by Terry Atkinson and Michael Baldwin in England and Ian Burn and Mel Ramsden in New York. According to Swidzinski, the language of conceptualism brought a semantic function to art in order to produce meaning rather than formalism. However, Swidzinski critiqued this model by claiming that the only difference between modernism and conceptualism was the locus of expression: relativists used visual signs, while conceptualists used the language of logic. This, he insisted, created a tautology in which the analytical sentence as an art form becomes a sign that is non-transparent, and therefore ceased to relate expression to reality. Swidzinski goes on to list the Collectif d'Art Sociologique of Hervé Fischer, Fred Forest, and Jean-Paul Theno in France, who situated art as "the practice of negative utopianism directed against the bourgeois order;"[33] Joseph Kosuth's *Artist as Anthropologist*; and the neo-Marxist debates in the Art and Language publications as examples of a "declaration of good will"[34] seeking to escape this tautology. In conclusion, he forwarded his model of contextual art as the solution for a social theory and praxis of art.

For Marras, Swidzinski's model of contextual art provided a philosophical synthesis of KAA's programming strategy to date: encompassing ritual performance, Missing Associates' structural dance actions, and Beth Learn's use of the term "contexturalism" in *Language and Structure in North America*. Moreover, the model that Swidzinski proposed offered CEAC the theoretical means to locate their activities on an international art map of manifestos and debates. Contextual art was appropriated by CEAC as the paradigm by which didactic, interrogative, and situational performance art realized an "object" of social practice through the dialectic of meaning created between the audience and the performers. What was still to be done, however, was to inform the coterie of international artists involved in conceptualism about CEAC's

imminent role as the new vanguard of contextual art. And so Marras
invited the key players in the conceptual-art arena to a "Contextual Art
Conference" held at CEAC from November 10–12, 1976. Among those
who participated in this conference were Anthony MacCall, a British
structuralist filmmaker; Joseph Kosuth and Sarah Charlesworth, New
York artists involved with the Art and Language publication *The Fox*;
Jan Swidzinski and Anna Kutera of the Polish contextual-art movement;
Hervé Fisher of the Collectif d'Art Sociologique; and Jo-Anne Birnie-
Danzker, who had worked for *Flash Art* and was currently working for
the NDP. Others who were invited but declined to attend included
Victor Burgin; Peter Kubelka, an Austrian filmmaker associated with
the structuralist cinema movement of New York; Chantal Pontbriand,
the editor of *Parachute* magazine; and Ian Burn from Art and Language.
Karl Beveridge and Carol Condé, who had been involved with *The Fox*
while living in New York, declined to sit directly on the panel but partic-
ipated from the audience floor. Others who participated from an audi-
ence position included Vera Frenkel, John Scott, John Bentley Mays, AA
Bronson of General Idea, John Faichney, and Ron Gillespie.

In bringing together this configuration of participants, Marras
assembled a fractious group of artists who in many cases brought to the
table a legacy of theoretical and political squabbles. Kosuth and
Charlesworth implied that the conference was a set-up meant to posi-
tion their conceptual-art practice in opposition to a previously
unknown Polish artist's critique, with Marras as an opportunistic mid-
dleman. This issue of positioning was complicated further by the intri-
cacies of a split that had occurred between Kosuth and the New York Art
and Language group. The "declaration of good will" that Swidzinski had
attributed to Art and Language's adoption of a neo-Marxist position
had subsequently disintegrated through internal divisions that had
occurred over the publication of *The Fox*. The New York collective
involved in producing *The Fox*, including Kosuth, Ramsden, Burn, and
Beveridge, sought to identify a revolutionary platform for art, foregoing
identification as individuals in support of cell solidarity. In the context
of the New York art market, however, the publication soon became asso-
ciated with Kosuth, undermining the collaborative attempt to define
revolutionary practice and leading to internal divisions over issues of
individualism and group hierarchy. These rifts deepened over the collec-
tive members' differing political alignments—with Maoism, Marxist-
Leninism, and anarchism—and *The Fox* ceased publication after three
issues. By the time of the conference, Kosuth and Charlesworth had dis-
associated themselves from *The Fox*, adopting a loose and self-styled
combination of feminist, anarchist, and Marxist ideas. Karl Beveridge

and Carol Condé had thrown up their New York art practice and returned to Canada after exhibiting their Mao-inspired call to arms, *It's Still Privileged Art,* at the Art Gallery of Ontario in February 1976.[35] Feelings ran high at the conference over these ideological differences, producing an atmosphere of hostility and political infighting that was all but opaque for those unfamiliar with the specific histories of these artists and with the rhetorical polemics of 1970s neo-Marxist theory.

What the conference transcripts reveal is an intense two-day discussion that oscillated between theoretical posturing and personal invective, in which the participants attacked, denied, and redefined their positions on the nature and practice of political art. For Kosuth and Charlesworth, the conference was engaged in a highly specialized discourse they had expressed a wish to demystify, and positioned them within a theoretical arena they had recently rejected. On another level, their condemnation of the conference revealed the arrogance of artists producing at the cultural centre who felt no obligation to provide the periphery with a clear understanding of their aims. Swidzinski himself was attacked at the beginning of the conference for assuming he could propose a "social practice" based upon forty pages of theoretical generalizations. Hervé Fischer tried to re-establish an amicable level of discourse by stating his collective's intention to create not a social practice but a sociological practice. Basing his ideas upon Adorno's negative dialectic, Fischer proposed a theory and practice of art that would enable a productive criticism of society rather than the creation of prescriptive models that included Marxism, which he characterized as "an answer system, ready-made, to try to get the power, to try to get into a bureaucracy."[36] For Fischer, the role of the artist was not to produce vanguard ideas but to facilitate the means through which all classes in society could arrive at their own self-determinism of language and structure. Charlesworth, in turn, refused to participate in a dialogue at this level, and launched into a polemic stating that the conference's context made any viable analysis of the participants' roles as producing artists impossible. Birnie-Danzker insisted throughout the discussion upon the importance of framing the debates within a context of ideology and economics that would engage the audience. In response, John Scott introduced from the audience floor his dilemma of exhibiting in the art world as a self-identified Marxist artist and working as a union shop steward, while AA Bronson and John Bentley Mays found the whole discussion of artistic imperialism and economic appropriation "astounding," failing to see what was wrong with a hierarchical structure that valued "famous" artists' discourse over the average person's perception.

Despite the obtuseness of much of the conference, in the final analysis it provided a valuable opportunity for local artists to consider and debate issues of politics and art that were not monolithic in their assumptions or aims. Among the key issues raised during the conference were the relationships of the artist to cultural imperialism, to a mercantile market and the absence of one in Canada, to the problems of producing work in a system that buys and sells both objects and ideas, and to the posturing of art as communication through inaccessible language. As convoluted as the discussions may have been, they offered a context for Scott to argue that General Idea's strategy of appropriation "reinforces oppressive structures" and for Birnie-Danzker to argue for the importance of Partisan Gallery's murals as "community art." These issues of strategy, community, markets, and funding remain pertinent for the practice of a politically engaged art in Toronto, while the complexity and contradictions of the political debates of the 1970s, often unacknowledged, underlie many of the representational strategies of the 1980s.

Scene Three: Behaviour Art

CEAC's interest in promoting contextual art continued through 1977. In February 1977, CEAC presented three lectures on "contextualism" in New York City to introduce the idea of "art-as-empty-sign, that is structure in which the introduction of meanings is the activity of the audience."[37] During the same year, an exhibition of Katherina Sieverding's work-in-progress examining Chinese and American propaganda photographs, as well as an interest in the performance work of Marina Abramovic and Arnulf Rainer, also contributed to CEAC's articulation of a "contextual" art practice. Through the three-week residency in March 1977 of the British performance collective Reindeer Werk, CEAC's objective of promoting "contextual" performance became linked to the idea of behaviourism. Reindeer Werk, composed of Tom Puckey and Dirk Larsen, proposed a behavioural school of performance in which investigations of deviance and response could provide a critique of Skinnerian models and the dominance of behaviour modification in the social sciences. Through their writings and performances, they found a receptive audience in an international circuit of alternative spaces, including Galerie Remon in Poland, De Appel in Amsterdam, and CEAC in Toronto. Their manifestos, reprinted in *Art Communication Edition*, called for an expedient artistic exploration of the "doublethink" in society that "begat ideas, which begat literacy, which begat the

concept."[38] Their action-oriented collaborations involved the formal mechanics of socially unacceptable behaviour. In a review of their performance, Peter Dunn described them as having the appearance of two people "suffering the traumatic contortions and involuntary spasms of severe behavioural disorder,"[39] in which:

> …small idiosyncratic gestures acceptable as "habit" slowly transformed into the involuntary pacings, rubbings, and scratching associated with neurotic "ritual." Finally, after random fluctuations of intensity, it attained a pitch comparable to severe hysterical psychosis ending with the performers spent in exhaustion.[40]

For the artists associated with CEAC—whose work shared an affinity with Reindeer Werk's shock tactics and whose critique of media-saturation and state-funded conformity echoed the British artists indictment of conditioned response and "double-think"—behavioural art offered a platform to achieve theoretical credibility in a European context. Misunderstood or disregarded in Toronto, and perhaps indifferent to the community's acceptance of its objectives, CEAC began to aggressively promote behaviour art in New York and on the European continent. Functioning as a collective in their approach to cultural exportation, CEAC artists had already toured Europe in 1976, highlighting the work of Missing Associates and Ron Gillespie and making their initial connections with the Polish contextual artists, the "action" school of performance, and Reindeer Werk. In seeking to consolidate their collaboration and alignment with these groups, Marras characterized CEAC's "contextual behaviouralism" as a social practice that refused to cooperate with the capitalist reinforcement of production and consumption. He described a range of potential activities from therapy communes to the establishment of a school where members would exist as "behavioural catalysts—non-functioning as 'tutors' or 'students' but existing as questions."[41] In the context of performance, he defined behaviour art as the interface between the provocation and demarcation of aggression, listing the actions facilitating this interface as:

> psycho-physical deprivation of a precise element.
> confrontation with an unaware group.
> analysis of social conditions through the effects of a given ideology.
> media analysis and its assumed language.
> dialectical interface and collective creation.
> bringing to its extreme contradiction a definitive condition.[42]

This fusion of hot psychotic behaviour and the cool analysis of context was first presented as a "behavioural action" on March 24, 1977, at Pier 52 in New York. A collaboration among Bruce Eves, Ron Gillespie, Amerigo Marras, Marsha Lore, and Reindeer Werk, the action was intended to challenge the definition of acts such as cruising, a common occurrence on the pier, as culturally deviant. Puckey, Larsen, and Lore sat in a car with its headlights shining through a hole in the wall, creating an interior context of "a leather queen cruising ground."[43] Inside the wall, illuminated by the car headlights and a single flashlight, Gillespie, Marras, Eves took a series of photographs of:

> Me [Eves] on my knees with Ron's cock in my mouth.
> My legs hanging over the edge.
> My foot holding Ron's hand down securely on a broken pane of glass.
> The flashlight in Ron's, Amerigo's and my mouth.
> My cruising stances.
> The tension on Ron and Amerigo's faces.[44]

Similar in aim, but different in content, were the collaborative performances presented by Eves, Marras, Suber Corley, and Diane Boadway during CEAC's second European tour in May of 1977. Taking part in discussions held in Paris by the Collectif d'Art Sociologique and in Poland by the contextual-art movement, the CEAC group also presented, in various art venues, a didactic seminar/performance critiquing the art-world frame of reference and asserting the importance of performance as a means to break down audience/performer barriers. In this seminar/performance, Eves, Marras, Boadway, and Corley placed themselves in the four corners of a gallery, and reading from a text, spoke in turns into a microphone for fifteen seconds at a time, reading from a lengthy text. A photographer, obscuring audience's view, intimidated the audience with a barrage of candid-camera shots. The text consisted of seventy statements proposing an antithetical stance to dominant ideology rather than "alternative" positions that could be re-appropriated by the cultural hegemony. Samples of the statements read include:

> Any particular performance, like any particular moment in time,
> can only be presented once.
> The spontaneous situation is the performance.
> Performance is flux.
> Theatre is in direct opposition to the theory and praxis of behaviour
> and context.
> Performance art has not yet left the wall.

The performer and the audience are autonomous.

Performance art creates no interchange.

Performance art creates no solutions.

Performance art does not alter perception.

Performance art can no longer exist within the art world frame of reference.

The art world frame of reference fails.

Performance fails.[45]

The European reaction to this didactic approach to performance reveals much of the irony implicit in a project that sought to announce its own failure while maintaining the privilege of speaking within an "art-world frame of reference." At De Appel in the Netherlands, a member of the audience felt as if the CEAC performers were "acting like gods of the art world, talking down to people there."[46] At the Museo d'Arte Moderna in Bologna and the Palazzo dei Diamanti in Ferrara, CEAC's questioning of the audience's collaboration with bourgeois-capitalist ideology evoked a less-than-civil response. According to Diane Boadway, who described the performance in her journal of the tour, the reaction of the Ferrara audience was the most exciting. In response to such questions as, "Does a repressive society reproduce repressive social models?" she writes that

> Some students get up on stage and begin to mimic us. They stand in
> the corners and one at the microphone on the table takes a beetle and
> places it upon the microphone and then tries to hit it with a sledge-
> hammer. Amerigo begins to stamp his feet loudly and clap yelling
> 'bravo bambino.' More students join in and they rip the paper with the
> statements and the questions off the wall and take it out in the court-
> yard and burn it in a ritual.[47]

In contrast to the tumultuous audience reaction that greeted their performances, the seminars CEAC attended in Paris and Poland were long, drawn-out, and intensely serious discussions of the nature of defining a revolutionary practice of art. The Paris seminar, attended by the CEAC group, Jan Swidzinski, Peter Dunn and Lorraine Leeson, and sponsored by the Collectif d'Art Sociologique, agreed upon a manifesto entitled "The Third Front" that was subsequently published in *Art Communication Edition*. Committing themselves to a collective strategy of combating the "capitalist division of labour in the art market" and establishing an "international network of communications,"[48] the Third Front spent much of the seminar attacking the cultural hegemony of the New York art world. Similarly, a "Polish Front" was established at the

seminars in Warsaw to oppose the imperialism of a New York international centre. From the Contextual Art Conference at CEAC in November 1976 to the seminar in Poland in July 1977, a recurring theme dominated discussion: how to achieve an art practice antithetical to the consumerism of American ideology within an art world dominated by the New York market. The contradiction implicit in this objective, in which the emphasis upon New York as the centre of the art world only reinforced its hegemony, would end up defeating attempts on the part of these groups to create an oppositional front. The hegemony of New York, whether real or perceived, created a situation in which artists such as Sarah Charlesworth could declare that "I am not about to become a political artist, although I am concerned with political questions and I am an artist,"[49] while CEAC scrambled to establish political platforms and political fronts to oppose the ease with which she was able to breeze in and out of ideological stances.

Scene Four: Raw/War

In the spring of 1977, the Toronto scene saw an explosion of local bands adopting the paraphernalia and alienated stance of the British punk movement. Marras initially perceived the phenomenon as a spontaneous behavioural reaction against mainstream media and CEAC sponsored the first punk venue in Canada, Crash'N'Burn. Organized by The Diodes, a band of composed of OCA students, Crash'N'Burn was located in the basement of CEAC from May through August 1977. The Diodes original members—John Catto, David Clarkson, John Hamilton, and Ian MacKay—collaborated with Marras and Eves in the production of a 45-rpm disc entitled *Raw/War*, which was distributed as *Art Communication Edition* 8. The music on the disc was interspersed with droning statements by Marras and Eves from the behavioural manifestos of CEAC and Reindeer Werk. Heralded by Marras as the instrument to produce the "great awakening in the brainwashed television public,"[50] *Raw/War* stands as an example of the incongruity of a highly sophisticated rhetoric pasted onto the extremely raw and naive sound of hard-core punk. The probably unintentional saving grace of the record is the voice of a woman at the end of the single who responds to the polemic of "you people are the police" and "how can ideology change social practice" by crooning "fuck off" and "stick it up your ass." Other bands that played Crash'N'Burn, a hole-in-the-wall space with a bathtub for a beer fridge, included the all-female bands The Curse and The B Girls; The Poles, featuring Michaele Berman, who had taken ritualistic performance to its media extreme; the

Viletones, featuring the sensationalist violence of Nazi Dog's self-inflicted wounds; The Dishes; and The Dead Boys. Performance-oriented events such as Fashion'N'Burn added a sarcastic and humorous overtone: the interjection "Is that new wave a permanent wave?" pointed to the fleeting nature of the punk craze in the wake of promised record contracts and media hype. As punk's clarion call of "no future" sold out to a music-industry future, CEAC's initial enthusiasm for punk revolution was as quickly transformed into disillusionment by its consumerist appropriation. In September 1977, CEAC closed Crash'N'Burn, and the short-lived energy of the initial punk explosion dissipated as bands found alternative venues and record contracts. All that remains of the heyday of Toronto's musical nihilism is the record *Raw/War* and a film documenting its excesses, Ross McLaren's *Crash'N'Burn*.

Scene Five: Free International University Workshops at Documenta VI

When Amerigo Marras, Bruce Eves, Lily Eng, and Ron Gillespie were invited to Joseph Beuys's "Violence and Behaviour" workshop at the Free University for Creativity and Interdisciplinary Research in Kassel in September 1977, it was as if all of their work mounting the CEAC opera became a dress rehearsal for an audience that counted. Beuys was the radical art darling of New York and Europe, and CEAC was being admitted to his church. With the invitation in hand, CEAC artists scrambled to explain how they could accept participation in an event that had excluded other groups in their Third Front. To this end, Marras issued a communiqué in *Art Communication Edition* directed at Hervé Fischer and the Collectif d'Art Sociologique, in which he attempted to worm out of the contradiction of Fischer's exclusion, declaring with the same vigour CEAC's autonomy from alliances that they had embraced only four months earlier in a united front of common ideals and aims. Hegemony, it seemed, extended further than the New York art market, with the wag of Beuys's little finger creating the same divisions among artists in the Third Front that CEAC had denounced as a capitalist and imperialist ploy of the New York art scene. In addressing this contradiction, Marras argued that "to share commonalities does not necessarily mean to stagnate in a precise model. In fact, shifting the focus makes us realize that there are alternatives to anyone's alternatives."[51] Then, in an absolute tumble of discursive somersaults, he asked:

> How does one defeat the dominant ideology if the alternatives are split by the same dominant ideology? Precisely by oneself becoming the occasional member of some of the thousands of networks in operation and thereby shifting the ground without freezing the role.[52]

This decision on the part of CEAC to justify others' exclusion on the grounds that such divisions would defeat dominant ideology suggests that rather than achieving an antithetical practice to bourgeois individualism, they had ended up being co-opted by the "double-think" they so vociferously critiqued.

CEAC's experience at Documenta VI could be likened to the "perverse art crimes" that they had accused the art world of generating. At the Documenta sessions of the "Violence and Behaviour" workshop, Bruce Eves's argument that the homoerotic in art, the mimicry of drag, and sadomasochism were a safe distraction from and an effective appropriation of violence was neither understood nor well received. His use of mimicry in punk, fashion, and gay art was, however, one of the most succinct statements on the postmodern recuperation of subversion to be issued from the CEAC platform. Eves was personally ostracized after his presentation, and the CEAC group as a whole experienced Documenta as a competitive showcase in which each participating group went out of its way to prove it was more radical and more marginal than the next for the fedora-bedecked master.[53] Documenta had become the pivotal scene in the opera, where comedy turned to tragedy, politics became a bargaining site of bad faith, and polemic ceased to function as an antithetical tool. Nevertheless, Marras returned to Toronto, bent, bound, and determined to establish a free international university at CEAC and to up the ante of his political stance against art-world systems.

Act Three: *STRIKE!*

We want to come out closer to the de-training programme, opposed to the service systems…. We have to realize a polemical state, a state of permanent questioning. The polemics and its art are the core of our surfacing and switch. To uncover the sore points, the polemics, to challenge them is what we mean with *STRIKE*.[54]

NO BUTTER, NO BUTTER, NO BUTTER: CEAC DRY HUMPS THE AUDIENCE. MOTOR CITY MEETS CEAC: A CONFRONTATION WITH SEARING ANARCHOFAGGOTRY. ENCOURAGING YONI CONSCIOUSNESS. HETEROCLONES FOR GAY CONSUMPTION: THE AUDIENCE AS SURROGATE SEX VICTIM. WARM IT UP BEFORE YOU EAT IT; MOTOR CITY GETS CRAMPS AND GOES HOME.[55]

In the autumn of 1977, as the thirtieth anniversary of the founding of the Federal Republic of Germany neared, a wave of assassinations of prominent West German citizens—including chief prosecutor Siegfried Buback, Dresdner Bank head Jürgen Ponto, and president of the manufacturers' association, Hans Martin Schleyer—by the left-wing Baader-Meinhof Group stunned the country. As outrage and paranoia escalated in the media, Andreas Baader, a leader of the group, died under mysterious circumstances in a high-security West German prison. The state's announcement that the official cause of death was suicide instigated a backlash of outrage and paranoia on the part of students and left-wing sympathizers. In Italy, the Red Brigades had engulfed the country in an unpredictable war of violence and chance terrorism, culminating in the kidnapping of former Italian premier Aldo Moro on March 16, 1978, and the discovery of his slain body on May 10. In response, the Italian state initiated a total crackdown on the autonomous workers' movement. Terrorism, state retaliation, and paranoia were in the air. It was the beginning of the post-political era.

In January 1978, at CEAC in Toronto, Bruce Eves, Amerigo Marras, Suber Corley, and Paul McLelland changed the name of their in-house publication from *Art Communication Edition* to a "brave new word": *STRIKE*. The nature of the polemic between the covers of the magazine, however, did dramatically alter at first. In the first issue of *STRIKE*, Marras affirmed his search for an antithetical ground on which to locate a critique of dominant ideology and a mercantile art system. Peter Dudar and Lily Eng published an invective against the Art Gallery of Ontario and the state of dance in Toronto similar in tone to the articles that appeared in *Art Communication Edition* after Heather MacDonald's suicide. John Faichney featured examples of artists' books. Fred Forest of the Collectif d'Art Sociologique published a communiqué explaining a sequence of events that led to *Newsweek*'s refusal to run his advertisement selling "Artistic Square Meters" in France. According to Forest, his ad, entitled "Buy France Piece By Piece," was considered by Newsweek to be deceptive advertising, given there was "inadequate information concerning the financial structure of your company."[56] From the absurd to the sublime, the issue also listed a number of workshops and seminars conducted by members of the newly established CEAC school. Among the eclectic courses on offer were Ross McLaren's Basic Filmmaking; Ron Gillespie and Veronica Lornager's Introductory Seminar on Evolution; Harry Pasternak's Kindergarten and Inflato-Art; Saul Goldman's Video Cassette Editing;

Amerigo Marras's Art and Revolution; and Lilly Chiro's Buddha Maitrey Ame Wears a Purple Taffeta Dress.

In conjunction with the CEAC school, a set of open discussions were held on Monday evenings in the CEAC library to plan a series of seminars on the topics of human rights, ideology, behaviour, work, and community. Entitled *Five Polemics to the Notion of Anthropology*, the seminars took place in April and May of 1978. Guest speakers included Marty Pottenger of *Heresies* magazine; Bruno Ramirez of *Zerowork*, a journal calling for the elimination of work; Maria Gloria Bicocchi of Art/Tapes in Florence; Gerald Borgia, a socio-biologist pioneering work in the field of genetic science; and Bernard-Henri Lévy, a founder of the *nouvelle philosophie* in Paris. Guest artists included Lorraine Leeson and Peter Dunn, whose work in Britain focused upon community intervention through poster campaigns, and Marina Abramovic, a performance artist from Yugoslavia. Also planned was a Toronto segment of Caroline Tisdall and Joseph Beuys's Free International University, which fell through in the aftermath of the scandal that broke in May 1978 over the second issue of *STRIKE*, which would number CEAC's days.

The most widely publicized event of the seminar series was a lecture and discussion led by the French philosopher Bernard-Henri Lévy. Based on a critique of Marxism, rationalism, and classical dialectics, Lévy's anti-authoritarian and anti-system stance was derived from the influence of Aleksandr Solzhenitsyn. To understand the last fifty years of history, he argued, "you must understand the camps. You must begin with the point of view of the prisoner."[57] Jay Scott, reporting in the *Globe and Mail*, described the seminar:

> Several people are on hand, an oil and water beaker of leftists who ask questions and sneer at Mr. Lévy's answers and rightists who make statements and sneer at Mr. Lévy's responses. To mix the metaphor, since nothing else is mixing: his audience is hard-top not convertible.[58]

Lévy, in calling for a philosophy that was immediate and individual in protest, stated that if he were a Canadian, he would "talk about Indian reserves, about unemployment, and the RCMP—who are listening to you and opening your mail."[59] Upon opening the second issue of *STRIKE*, it was as if Levy had had a profound influence on a group that had managed to assimilate only half of his platform. In CEAC's publication of court transcripts from the Red Brigades' trial and the exposé of Salvadorean death-squad tortures, it was clear that they had internalized the point of view of the prisoner. Their editorial, seeking a radical solution to the incarceration of artists by a capitalist system, advocated "leg

shooting/knee capping to accelerate the demise of the old system."[60] Their cover displayed the bullet-ridden bodies of Aldo Moro's body-guards, killed during the Red Brigades' kidnapping. With the discovery of Aldo Moro's body only days after *STRIKE*'s publication and a *Toronto Sun* headline denouncing CEAC as bloodthirsty radicals, Scott's article would be the last sympathetic press CEAC would receive. And it would only be after the ensuing scandal that CEAC appeared to have absorbed the other half of Lévy's anti-system philosophy. In the next and final issue of *STRIKE*, a critical exposé was published on the RCMP, who clearly had been opening CEAC's mail and listening to their phone-calls.

Scene Two: Finale with Full Chorus[61]

It's the ferment of ideas that makes these people cultural revolutionar-ies. Where their revolution is headed and how influential it will be is pure speculation, but what they are doing now is worth more than a cursory glance.
—Bruce Kirkland, *The Toronto Star*, March 19, 1977.

The mutilation behaviours, virus works, punk art, kidnapping practices, bombings, terrorist actions, arson and even political behaviours have made art-behaviour a vastly more effective instrument than the simple subjective artists in the 1960s and their paper tiger paws.
—Ron Gillespie, unpublished text on behaviourism.

CEAC is an institution in power, and therefore dangerous. Solidarity is rarely a communion and commonly a retreat into fear and alienation, a block with which to wield power: ideology as corporate alienation. The projection of violence is not altruistic but masturbatory and adolescent.
—Tom Dean, "No Butter, No Butter" January 1978.

We are opposed to the dominant tendency of playing idiots, as in the case of punks or the sustainers of the commodity system. The question-ing of thorough polemics of the cultural, economical and political hegemony should be fought on all fronts. To still maintain tolerance towards the servants of the State is to preserve the status quo of Liberalism. In the manner of the Brigades, we support leg shooting/knee capping to accelerate the demise of the old system. Despite what the 'new philosophers' tell us about the end of ideology, the war is before us and underneath us. Waged and unwaged sector of the popula-tion is [sic] increasing its demands for 'less work'. On the way to surpass liberalism we should prepare the barricades.
—*STRIKE* Editorial, "Playing Idiots, Plain Hideous," May 1978.

Ont. Grant Supports Red Brigades Ideology: Our Taxes and Blood-Thirsty Radicals
—*The Toronto Sun*, May 5, 1978.

What position do we take in relation to the BR [Red Brigades]? We present their accusations of the ruling order in an extract of their court proceedings published in our paper. We share their anger and we agree that it is the power sector that must be on trial. We do not believe that terrorism makes any sense in the context here and we question the theoretical basis of any vanguard group that intends to lead or speak for the people, as little better than the farce of representation that exists in the present power structures of the state. We have published this material on the BR to rectify the repressed and distorted coverage they have received by all media.
—Statement to the Press, May 12, 1978, *STRIKE* Collective (Amerigo Marras, Suber Corley, Bruce Eves, Paul McLellan, Roy Pelletier, Bob Reid).

I move, seconded by the Hon. Member for Winnipeg South Centre (Mr. McKenzie): "That the method of deciding on Canada Council grants be made fully public at once, that all grants to organizations, groups or individuals under investigation by Canadian security service be immediately suspended and that the Prime Minister is forthwith ordered by the House to call a judicial inquiry into the shocking aims, decisions and actions of the Canada Council."
—Defeated motion by Tom Cossitt (MP, Leeds), May 23, 1978, Canada. House of Commons Debates.

Make no mistake about the seriousness of *STRIKE*'s threat to humanist values. Art is only a minor battlefield. The Board of Directors of *STRIKE* is well prepared for a larger fight. Through the Free University, International Art Fairs and visiting guests, experts in the fields of sociology, economics, philosophy, psychology, architecture, they are preparing for long-term revolutionary work. In recent issues, the journal has denounced art, capitalism, Russian and Chinese models of Marxism, Liberalism, CAR.... Ironically, *STRIKE* is the official publication of CEAC which relies for the majority of its revenue on federal and provincial funding.... Having established a façade of respectability, CEAC, through its affiliated publication, has now formed a political front to denigrate all art-making, to urge the overthrow of all existing structure and to declare its support for the terrorist strategy of the Red Brigades. Now that *STRIKE* has declared its destructive platform, continued financial aid by the provincial or federal government must be seen to be a support of the publishers' connections and entrenchment with violent

political revolutionaries. It is equally ironic that *STRIKE*'s indulgence in self-promotion by sensationalized and deviant behaviour, and its endorsement of "leg shooting/knee capping to accelerate the demise of the old system" has been supported by the tolerance and silence of an art community unwilling to take any moral stand on art or politics.
—Letter to the Editor," in *Open Paper Today*, June 1978.
Signed by Fran Gallagher, Bruce Parsons, Roby MacLennan, Ron Shuebrook, Art Green, Alison Parsons, Natalie Green.
cc to Louis Applebaum, Director of the Canada Council.

I feel obliged to respond to a letter that was directed to Louis Applebaum by persons affiliated with the Fine Arts Department of York University.... 8. "CEAC has now formed a political front" "the publisher's connections and entrenchment with violent international political revolutionaries." Oh, come on now. Are these more people who read the *Sun* and take it literally? There is absolutely no foundation in reality for such ridiculous statements.... 9. We totally agree with the next paragraph that the "art community is silent" and "unwilling to take any moral stand on art or politics."
—Letter to Arthur Gelber, Vice Chairman, Ontario Arts Council from Suber Corley, dated May 29, 1978.

Quite clearly, such a statement [the *STRIKE* editorial of May 1978] is an indictment to physical violence which is to be directed at individuals and to be carried on outside the legal framework of our society. Council members believe that such statements are unacceptable in a democratic society where there are other means of expressing protest or criticism.... They do not believe that public funds should be used directly or indirectly to support the advocates of such views.... They have therefore decided that the Council should not make further payments to the centre until they are provided with a satisfactory explanation of the philosophy and objectives of the centre's directors.
—Letter to Amerigo Marras from Timothy Porteous, Associate Director, Canada Council, dated July 4, 1978.

Because we hold the Kensington Arts Association/Centre for Experimental Art and Communication responsible for *STRIKE*, and because *STRIKE* has taken a position in support of terrorism, the Ontario Arts Council withdraws its funding from both *STRIKE* and CEAC.
—Letter to Amerigo Marras from Arthur Gelber, Vice-Chairman, Ontario Arts Council, dated July 10, 1978.

It grieves me to hear that you have decided to hold back funding which you have promised CEAC for this coming year's projects. I find it hard to believe that an educated man as yourself could possibly be so influenced by the media. I am of course referring to the articles on *STRIKE* magazine in the Canadian press. I, as any rational creature, must question the credibility of the issue and the underlying factors which relate to this matter. I can only come to one conclusion, and that is that *STRIKE* magazine exposed the ideas of the Red Brigades in Italy. Now you may say this is reason enough to cut the funding, but I ask you how such a matter as freedom of speech can be ignored?... many people depend on the facilities of the centre, myself included. Can we now say that these ten words which created so much controversy are enough ground to stop the funding of such a crucial centre?... I leave you with one question and that is can we allow the media to create the demise of such an important member of the world art community? The answer is no! If this continues there is surely no hope for this country and all of the artists and intellectuals who view their opinion of it.

—Letter to Arthur Gelber from Gerard Pas, undated.

Postscript

With the withdrawal of government funding in June and July of 1978, KAA was unable to meet its payments on the 15 Duncan Street space, the bank foreclosed on its mortgage, and CEAC closed its doors. Wintario, however, permitted the organization to maintain its matching purchase funds if the group that was left, spearheaded by Saul Goldman and John Faichney, bought a building with similar overhead. Television Production Studios, as they named themselves, bought a large building at 124 Lisgar Street in early 1980. Hoping to rent out the premises and maintain an artist-access video production studio, they were also unable to survive without grants. In 1981, TPS walked away from Lisgar Street and the Canada Council repossessed the video equipment, distributing it between The Funnel and Trinity Square Video. As far as I have been able to ascertain, Amerigo Marras and Suber Corley left for New York in January 1980, with neither the proceeds of the sale of Duncan Street nor the video equipment from CEAC's production studio. What they did take with them, however, was a history of RCMP harassment and investigation, as documented in detail in *STRIKE*, and the cold shoulder of an art community struggling to maintain its equilibrium in the aftermath of a funding scandal.

The year 1978 saw not only the end of CEAC, but also a crisis at A Space involving the purge of its original director; a crackdown across Canada on written publications that included the banning of Pulp Press's publication of a German terrorist's memoirs; and the *Body Politic* court case over a gay-sex article.[62] The arts councils, in the aftermath of the CEAC funding scandal, which had reached the debating floor of the House of Commons, demanded more financial and budgetary accountability in their grant applications, and the era of General Idea's "shell" of history began. With CEAC's demise, Toronto's art community would turn from radical stances and towards an awareness of their dependence upon state-funding. There would be no more scenes in the "let's not cause a scene land of the beavers." Oppositional energy, with all its contradictions and radical stances, would dissipate, and Philip Monk's lack of history would become the political analysis of the 1980s.

Notes

The title is from an advertisement placed by CEAC in the Ontario Association of Art Galleries, *Magazine*, Winter 1978/79 that read as follows: "As the futurists were in fascist Italy, as the Bauhaus was in Nazi Germany, as the constructivists were in the Soviet Union, the CEAC was banned in Canada."

The epigraphs are taken from General Idea, "Glamour," *File* 3:1 (1975), 21; and Amerigo Marras, "On Organization," *STRIKE* 2:1 (1978).

1. General Idea, *File* 3:1 (1975), 22.

2. Philip Monk, "Axes of Difference," *Vanguard* 13:4 (1984), 14.

3. Amerigo Marras, "Notes and Statements of Activity, Toronto," *Europe, Art Contemporary* 3:1 (1977), 30.

4. Ibid.

5. Ibid.

6. Ibid.

7. *Supervision* was a magazine produced by Blast-Bloom Associates, comprised of Amerigo Marras and Angelo Sagbellone.

8. Letter from Amerigo Marras and Suber Corley to KAA members. CEAC Collection, York University Archives, Toronto, Ontario. No archival designations are available as the CEAC Collection is uncatalogued.

9. Beth Learn. "Language and Structure," *Queen Street Magazine* 3:1 (1975).

10. For an historical overview of the Roy Ascott years at OCA see Morris Wolf, *OCA 1967–1972: Five Turbulent Years* (Toronto: Grub Street Books, 2002).

11. Marras met these video artists during a video encounter at CAYC, a centre for art and communication that was a focal point of the Buenos Aires avant-garde. Information on their project was described in promotional flyers. CEAC Collection, York University Archives.

12. Amerigo Marras, "Revolutionary Process of Organization of Telemedia: Towards the End of Separation Between Television and Video," unpublished text. CEAC Collection, York University Archives.

13. Ibid.

14. Jean Baudrillard, *In the Shadow of the Silent Majorities*, trans. Paul Foss, Paul Patton, and John Johnston (New York: Semiotext(e), 1983).

15. Marras, "Revolutionary Process of Organization of Telemedia."

16. Letter from the Canada Council to CEAC, dated October 26, 1978. CEAC Collection, York University Archives.

17. *Art Communication Edition* 2 (1977), no author cited. From here on cited as *A.C.E.*

18. *A.C.E.* 4 (1977), no author cited.

19. Wendy Knot-Leet and Michele Berman, "Ritual Performance," *A.C.E.* 3 (1977).

20. Peter Dudar, "I Don't Know If You Believe This Could Actually Happen At The Art Gallery of Ontario," *STRIKE* 2:1 (1978), reprinted in *Missing in Action* 1.

21. Amerigo Marras, Editorial, *A.C.E.* 3 (1977).

22. *A.C.E.* 3 (1977), no author cited.

23. Ibid.

24. Ibid.

25. Ibid.

26. Ibid.

27. Sarah Charlesworth, unpublished transcripts from the Contextual Art Conference. CEAC Collection, York University Archives.

28. Joseph Kosuth, "What is this Context," [a response to the conferences proceedings], unpublished transcripts from the Contextual Art Conference.

29. Jan Swidzinski, *Art as Contextual Art* (Warsaw: Art Text, Galerie Remont, 1977), 9.

30. Ibid., 5.

31. Ibid., 5.

32. Ibid., 15.

33. Ibid., 17.

34. Ibid., 17.

35. For a description of *It's Still Privileged Art* see "Is It Still Privileged Art? The Politics of Class and Collaboration in the Art Practice of Carole Condé and Karl Beveridge" (1994) reprinted in this volume.

36. Hervé Fischer, "Sociological Art as Utopian Strategy." CEAC Collection, York University Archives.

37. Amerigo Marras, "Programme Notes for Artists' Space," February 26, 1977. CEAC Collection, York University Archives.

38. Reindeer Werk, "The Last Text: Some Notes On Behaviouralism," *A.C.E.* 4 (1977).

39. Peter Dunn, "Review: Performance," *Studio International* 193:983 (1976), 199.

40. Ibid., 199.

41. Amerigo Marras, text in *Behaviour School*, unpublished catalogue. CEAC Collection, York University Archives. (Versions of this text can be found in *A.C.E.* 4-7.)

42. Ibid.

43. Bruce Eves, text in *Behaviour School.*

44. Ibid.

45. Ibid.

46. Diane Boadway, unpublished diary of CEAC Tour. CEAC Collection, York University Archives.

47. Ibid.

48. "The Third Front," *A.C.E.* 6 (1977).

49. Unpublished transcripts from the Contextual Art Conference transcripts.

50. Amerigo Marras, "The Punk Scene," unpublished text. CEAC Collection, York University Archives.

51. Amerigo Marras, "Alternative Work Process," *A.C.E.* 9 (1977).

52. Ibid.

53. Unpublished description by Marras. CEAC Collection, York University Archives.

54. Editorial, *STRIKE* 2:1 (1978).

55. Tom Dean, "No Butter, No Butter," *STRIKE* 2:1 (1978).

56. Fred Forest, "Artistic Square Meter," *STRIKE* 2:1 (1978).

57. Quoted by Jay Scott in "The Young Turk of the New Philosophy," *Globe and Mail*, (May 10, 1978).

58. Jay Scott, "The Young Turk of the New Philosophy."

59. Ibid.

60. "Playing Idiots, Plain Hideous," *STRIKE* 2:2 (1978).

61. All citations for the Finale were taken from the CEAC Collection, York University Archives.

62. On Friday, December 30, 1977, the Toronto police raided the office of the *Body Politic* and seized twelve boxes of files, including subscription lists after the *Body Politic* published an article by Gerald Hannon entitled "Men Loving Boys Loving Men." Three people were charged under two obscenity statutes and subsequently acquitted.

This essay first appeared in *C Magazine* 11 (1986).

60 ¢

STRIKE

ART COMMUNICATION EDITION VOLUME TWO ISSUE NUMBER 1

THE ART OF NATION-BUILDING

CONSTRUCTING A CULTURAL IDENTITY FOR POST-WAR CANADA

The most "intrinsic" form of argumentation for government interven-
tion into cultural activities maintains that the promotion of culture is
necessary for national survival and that the state has a responsibility for
ensuring the survival of "artistic markets." Given "necessity" and a state
responsibility for the quality of life, this "meritocracy" argument is
clearly sufficient for state intervention into cultural activities, assuming
that intervention can increase the supply and consumption of the arts.
However, if there is no consensus within society on what constitutes the
"good society" with a high degree of arts activity, then the argument
can be reduced to a claim that some tastes are "better" than others. This
is an unacceptable basis for government action in a democratic society.
—Seven Globerman, *Cultural Regulation in Canada*, 1984.

To demand the preservation of the independent artist, the unique
integrity of the precious art object (outside of its historical entomb-
ment), the so-called autonomy of such bureaucracies as the Canada
Council, etc., is not just unrealistic but suicidal. This type of cultural
production belonged to the age of genteel colonialism. The issue at
point is not the privileges of the individual artist, but the social control
of cultural production.
—Karl Beveridge, "Goodbye Canada Council, Hello Bay Street," 1979.

In January of 1992, it seems as if the crisis of liberal ideology has
reached its terminal stage. The paternal policies of a post-war welfare
state that steered clear of socialism but ensured baby bonuses, branch
plant industries, and funding for the arts are being chipped away at
from all sides and angles. Global restructuring, corporate border-hop-
ping, regressive taxation, and an ever-tightening knot of recession are
exacting their toll. Government spending and loose fiscal policies are an

Ottawa no-no. Cutbacks and layoffs lead the evening news, sharing top spot with the latest developments in a rapidly shifting international map that has seen the dissolution of the Soviet Union and a United Nations sponsored-war in the Middle East in a matter of months.

In all of this ideological slippage towards free markets in theory and tightly controlled multinational enterprises in practice, it is no surprise that Canada's post-Second World War commitment to subsidized culture is under attack. After all, the federal government has already torn up the railway ties of Confederation's far more sacred cow. The arts sector, grappling with deficit budgeting, GST indigestion, burnout, and spiralling costs, responds to rumours of its own demise by evoking the immutability of national identity and cultural sovereignty, repeating like a mantra the terms of a debate over nation-building that constructed state patronage in the 1940s. But as battles over funding priorities heat up and the recession deepens, appeals to the vaguely reassuring balm of national identity may no longer, like abracadabra, open the secret door to people's hearts and government pocketbooks. With the Reform Party's populist vision of a country freed from government handouts spreading like prairie wildfire, Quebec's bid for independence rattling constitutional nerves, and the complex issues of identity politics and aboriginal self-government on a collision course with official multiculturalism, the concept of "national identity" is increasingly difficult to hold on to in the 1990s.

The Committee of the Privy Council have had before them a report dated April 7, 1949, from the Right Honourable Louis S. St. Laurent, the Prime Minister, submitting:

That it is desirable that the Canadian people should know as much as possible about their country, its history and traditions; and about their national life and common achievements;

That it is in the national interest to give encouragement to institutions which express national feeling, promote common understanding, and add to the variety and richness of Canadian life, rural as well as urban.
—*Royal Commission on National Development in the Arts, Letters, and Sciences*, 1949-51.

If an enlightened modern state will concern itself with the arts as an agency of promoting national unity through public spiritual welfare, there would appear little justification for concern, and no conflict with the principles of democratic freedom.
—Charles Comfort, *Royal Commission Studies*, 1951.

The questions that beg to be asked, of course, are: what actually lies behind the sanctified aura that links federal support of the arts to national identity, and links the centralization of cultural funding to the preservation of national unity? What were the motivations behind Louis S. St. Laurent's decision to appoint the Right Honourable Vincent Massey to head a Royal Commission on National Development in the Arts, Letters, and Sciences in 1949? What was the "national identity" that the Massey Commission sought to preserve or construct when it tabled recommendations leading to the founding of the Canada Council for the Arts in 1957 (with the considerable nudge of an endowment of $100 million from Atlantic Canada entrepreneurs Isaac Walton Killam and Sir James Dunn)? Whose culture and whose identity are we talking about anyways?

> The question of whether or not there exists an authentic and apprehendable spirit, symbolic of Canada and Canadian life, leaves no doubt in my mind…the characterful Canadian spirit [is] essentially northern, individualistic, conservative, loyal, independent, virile, and industrious.
> —Charles Comfort, *Royal Commission Studies*, 1951.

> The Canadian suffers, without realizing that he does so, from an ingrained sense of inferiority which is the inevitable consequence of history and geographical relationships…. He is reticent, a little puritanical perhaps, and decidedly unsure of himself. He takes no great pride in being Canadian; he accepts the fact without regret but is seldom disposed to shout it to the world. All of this should mean that Canadians are pleasant people to live with. It also means that we are hardly likely to create great art.
> —Edward McCourt, *Royal Commission Studies*, 1951.

In one sense, to ask these questions is to open the door to the debate over Canadian nationalism that dominated progressive cultural critiques in the 1970s. Susan Crean, in her 1976 book *Who's Afraid of Canadian Culture?*, is blunt in her assessment of arts funding in the late 1950s and 1960s. "The growth of the arts established during this period, and the Massey Report that paved the way for government subsidy," she writes, "may be regarded as the effort of an elite class of patrons to preserve its own cultural forms by transforming them into Official Culture."[1] Linking state-sponsored high culture (including traditional art forms such as ballet and opera and contemporary art validated by the metropolises of London, New York, and Paris) to government policy undermining Canadian control of mass media, Crean concludes that Canadians

are caught between "Official Culture, reactionary and colonial to the core, and the culture of U.S. imperialism."[2] In the context of government policy that produces cultural "inferiority and dependence,"[3] Crean suggests that appeals to the importance of the arts in the formation of national identity function as little more than a political smokescreen, leaving the creativity of Canadian society unrecognized and unvalued.

> The greatest need in Canada is for a unity of spirit over and above the great diversity of its life…. It would seem that the arts, because at their best they include the religious spirit, and because they touch the life of every individual in some degree, can be most effective in creating Canadian unity.
> —Lawren Harris, "Reconstruction through the Arts," *Canadian Art*, 1944.

> Though our material achievements are notable, our spiritual achievements are finer still. Considering what little respect most humans have for people of different races, cultures and religions, and considering the strife this causes elsewhere, Canada shines as an enviable model of tolerance and goodwill. Is it any wonder that the arts prosper here, that less fortunate people long to live here and that Canadians, through foreign aid, have shared their good fortune with the underprivileged and dispossessed. In the years ahead, it will be difficult to survive in a world dominated by competing superpowers and near superpowers. It will require struggle and strain to eliminate our society's imperfections. But as these 12 stamps remind us, a country with the strength of unity behind it, and a country with a record as outstanding as ours, can face the future with confidence.[9]
> — Canada Post Office Miniature Sheet, 1979.

In another sense, to pose questions about national identity and culture is to open a present-day Pandora's box of multiculturalism, adding to cultural "inferiority and dependence" the issue of cultural diversity and internal colonialism. Fifteen years after Crean called for reformulation of Canadian nationalism that would account for the "sensitivity to differences and regions that few other societies have,"[4] the creative roots of these differences are proving a less-than-unifying force. From the vantage point of ethnic communities, visible minorities, and First Nations, national unity constructed from subsidized culture pays lip service to difference while funding uniformity, invokes democracy while preserving the structures of elitism.[5] As it turns out, cultural subsidies are engaged not only in benign neglect, but also in active deceptions, constructing what Tony Wilden so eloquently describes as an

Imaginary Nation, where representations of Canada's national life and common achievements are "not the same as the country we actually live in, nor the land we know."[6]

> We have denatured our history, squeezed all the juice out, hidden the actors behind official masks and produced such a pallid show that we turn to other countries in search of adventure when our life has consisted of nothing else. We are, I suppose, a dull people by nature but we are not that dull.
> — Bruce Hutchinson, *The Saskatoon Star Phoenix*, 1949.

> We have listened to many interesting discussions on the significance of culture: "The greatest wealth of a nation," says a French-speaking group; of "equal importance" with bathtubs and automobiles observes a more cautious English-speaking counterpart.
> —*Royal Commission on National Development in the Arts, Letters, and Sciences*, 1949-51.

> The conclusion must be then that we have as yet no national history and no genuine consciousness of the past.
> —Hilda Neatby, *Royal Commission Studies*, 1951.

In a third and interdependent sense, to question the role of subsidized culture as the guardian angel of national identity is to engage in a questioning of history itself. In recognizing the distance that lies between official ideology and lived reality, one imagines that the past should reflect present contradictions, revealing a cultural legacy rich in conflict and rife with unaccounted-for ghosts. Yet despite the intensity of current debates over issues of representation and access, devolution and funding, the historical narratives constructed to house Canadian art remain remarkably one-dimensional, with the Massey Report held up as the defining influence in the creation of a national culture. Succinctly expressing the degree to which this watershed document overdetermines Canada's historical imagination, Paul Litt observes that "some nations develop a culture through centuries of accumulated custom and achievement; others forge an identity through revolution or war. Canada established a Royal Commission."[7] No matter whether one gazes at the crystal ball of history in order to dismantle or to preserve the status quo, the Massey Report stands as an act of divine submission: its promotion of state-funded culture as a strategy for nation-building establishing a "wide and substantial federal presence in the area of culture and the arts."[8]

The recommendations forwarded by the Massey Report were also deeply ideological, framed by opposition to the vulgar materialism of American consumerism and affirmation of European high art. The commission, expressing concern over the dependence of Canadian artists on American patronage through organizations such as the Carnegie Foundation and voicing a distrust of mass culture, drew a dividing line between art and popular culture, designating the former as Canadian and in need of state patronage, and the latter as American and subject to regulation. In so defining the parameters of national culture, the contradictions inherent in the commission's attempt to position subsidized culture as simultaneously anti-imperialist and anti-populist could only deepen over time. Current appeals for increased funding to the arts as the first line of defence in preserving national cohesion have failed to stem accusations of elitism from across the political spectrum. Audience surveys on arts funding demonstrate the generalized perception of an inherent class bias. Their findings indicate that "the type of culture [high/elite vs. popular/mass] considered worthy of support is dependent on the respondent's place in the socio-economic system,"[9] with the typical consumer of the arts well-educated and well-paid, adding fuel to a mounting attack upon cultural subsidy as a "regressive distribution of wealth."[10]

> The democratization of culture must not imply a dilution of standards; it is no longer a question of handing out "high-class" culture which is unfamiliar to the masses, but of enabling everyone, men and women alike, whatever their social origin or economic condition, to develop their personality to the full and to participate fully in cultural activities in accordance with their tastes and their needs.
> —UNESCO Cultural Policy, 1969.

> It all comes down to a fundamental difference in philosophy. We have some choices to make this weekend as to which way we swing. I don't think it's simply a matter of going for a little bit of corporate funding and trying to persuade government to keep the public funding in place. Either we have to argue for real subsidies to develop the arts so they're relevant to every community in this country, or we have to give up a tradition that others have established during years of struggle.
> —Sara Diamond, Halifax Conference on Canadian Cultural Policy, 1985.

> The interest of an elite at the expense of the majority of the population can hardly be justified on the grounds that they are for the "social good."
> —Steve Globerman, *Culture, Government and Markets*, 1987.

While it is difficult to argue against equity in funding—a position adopted by UNESCO, community activists, and neo-conservatives alike —it is equally difficult to endorse free-market mechanisms as the solution for cultural democracy, which Globerman does as a researcher for the Fraser Institute. Discussions of alternatives to this either/or scenario of subsidized culture for a few or free-market (read American) roller-coaster ride, however, are at an impasse. Attempts to raise issues of decentralization for funding and resources as a form of democratization evoke the spectre of cultural devolution and federal withdrawal of all subsidies to the arts. Claims for the importance of cultural subsidies to counter mass-market uniformity ring hollow when juxtaposed with rising tensions over the lack of cultural diversity in granting agencies, galleries, and museums. Proposals to shift the emphasis in evaluating artistic contribution from standards of professional excellence to community access run up against the "holding the dyke" theory, which assumes that altering the terms of funding would release a flood of requests, drowning funding bodies' capacity to respond.

Nowhere have assumptions about what constitutes cultural democracy and artistic practice surfaced more clearly than in recent attacks by Christopher Hume (the art critic for the *Toronto Star*) on Rosario Marchese (the Minister of Culture for the Ontario NDP). In an article entitled "Culture or Multiculturalism?" published on March 2, 1991, Hume responds to Marchese's initiatives to reflect cultural diversity institutionally by describing him as an "affable polyglot who came to Canada from southern Italy in 1961,"[11] and attributes his concern over community access to an instinct for social work. Noting that "Western culture, even as it has existed in Ontario for 150-odd years" has roots that lie in the "civilizations of Greece and Rome, neither particularly Anglo-Saxon," Hume dismisses as "pernicious nonsense" the perception of high art as Eurocentric and elitist. He scoffs at Marchese's suggestion that "we have a cultural bias in terms of what we mean by excellence" and accuses Marchese of reducing all cultural activity "to a kind of ersatz folk self-expression whose value is determined solely on the basis of its ethnicity." He concludes the article by suggesting Marchese's "misunderstanding of the nature of contemporary culture is profound." Through his comments, Hume not only reveals a personal antipathy towards community-based initiatives and cultural diversity, but also suggests the degree to which national culture as a whole has failed to assimilate the "complexities of and diversities of race, religion, language, and geography"[12] earmarked by the Massey Commission as integral to the Canadian psyche.

It is 44 years since Canadian artists met in Kingston and laid the foundations of national policy and growth. The foundations included: public support, as the cornerstone of arts and culture policy in Canada; the arm's length principle; the central role of the artists in the development and implementation of policy; commitment to the cultural integrity of the regions. The purpose of these foundations was to serve uniquely Canadian voices and visions, and we are proud of what Canadians have built upon them in the past four decades. Art and artists are no longer peripheral to Canadian life. They are at the heart of it. The future could hold even greater promise.
—Declaration of the Halifax Conference on Canadian Cultural Policy, 1985.

In 1985, when artists from across the country met in Halifax to discuss the future of Canadian cultural policy in the face of massive funding cuts by the newly elected federal Conservatives, issues of cultural diversity barely made it onto the agenda. The published proceedings indicate that the English/French divide was of primary concern to the participants, although multiculturalism was touched upon in one workshop entitled, "Culture or Cultures."[13] History, on the other hand, took centre stage. Several speakers—including Arthur Gelber, the founder and former chairman of the Ontario Arts Council, and Rick Salutin, writer and editor of *This Magazine*—noted the pivotal role that the 1941 Kingston Artists' Conference (as the first nationwide gathering of artists in Canada), played in establishing the cornerstones of a national cultural policy. Salutin, bemoaning "the case study in amnesia" that is the history of Canadian culture, emphasized the importance of the conference to the creation of the Canada Council for the Arts, which "came about partly because, 44 years ago in Kingston, a bunch of artists called a conference much like this one."[14] Gelber pointed to the formation of the Federation of Canadian Artists (headed by sculptor Elizabeth Wyn Wood, painter Lawren Harris, and conductor Sir Ernest Macmillan) during the Kingston Artists' Conference, and the pivotal role it assumed in voicing artists' concerns to government in the post-war period. The federation was the primary organizer of drafting the "Brief Concerning the Cultural Aspects of Canadian Reconstruction," presented to the federal Turgeon Special Committee on Reconstruction and Re-establishment in June of 1944. Gelber identified this brief as the impetus for the appointment of a Royal Commission on the Arts and suggested it contributed the groundwork for arm's-length public funding of the arts, in which funding is awarded by peer juries of artists.[15]

In a time of crisis and cutbacks, the artists participating in the Halifax Conference located a historical parallel for their contemporary struggles and a focal point for citing resistance in the Kingston conference. Oppositional voices had not exactly been uncovered, but at least the participants at the Halifax conference had identified artists rather than officially sanctioned documents as the driving force behind the initial drafting of a national cultural policy. In the final declaration of the conference, the participants aligned themselves with this history of art and activism, proclaiming that "just as Canadian artists at Kingston in 1941 opened the path for the development of public policy in the cultural sphere, the artists assembled here hope to re-open the process. We reaffirm that it is the cultural community that should initiate cultural policy, and that it is the role of the government to implement it."[16] What the Halifax Conference did not acknowledge or debate in claiming the Kingston Conference as a cultural precedent for their own activist agenda was that the Kingston artists had a very different objective in mind for government funding of the arts. While cultural communities currently under siege argue for an historical continuum linking centralization to the preservation of national culture, artists in the 1940s were arguing for the decentralization of culture through a system of community arts centres.

The one great possibility of integrating all of the arts with the life of our people, of evoking the creative spirit in our people into a rewarding life, is through the establishment of community centres for the arts all across Canada. In these, each community and region can be brought into living contact with the arts and thus be inspired to initiate its own cultural form, realize and individualize its regional environment and life and achieve a measure of inner freedom without which its life would have but little meaning. Herein we can have the essential complement to whatever regimentation the trend toward uniformity may impose upon us.
—Lawren Harris, "Community Art Centres—A Growing Movement," *Canadian Art*, 1944.

Some day there will be a Community Centre at Mud Corners. It will be a spot where nearby folk will gather to hear good music and to see good pictures and shows. A spot where children and grownups will learn to make pottery, to act in plays, to blow saxophones and trumpets, to paint, to sing. It will be a spot for baseball games and picnics and concerts and discussions. There will be many of these centres throughout Canada, and all of them will be focal points where

Canadians may find outlets for artistic urges and food for cultural
hunger…. All of this is to be the ultimate fruit of an acorn that was
planted on Parliament several days ago.
—Walter B. Herbert, *Ottawa Journal*, 1944.

The idea of a federally funded national network of community arts
centres, as conceived by Lawren Harris, emerged as a strongly articulated
goal in the artists' brief presented to the Turgeon Committee in 1944.
According to the details outlined in the brief, community centres, each
equipped with a theatre, movie projector, art gallery, and library, would
provide artists with local contexts for exhibition and community recog-
nition. They would also engage in an ambitious adult art education pro-
gram in order to build an informed audience for local and national
cultural activities. Much like the National Film Board of Canada, the
National Gallery of Canada would offer extensive outreach programs
and circulate its permanent collection to each of the community centres
on a rotating basis. As well, the plan called for a handicrafts office to be
located in the National Gallery. The response of the Turgeon Committee
was enthusiastic. Maria Tippett describes in her book, *Making Culture:
English-Canadian Institutions and the Arts Before the Massey Commission*,
how the community arts centre idea captured the Committee's imagina-
tion, especially given its potential to create an infrastructure that would
serve "the amateur and the professional; which made federal, provincial
and municipal governments financially responsible for culture; and
which addressed the problems created by central Canada's domination,
the country's vast size, and its reliance on foreign cultural producers,
organizers and philanthropists."[17] The press was also uniformly receptive
to the idea. Concerns voiced around issues of government intervention,
such as the *Globe and Mail*'s equation of public control of the arts with
the "single worst feature of the Nazi regime,"[18] were actually directed at
the proposal of a government body supervising cultural activity and not
at the "marvelous" idea of community centres. With the support of the
popular press and the endorsement of a range of organizations, from the
Labour Arts Guild of Vancouver to the Royal Architectural Institute of
Canada, and in tune ideologically with wartime mobilization and collec-
tivization of resources, the community arts centre idea enjoyed much
public discussion and increasing public support in English Canada dur-
ing the mid-1940s.

The community arts centre plan, however, had its enemies. O.H.
McCurry, director of the National Gallery of Canada, voiced his opposi-
tion to the idea, and provincial institutions such as the Art Gallery of

Toronto followed his lead. McCurry had his own plans for the reconstruction era in Canada, and these did not include the diversion of his gallery's resources and collections to favour decentralization and regionalist aspirations. The movement also failed to gain any significant support in Quebec, which identified a federal initiative of this scale as interference with the provincial jurisdiction of education.[19] In addition to opposition from the powerful lobby led by McCurry and hostility from Quebec, the community arts centre idea also ran up against a configuration of post-war federal politics. According to Maria Tippett, the appointment of the Massey Commission by the ruling Liberals was in direct response to groundswell of support for the socialist CCF (Co-operative Commonwealth Federation) party, which was spilling over its regional boundaries in the prairies and threatening the traditional Liberal party constituency in central Canada. In this context, Liberal funding of the arts was a strategic manoeuvre designed to upstage growing support for a CCF policy articulating the importance of national culture and national identity. In particular, Brooke Claxton, as the Minister of Defense under Louis S. St. Laurent, was adamant in stressing the need for a strong initiative regarding national culture that would defuse the CCF's "definite appeal to those Canadians who have a distinct national consciousness and feel that more should be done to encourage national culture and strengthen national feeling."[20] Given this configuration of partisan interests and the encroachment of the Cold War by the end of the 1940s, it is not surprising that the community arts centre plan, which encompassed the decentralization of culture and collectivist ideals, did not ignite the imagination of the Massey Commissioners in the same way it had their Turgeon Committee predecessors. That the community arts centre proposal was completely lost in the historical shuffle, however, does suggest the degree to which the recommendations that emerged from the Massey Commission have historically overdetermined our imagination of the past and impoverished our vision of the future.

Within the context of its ongoing long-range planning exercise begun two years ago, the Canada Council identified cultural diversity as one of the principle challenges facing it in the 1990s. Recognizing that Canada's artists come from an increasing diversity of cultural and racial backgrounds and work within a broad range of art forms, the Council wished to insure that its policies, programs and practices were appropriately responsive to the reality of contemporary artistic practice in Canada.
—Joyce Zemans, The Canada Council for the Arts, 1992.

In the context of current cultural debates over devolution and diversity, the materialization of the unaccounted-for ghost of the community arts centre plan is not intended to recast past omissions as future prescriptions. As much as the Massey Commission itself, the idea was bound to a historical context, to a time in which technology had yet to superimpose global images upon local contexts, and the social safeguards of Keynesian economics were viewed as anti-communist rather than proto-socialist. In today's world of structural-adjustment economics, virtual-reality war games, and one-empire hegemony, the parameters that frame the relationship of state and culture have altered dramatically. At the same time, however, the "complexities of race, religion, language, and geography" raised by the Massey Commission as central to the arts in the 1940s remain central to contemporary struggles over cultural democracy and access to public funding. Hopefully, the process of questioning a historical narrative that links the preservation of national identity to a centralist solution and the emergence of dissenting voices from the past create the potential to construct a future that accommodates rather than masks differences.

When the Massey Commission no longer functions as the crystal ball, into which artists gaze to predict a happy future for the arts in Canada, then perhaps the fundamental schisms between centre and periphery, high art and mass culture, official ideologies and lived differences that underlie our invocations to national identity can be acknowledged. When Canadian cultural history is viewed as multifaceted, in which regional, racial, and ethnic identities, First Nations self-determination, and colonial injustices are acknowledged as central to the formation of national identity, then perhaps we can move beyond the impasse of an either/or dichotomy that pits subsidized culture for a few against the onslaught of a mass-culture uniformity. If framed by a cultural legacy rich in conflict, the questioning of the rationales that underpin state funding of the arts would not be cast adrift in a sea of free-market zealots and disaffected publics. Rather, the process of questioning would resist a rigid conceptualization of devolution as an all-or-nothing battle to save national culture; it would insist that public support for the arts without an institutional diversification of culture can only serve to obscure our national identity and sound the death knell for state patronage.

Notes

1. Susan M. Crean, *Who's Afraid of Canadian Culture?* (Don Mills, ON: General Publishing, 1976), 123.

2. Ibid., 277.

3. Ibid., 277.

4. Ibid., 278.

5. For an overview of the debates over issues of cultural diversity see *Fuse Magazine* from the late 1980s and early 1990s.

6. Tony Wilden, *The Imaginary Canadian* (Vancouver: Pulp Press, 1980), 1.

7. Paul Litt, "The care and feeding of Canadian Culture," *The Globe and Mail,* May 31, 1991, A15. Also see Paul Litt, *The Muses, the Masses and the Massey Commission* (Toronto: University of Toronto Press, 1992).

8. Comments made by the Ontario Arts Council regarding constitutional policy, cited in *Parallélogramme* 17:3 (1991-92), 12.

9. I am referring here to the findings of a survey cited in Jeffrey Brooke, *Cultural Policy in Canada: From Massey-Lévesque to Applebaum-Hébert* (Ottawa: Library of Parliament, 1982), 26.

10. Steven Globerman, *Culture, Government and Markets: Public Policy and the Culture Industries* (Vancouver: The Fraser Institute, 1987), 40.

11. Christopher Hume, "Culture or Multiculturalism?" *Toronto Star* (March 2, 1991), H1, H7. All subsequent quotations by Hume are taken from this article.

12. *Royal Commission on National Development in the Arts, Letters, and Sciences,* 7.

13. Harry Bruce, ed. "You've got ten minutes to get that flag down": Proceedings of the Halifax Conference: A National Forum on Canadian Cultural Policy (Halifax: Nova Scotia Coalition on Arts and Culture, 1986), 69–73.

14. Ibid., 19.

15. Ibid., 23.

16. Ibid., 99.

17. Maria Tippett, *Making Culture: English-Canadian Institutions and the Arts Before the Massey Commission* (Toronto: University of Toronto Press, 1990), 173.

18. "An Acorn on Parliament Hill," no author cited. *Canadian Art* 2:1, (October-November 1944), 18.

19. Michael Bell, Introduction to *The Kingston Conference Proceedings* (Kingston: Agnes Etherington Art Centre, Queen's University, 1991), xv-xvii.

20. Tippett, *Making Culture,* 182.

Epigraphs and quotations cited by title throughout the essay are taken from the following sources:

Steven Globerman, *Cultural Regulation in Canada* (Montreal: Institute for Research on Public Policy, 1983) and *Culture, Government and Markets: Public Policy and the Culture Industries* (Vancouver: The Fraser Institute, 1987).

Karl Beveridge, *Spaces By Artists: 3rd Parallélogramme Retrospective*, (Toronto: ANNPAC/ RACA, 1978-79).

Lawren Harris, *Canadian Art* 1:5 (June-July 1944) and *Canadian Art* 2:2 (December 1944-January 1945).

Royal Commission on National Development in the Arts, Letters, and Sciences (Ottawa: Government of Canada Publication, 1949–51).

Royal Commission Studies, A Selection of Essays Prepared for the Royal Commission on National Development in the Arts, Letters, and Sciences (Ottawa: Government of Canada Publication, 1951).

Cultural Policy: A Preliminary Study (Paris: UNESCO, 1969).

Recommendations of the Advisory Committee to the Canada Council for Racial Equality in the Arts and the Response of the Canada Council (Ottawa: Government Publications, 1992).

This essay first appeared in *Parallélogramme* 17:4 (1992).

IS IT STILL PRIVILEGED ART?

THE POLITICS OF CLASS AND COLLABORATION IN THE ART PRACTICE OF CAROLE CONDÉ AND KARL BEVERIDGE

One of the problems today is that art exists as something "external." We use "universal" and institutionalized standards to evaluate the artwork, rather than considering how it affects a specific community, or gives "expression" to that community's needs.
—Carol Condé and Karl Beveridge

The Homecoming

On January 24, 1976, an exhibition of recent works by Carole Condé and Karl Beveridge, *It's Still Privileged Art*, opened at the Art Gallery of Ontario in Toronto. Since their decampment from Toronto to the New York City art scene in 1969, Condé and Beveridge had attained reputations south of the border as Minimalist/Conceptualist artists, and their homecoming was expected to bring local veneration for artwork already validated (in that inevitably Canadian way) elsewhere. To the surprise of the audience and the institution, however, the exhibition revealed a radical shift in aesthetic orientation. Rather than encountering sculptural works exploring questions of perception and materiality, the audience was greeted by large banners extending the length of the gallery walls with slogans announcing: "ART MUST BECOME RESPONSIBLE FOR ITS POLITICS" and "CULTURE HAS REPLACED BRUTALITY AS A MEANS OF MAINTAINING THE STATUS QUO." Underneath the banners, a series of silk-screened works featured the artists in various "heroic" poses transplanted from Soviet and Chinese workers' posters. In keeping with the unconventional nature of the exhibition, a bookwork designed in the style of Chinese comics was produced in place of the traditional catalogue.

The bookwork for *It's Still Privileged Art* served to document the artists' politicization and to question the underlying assumptions of an institutionalized art practice. Within its pages, cartoons illustrate the artists' everyday activities (their studio production, interactions with collectors and curators, the raising of their children) and trace the development of a visual strategy for the expression of art as a social practice. Short texts accompanying the cartoon images break open the hermetic seal of artistic discourse to provide discussion on a wide range of issues affecting art practice, from competition and individualism to gender inequality and cultural revolution. In one of these texts, Condé and Beveridge address the context for the reception of overtly political images, speculating on the reactions their work might provoke from the Art Gallery of Ontario audience. They imagine that some artists will find the work an embarrassment, "they'll fall on the floor laughing," while others will try to reduce their politics to fashion, "so now you're doing 'Political Art.'"[1] As it turned out, the actual exhibition proved more controversial and its reception more adversarial than Condé and Beveridge had envisioned. It was one thing to be an artist with politics. It was another matter altogether to make the transparent theme of an exhibition a call to social revolution.

Crossing the boundaries of "art" as defined by an international art market and breaking with conventions of form and content, the didactic nature of the exhibition met with hostility and silence. Written commentary tended to be dismissive in tone, with one local critic decrying their work as "a vapid and gullible recycling of someone else's propaganda."[2] For the most part, however, critique of the work took place around kitchen tables and to the artists' faces. Art pundits and colleagues alike attacked the use of agitprop and social realism as naïve and crude political posturing. Condé and Beveridge's insistence that a radicalism of ideas without a radicalism of society ended up reinforcing, rather than disrupting, the cultural status quo was interpreted as a betrayal by those artists who viewed participation in the art world as subversive rather than complicit. Touching upon issues of gender, class, community, and identity, *It's Still Privileged Art* no longer spoke the language of the art world and the connoisseur, but that of political activism and the *agent provocateur*. In so doing, it set the stage and the parameters for Condé and Beveridge's subsequent cultural practice. Taking seriously their rhetorical call for art to "become responsible for its politics," Condé and Beveridge returned to Canada at the end of 1977 to initiate a series of community arts projects with a focus on developing collaborative works with the Canadian labour movement.

By choosing the trade-union movement as a primary site of cultural production and reception, Condé and Beveridge sought to anchor the theoretical analysis of *It's Still Privileged Art* to an institutional space in which issues of class form a practical basis for organized resistance to capitalism. From their first collaborative project with a union, *Standing Up* (1981), a chronicle of female workers' fight to win a first labour contract, to *OSHAWA* (1983), a photographic history of United Autoworkers' Local 222, to *No Power Greater* (1991), an examination of the impact of globalization and technological change on the unionized workforce, their work reflects an ongoing commitment to grounding their images in specific political struggles between capital and labour, individualism and collectivization. Formally, this process has taken shape through the use of highly stylized photo-narratives that combine sets, props, actors, and photo-montage to stage oral histories of union members as told to Condé and Beveridge. Conceptually, these narratives provide an ideological space that is class-identified and community-based. Working in consultation with trade unionists to produce images that represent their point of view and their stories, and to circulate these images in their workplaces and union halls, Condé and Beveridge explicitly counter the effacement of class divisions endemic in both the mass media's populist appeal and the art museum's sanitized presentation of culture.

Setting the Political Stage

While *It's Still Privileged Art* signalled the future direction of Condé and Beveridge's representational strategy, it also reflected, Janus-like, the many debates over aesthetics and politics integral to the turbulent New York art world of the 1970s. From 1969, when Condé and Beveridge arrived in New York City, until their departure at the end of 1977, the SoHo art scene of downtown Manhattan was witness to the crumbling of a modernist orthodoxy. Formalist camps of hard-edge painting and minimalist sculpture ran aground against a dematerialization of the art object that encompassed everything from Andy Warhol's films to body art. Conceptualism as an art movement took hold, leading toward a cul-de-sac of language games in which the extrapolation of the idea from the object left artists owning concepts and spinning visual cobwebs. The art market, while adaptable enough to support the dematerialization of the object, went through its own convulsions in the wake of a recession precipitated by the oil crisis of 1973. A heady measure of anti-Vietnam War sentiment, Maoist ideals of cultural revolution, and feminism contributed to this ferment, as well as to the sense of the New York art world as a closed shop of aesthetic intrigues and jangling politics.

Like another famous Canadian art couple before them, Michael Snow and Joyce Wieland, Condé and Beveridge came to New York City in order to achieve recognition as "international" and "avant-garde" artists and were radicalized by the process of confronting this mythology. When Snow and Wieland returned to Canada, it was as cultural nationalists. Condé and Beveridge's embrace of community-based art and the labour movement reflected a similar anti-imperialist stance and, in addition, the influence of the feminist and Marxist debates unfolding in New York City during this period. For Condé, politicization began with her involvement in the ad hoc Women Artists' Committee, a group of New York-based female artists whose protests against the art world's systematic exclusion of women included weekly discussion groups, street actions, and a boycott of the 1970 Annual Exhibition at the Whitney Museum of American Art. On Beveridge's part, his friendship with the New York City component of a conceptualist collective, Art and Language, led to his participation in their increasingly politicized discussions concerning rhetoric and power. By 1975, both Condé and Beveridge were working through the implications of gender inequality on the home front and jointly attending editorial meetings for Art and Language's publication, *The Fox*.

Published three times before the group disbanded in 1976, *The Fox* is a rare artifact of the fractious and internecine political discourse that gripped SoHo in the mid-1970s. In its voluminous pages, artists such as Ian Burn, Joseph Kosuth, and Mel Ramsden thrash out the finer points of Marxist-inspired theory and ponder their role as non-proletariat petty-bourgeois artists with revolutionary sympathies. Editorial meetings often lasted for days at a time, with ensuing discussions about workers' consciousness and social transformation adroitly captured in a transcript published in the third issue of *The Fox* and entitled "The Lumpen-Headache."[3] By the time of *The Fox*'s demise, serious rifts had occurred between members of the collective, and splinter groups had formed over such issues as group hierarchy, the need to abandon individual artistic identities, and male chauvinism. Some members declared themselves anarchists and unwilling to submit to collective discipline. Others, including Beveridge, Condé, and Burn, sought to push the implications of a class analysis of culture further, producing another magazine, *Red Herring*, which was less theoretically dense and more historically grounded than *The Fox*. Surviving for only two issues, *Red Herring* featured articles on art and unions, Langston Hughes's poetry, denunciations of capitalist exploitation, calls for anti-imperialist strategies, and a comic strip by Condé and Beveridge.

In contrast with the otherwise solemn tone and earnest stance of the publication, Condé and Beveridge's comic strip offered a humorous testimony to SoHo's uneasy mix of art and politics. Thinly veiled autobiography, the cartoons underscore the tensions experienced by artists whose advocacy of a theoretically inspired socialism contrasts starkly with their day-to-day lives as middle-class consumers. While the cartoon characters themselves arrive at no resolution for their ideological impasse, the artists associated with *Red Herring* continued to struggle with the widening gulf between practice and theory. Some decided to abandon art altogether, leaving SoHo to work in factories and experience proletarian life firsthand. Others muted the pitch of their militancy and slipped into a lifestyle attached to the idea of revolution and to the comfort of SoHo loft spaces. Condé and Beveridge found themselves in Newark, working with a group associated with Amiri Baraka, an East Coast Black Power poet turned Maoist. It was at this point that the tensions between an articulated commitment to a politicized art practice and their displacement as expatriate Canadians became most acute. As Condé tells it, "One day we were deep in the Bronx, meeting with African American militants, when I looked around and realized it was time to go back to Canada and begin to build a local culture there."⁴

In *It's Still Privileged Art*, Condé and Beveridge's musings over the contradictions of "living in the middle of New York and talking about decentralization; showing at the Art Gallery of Ontario and talking about not being in institutions; living in the art world ghetto and talking about getting out and working in the 'real' world"⁵ led them to declare that their politicization as artists could have only taken place in New York City. Inversely, it was through engaging with the specific conditions of Canadian culture that Condé and Beveridge put into practice the political lessons learned during their eight-year sojourn in the United States. In the early 1980s, Canada was at once influenced by and distanced from the globalizing, free-fall economy of the United States, defending its sovereignty through state-supported culture and a state-brokered economy. Unlike New York City, with its art world's confluence of money and hype in ascendancy during the Reagan years, Canada lacked an internal art market. Moreover, the nature of Canada's entrenched funding of the arts mitigated the harshness of the New Right agenda felt more directly in the United States. Fleeing the influx of European painting that swept through the U.S. art market in the late 1970s, Condé and Beveridge headed north of the border to a cultural climate where arms-length arts councils and peer-assessment juries offered the potential to sustain a commitment to oppositional culture.

While the anomaly of the socialist cultural infrastructure existing within capitalist economy left Canadian artists less vulnerable to the vagaries of an international art market than their American counterparts, it also tied them more closely to the ideological constraints of state patronage. Funding for the contemporary arts, since the inception of the Canada Council for the Arts in 1957, was predicated on avantgarde notions of formal experimentation, originality, and individual excellence; and hostility to popular culture and community arts.[6] It was this contradictory inheritance of funding support and elitist rationales that Condé and Beveridge faced in their efforts to democratize the production and reception of their art within a Canadian context.

In choosing trade unionism as a site from which to democratize culture, Condé and Beveridge also had to contend with the historical legacies of the labour movement in Canada. From the Industrial Disputes Investigation Act of 1907, in which the federal government appointed itself as mediator for labour conflicts, to a Social Contract in Ontario in 1993 that imposed wage restraints on all public-sector union employees, the state has played a highly interventionist role in managing working-class militancy. Through legislation, government has sought to harness rather than oppose union authority. In return for collective bargaining and the right to association won in the 1940s, trade unions are expected to keep rank and file in line and to maintain shop-floor discipline. Welfare-state policies of the post Second World War era also soothed labour antagonisms through the introduction of concessionary wage increases, pension plans, universal health care, and educational subsidies. Since the time of Condé and Beveridge's return to Canada, however, this Keynesian harmony has come unravelled at the edges. Technological shifts in production, recessionary economies, and globalization of markets and labour are enacting a growing toll upon concessions wrung from reluctant employers, leading one labour historian to describe the years between 1975 and 1990 as "ones of permanent crisis."[7]

Constructing a Collaborative Process

Stepping into this history, and into this crisis, with their decision to produce work in collaboration with the union movement, Condé and Beveridge reflect in their art practice a complex negotiation of possibilities within a broad cultural and political framework. In their preface to *First Contract: Women and the Fight to Unionize* (1986), a book project based on *Standing Up*, a photo-narrative about the unionization of female workers, Condé and Beveridge offer an impression of how this process of negotiation unfolds. Describing their initial meetings with

union representatives, they note that when the word "artwork" comes up, union members are hesitant and puzzled. Assurances from Condé and Beveridge that "for us this means art about the lives of working people...how you yourselves see things,"[8] do not immediately ease a general distrust; nor does their explanation that the proposed collaboration has received arts funding from the Canada Council. For the union local, the idea of getting involved in an artwork is difficult to embrace. Historically, the largesse of subsidized culture has not benefited their community, while the idea of art carries with it an indelible stamp of class privilege. In order to create confidence in the process of collaboration, Condé and Beveridge have to not only convince the unions of their sincerity as artists, but also convince them that the end product may have some meaning and validity for their membership.

In practical terms, confidence in the collaborative process is developed through a specific framework of participation and clearly defined divisions of labour. When Condé and Beveridge first approach a union local with an idea for an artwork, they bring to the bargaining table several important components of the project. Primary funding for the production of the work is secured from arts-council sources rather than from union dues. The themes and directions for the proposed artwork are discussed and agreed upon in consultation with union members. In return, the union is asked to provide information resources, including access to its archives and permission to interview its members. Once the general parameters of the project have been established, visual interpretation of the material is entrusted to Condé and Beveridge. With creative control and copyright resting with the artists, Condé and Beveridge enjoy substantial leeway in the construction of their images.[9] The results are staged tableaux photographs that intentionally engage the vocabulary and visual style of advertising to sift oral history and archival evidence through the codes of popular culture. With hints of Brechtian theatricality, Soviet avant-garde photography, and social-realist iconography, their images also reflect formal devices present in earlier works such as *It's Still Privileged Art*. The resulting merger chips away at the perception that art is inaccessible and elitist, and seeks to recast a cultural equation that has the rich attending art galleries and the working class watching television with the production of an artwork that can be equally at home in a union hall or on an art gallery wall.

With their cultural perspective formed by modernist art training and an engagement with contemporary artistic and political debates, Condé and Beveridge's distinctive photo-narrative style is also shaped by the direct input and feedback of union members. For example, in their first formal collaboration with the labour movement, *Standing Up* (produced

with the United Steelworkers of America in 1981), the documentation of female workers' fight to unionize Radio Shack brought with it certain constraints. While the female workers were willing to be interviewed, and to discuss the difficulties, both emotional and political, of fighting for a first contract, they faced potential reprisals by the company if they could be personally identified in the work. Thus, in order to protect the women, Condé and Beveridge decided to recreate rather than document their experiences. Adopting strategies that subsequently became their trademark style, they shaped composite characters from individual testimonies and used actors and props to stage a visual narrative. Similarly, the artists' decision to clearly define the division of labour between union participation and artistic production originated in the responses of union members to a more hands-on collaboration. As Condé and Beveridge explain in *First Contract: Women and the Fight to Unionize*:

> A few years ago we were doing a project with women who were organizing a union. We had these vague notions about involving them in the actual production of the work until one of them pointed out: 'Look, we're skilled in what we do. We know what we're dealing with. You're skilled in what you do. I wouldn't know one end of a camera from the other and I don't particularly want to. As long as you do a good job, we'll do our part.' It wasn't that they weren't interested, particularly in the use of media, which they understood. It was that their time was taken up with the union, their job, and family.[10]

For Condé and Beveridge, the process of negotiation that frames their collaborative relationship with the labour movement stretches beyond the actual production of art works to encompass a variety of union-related activities. Prior to the formal collaboration with unions that began with their *Standing Up* project, Condé and Beveridge were involved in a drive to organize farm workers in Ontario, and in English as a Second Language programs, producing posters and pamphlets. Condé and Beveridge have continued these activities up to the present day, creating posters, buttons, and banners for a number of different union locals and activist concerns. In 1982, a number of artists and labour representatives, including Condé and Beveridge, attended a symposium sponsored by the Ontario Arts Council on the role of popular movements in the development of Swedish culture. Timothy Porteous, director of the Canada Council at the time, proclaimed from the floor that a community-based art practice did not exist in Canada, nor—given the fact of state support for the arts—should it have to. Prompted to action by this cavalier dismissal, Beveridge, Condé, and

other symposium participants retired to a local bar and founded the Labour, Arts and Media Working Group (LAMWG), dedicated to forging closer ties between the labour community and artists.[11] Working in cooperation with the Canadian Labour Congress, and later the Ontario Federation of Labour and the Labour Council of Metropolitan Toronto, this ad hoc committee has since spearheaded a number of activities, encouraging unions to mount exhibitions of contemporary art in union halls and workplaces and to sponsor art-related activities.

The most public manifestation of the LAMWG's promotion of community and labour-based cultural activity is the Mayworks Festival of Working People and the Arts, held annually in Toronto since 1986. A month-long extravaganza of music, visual arts exhibitions, cabarets, theatre, artists' talks, and gallery tours, it brings cultural activities into the unionized workplace and unionized workers to events held in the downtown gallery district. As founding organizers of Mayworks, Condé and Beveridge have been instrumental in its growth, lobbying the labour movement and the arts councils for funding support and facilitating various events over the years. In conjunction with the growing success of Mayworks, LAMWG has also succeeded in establishing an Artists and the Workplace Program at the Ontario Arts Council that funds collaborative projects between individual artists and unions. With projects ranging from archival photographic research to murals and theatre workshops, this program directly challenges the unspoken parameters of state support for the arts, which discourage a collectivization of resources (as opposed to individual production for the market) and a community-based culture. On the labour side of the cultural equation, Beveridge has also been active as a board member of the Workers Arts and Heritage Centre, an organization of cultural activists, labour historians, and trade-union members founded in 1986 to work toward the opening of a workers' museum in Ontario.

As a parallel to the inroads made by LAMWG into the infrastructure of the art world, Condé and Beveridge are also committed to organizing a collective negotiating voice for artists. Founders of the Independent Artists Union in 1984, they sought to formalize a bargaining relationship between state funding and artists, recruiting members on a platform of a guaranteed minimum wage for artists, unemployment and pension benefits, and legislative recognition of artists as cultural workers. Unfortunately, the union's failure to realize its goals led to its demise by the early 1990s. In its initial stages, however, the Independent Artists Union provided a political space for discussion around issues of gender and racial equity that are now central to debates concerning state funding and cultural diversity. At the peak of its activity as a lobbying group,

the Independent Artists Union was a key pressure point in the art coun-
cils' decision in the 1990s to prioritize access to funding for racial
minorities, and to incorporate community context and community
representation as legitimate considerations in the peer jury process.
Condé and Beveridge are also long-standing members of A Space, one
of Canada's oldest artist-run centres. In this capacity, they were instru-
mental in shifting the orientation of the gallery from a theoretically
based postmodernism to a community-based activism in the late 1980s.
Through their organization of a community-arts committee at the
gallery, and their support in incorporating different artistic expressions
such as dub poetry and political video into the programming agenda,
Condé and Beveridge made the local art scene as well as trade unionism
a conceptual space of cultural democratization.

By extending their involvement with trade unions beyond the pro-
duction of artworks to embrace the cultural and social organization of
the arts and labour movements, Condé and Beveridge construct an art
practice that is simultaneously self-reflexive and activist in conception.
Here, representation of a collective self-identity (in this case trade
unionism) is balanced by the artists' active engagement in shaping com-
munity involvement. Cultural production is anchored in a process of
reciprocity, which allows for dialogue and exchange, rather than remain-
ing limited to explication and appropriation. As Condé and Beveridge
suggest, there are many organizations for artists to work with: "churches,
community centres, political organizations, various social movements,
and so on…the main thing is that you identify with them, share the
same goals—or you can forget about the trust. It's important that you
feel a part of whatever organization or group it is."[12] It is these principles
of trust and reciprocity that form the ethical base of their community
art practice and mediate the form and content of their art works.

Constructing Representational Strategies

The importance of this reciprocal process of dialogue and exchange in
their work becomes clear when we consider an early photo-narrative
piece, *Maybe Wendy's Right* (1979). Completed before they established a
formal collaborative relationship with the labour movement, *Maybe
Wendy's Right* features Condé and Beveridge enacting a fictional scenario
of everyday "working-class" life. Without any direct input from or con-
sultation with the workers they sought to represent, however, Condé and
Beveridge ended up producing a pastiche of what they imagined the
working class to be. Speaking for rather than with their subjects, Condé
and Beveridge translated the domestic environment of the middle-class

artist couple from *It's Still Privileged Art* into one of an imagined working-class family. In *It's Still Privileged Art*, Condé worries about cleaning and cooking, although she wishes she were in the studio. The caption tells us that the serene breakfast-table scene we see in the comic "is not really like this. In fact their mornings are neurotic and tense, but it's an image they all maintain."[13] In *Maybe Wendy's Right*, domestic tensions are foregrounded in the visual narrative itself. Wendy and Bill worry about mortgage payments, the price of food, and whether Bill should go out on strike or accept a wage settlement worse than the old contract. In comparison to later works, *Maybe Wendy's Right* appears a crude representation of a working-class world. Its emphasis on the domestic setting, however, and its concern for the relationship between gender and class conflict highlight the importance of a feminist perspective for their cultural practice.

In subsequent works, Condé and Beveridge traded in their impersonation of the working class for the production of images that are mediated by oral history and union participation. In turn, they bring to their projects a sensitivity to gender issues that reflects their own experiences and struggles to work together as artists. As such, their collaborations with unions mirror a personal commitment to the collective process of questioning and discussion in their own art practice. The result is a dramatization of union stories that holds itself accountable for dialogue taking place at both the personal level (between the artists) and the political level (between the artists and the union local). As they construct positive and didactic portraits of the labour movement that explore the contradictions and conflicts of workers' lives, the content of the work reflects the dialectical nature of Condé and Beveridge's artistic process. Seeking to redress the absence of women in traditional labour historiography and to reflect their increasing presence in the workforce, Condé and Beveridge have chosen to emphasize women's roles in the labour movement, both behind the scenes and as frontline organizers. Their photo-narratives point to the importance of women in contemporary union militancy as well as to the tensions that occur as gender roles are redefined in the workplace and in the home.

In *Standing Up*, a feminist perspective is formally inscribed through a juxtaposition of staged settings, contrasting an interior space of domesticity with an exterior world represented by photographic inserts. In each of the three photo-narratives making up this piece, composite images are combined with first-person testimony in order to explore the dichotomies that fracture working-class lives and paradoxically give women the strength and determination to unionize. In the case of Natalie, her kitchen table becomes the visual focus of the narrative,

while photographic scenes of the job site and striking women are mapped onto a picture window in the background. A single mother, Natalie voices her concern over the effects that her working conditions and the violence of the strike have had on her children, who are harassed at school by the manager's kids and on the telephone at home by union busters. Linda, whose story unfolds in the company washroom, is in conflict with her husband over her union activities. Here, the bathroom mirror becomes a window for the imaging of external forces, with photographic scenes revealing confrontations with her husband and the solidarity of her fellow female workers on the picket line. The situation of Vicky, seen working alone in the photocopy room with photographs of the company boss appearing above her on a television screen, exemplifies the company tactic of isolating workers.

OSHAWA similarly privileges the domestic environment and a female point of view as it retells the history of the United Autoworkers' Local 222 in Oshawa, Ontario, the centre of Canada's automotive industry. Divided by decade into five sections covering 1934 to 1984, *OSHAWA*'s narrative structure hinges upon the dramas that unfold in the workers' kitchens and living rooms over union organizing, the intrusion of technological change in the home and on the shop floor, and the internal struggles faced by the union during the Cold War. With intensive archival research and over thirty interviews conducted during the project, Condé and Beveridge discovered that despite the fact that one-sixth of the workforce consisted of women, there was no photographic evidence of their existence. In response, Condé and Beveridge took as their central organizing theme a trajectory tracing the roles of working women from kitchen-table organizers in 1934 to frontline workers on the assembly line in the 1980s. Here, the mapping of exterior upon interior spaces and the use of period props make explicit the relationships not only between gender and ideology, but also between culture and consciousness. In the photographs depicting the post-Second World War period, for example, Condé and Beveridge's tableaux represent the chill of Cold War ideology and the rise of a mass culture that released women from wartime factory jobs to return them to homes filled with supposedly labour-saving appliances and television sets. In contrast, an image representing 1959 identifies another casualty of the Cold War. In it, a union boss from the American head office accuses local members of communist sympathies while pushing up a window blind to unveil a painting that reveals the predominance of American Abstract Expressionism over local Canadian art.

Exploring the Contradictions of Class and Ideology

This visual exposition of the ways in which technology and culture inter-twine to enforce an ideological status quo in a post-industrial society is also central to a 1986 work addressing the nuclear-power industry, *No Immediate Threat*. In contrast with most of their photo-narrative proj-ects, *No Immediate Threat* was not a direct collaboration with a union local, but grew out of a summer theatre project written and produced by Catherine MacLeod. Following upon their work as visual consultants on MacLeod's play, a community-based production about the everyday lives of the nuclear-plant workers in her hometown of Kincardine, Ontario, Condé and Beveridge expanded the stories they heard to produce a proj-ect examining the unspoken tensions and unmentionable environmental hazards that shadow the lives of these workers. Perhaps owing to the fact that they are some of the highest-paid unionized workers in Canada, nuclear-industry workers form a tight-knit intergenerational group whose routine exposure to radiation is accompanied by a collective denial of the health risks they face and acquiescence to company safety standards. Choosing to focus on this denial as the central trope of the piece, Condé and Beveridge address the ways in which ideological con-tradictions are internalized and reproduced, in this case literally slipping under skin and into the cells of the nuclear-industry workers.

Visually, *No Immediate Threat* is the most striking and evocative of their photo-narrative works, incorporating social and political refer-ences that reach beyond the specific environment of these workers to address the global context ushered in by the nuclear era. Using painted backdrops, props, and photographs, Condé and Beveridge create a free-form spatial field in which cultural icons and historical references bump up against each other like particles in a cloud chamber. Einstein and Freud make appearances here, as does a United Nations flag and Play Zap, a board game designed by Ontario Hydro to give to visitors tour-ing its nuclear plants. Almost baroque in its effect, *No Immediate Threat* is thick with allusions to twentieth-century narratives of science and progress, technology and prosperity. By weaving these narratives through the twin sites of the nuclear family and the nuclear industry, *No Immediate Threat* exposes the industrial dream of unlimited resources and rising profits as an illusion. The end of modernism, with its attendant belief in a utopian future, is bathed here in a translucent radioactive glow. Juxtaposing the symbols of a brave new world with unfolding familial arguments over dose limits and radiation showers, Condé and Beveridge point to the working class as frontline casualties in a new era of nonrenewable resources and global restructuring.

In choosing to depict union history and union struggles within this shifting cultural landscape, Condé and Beveridge straddle modernist and postmodernist approaches to a complex intersection of ideology and representation. On one hand, their narratives are informed by a modernist desire to assert a representation of the working class that is absent from the dominant culture of North America. On the other, their visual vocabulary of montage and juxtaposition signals a postmodernist impulse to interrogate structures of representation as complicit in the construction of economic and social realities. The competing paradigms incorporated in their work raise several issues about the strengths and the limits of the work's reception. Locating in culture a key site of political contestation and in trade unions an arena of political intervention, Condé and Beveridge's photo-narratives have the potential to function at cross-purposes. The institutionalized nature of their artistic collaboration could lend itself to the production of "official" images for the labour movement that end up serving as a new cultural authority rather than as a grassroots mediation. At the same time, their use of an artistic vocabulary to represent working-class issues is potentially alienating to an audience that has internalized a populist MTV culture. Restaging the issue of class as a cultural as well as economic and social category, Condé and Beveridge perform a difficult balancing act between criticality and intentionality, running the risk of slipping into cultural prescription and a reification of working-class struggles.

Confronting the New World Order

While the working process of dialogue and outreach developed by Condé and Beveridge provides a safeguard against such risks, the geopolitical and economic changes of the 1990s threaten to destabilize the balanced approach they have worked so hard to achieve. As nationalist aspirations and ideological bipolarity give way to a post-Cold War era of globalization, capitalism, in the words of political theorists Scott Lash and John Urry, is being "disorganized."[14] In a global context, the net effects of this disorganization include the de-unionization and transnational exploitation of labour, the decentralization of capital, the dismantling of the social safety net, and the decline of traditional sectors of organized labour such as the manufacturing industries. In the local context, the cultural and political infrastructures that frame the production and reception of Condé and Beveridge's work are in crisis and under siege. With state intervention in the public sector in full retreat, cultural funding in Canada is being squeezed and scrutinized. Private-sector industries are being downsized and restructured. Public-

sector industries are being cut back and privatized. The traditional
power configurations that support trade unionism as an organized site
of class resistance are being eroded and disarmed. Correspondingly, the
equations of art and politics, class and culture, representation and
resistance that Condé and Beveridge have so carefully negotiated over
years of collaboration no longer add up in quite the same way.

As they confront the fallout from this global restructuring, Condé
and Beveridge have focused, in their most recent works, on the ways in
which corporate culture has appropriated and transfigured representa-
tions of class struggle. Both *No Power Greater*, completed with the
Canadian Auto Workers in 1991, and *Class Work*, an educational book
project produced for the Communications and Electrical Workers of
Canada in 1990, take as their central theme management's imposition of
the "team concept" on the shop floor. A reconfigured Taylorism, the
team concept replaces the regulation of work through production quotas
with ideological persuasion. Rather than answering directly to a boss,
workers are encouraged to monitor each other's productivity and to par-
ticipate in a team effort to eliminate inefficiencies (with the unstated
costs being their jobs and their union seniority). For example, in 1990
and 1991, McDonnell-Douglas, the aerospace company that is the sub-
ject of *No Power Greater*, mailed a video to every worker's home extolling
the virtues of empowerment through the team concept. Appropriating
the political language of union organizers and the visual codes of televi-
sion, McDonnell-Douglas's video portrayed management on the same
side as workers, urging them to work cooperatively with the company to
increase their productivity and the company's profitability.[15]

In response to this barrage of old-fashioned scientific management
dressed up in high-tech wrapping, the photo-narratives of *Class Work*
and *No Power Greater* seek to expose the consequences of being a team
player. Homelessness, underemployment, and fear are represented as
the endgame of corporate restructuring. Union organizing is posed as a
form of collectivized opposition to a corporate reconfiguration of
labour. On the visual level, Condé and Beveridge downplay the advertis-
ing look and the formal constructivism of earlier works, choosing to
counter the slickness of the corporate soft sell with hand-painted sets
and cutout figures reminiscent of nineteenth-century working-class
graphic and vaudeville stage traditions. Mapping onto these homespun
sets highly manipulated and digitized images of computer-driven
industries, Condé and Beveridge create a visual metaphor for the transi-
tion from an industrial to an information society. In suggesting how
nineteenth-century labour radicalism has been papered over by a mass-
consumer culture, their photo-narratives assert a representational field

that is diametrically opposed to the seamlessness of the corporate spin-doctor. Here, intentionality is privileged over criticality, and a modernist strategy of intervention is proposed in place of a postmodernist interrogation of corporate culture.

Pulp Fiction, completed in 1993 in collaboration with the Paper-workers' Union, extends this visual logic of hand-painted sets and cutout figures to chronicle an agitprop history of a pulp and paper mill in northern Ontario. Taking as its central focus the ways in which corporate culture positions the working class as an obstacle to a progressive agenda of change and innovation, *Pulp Fiction* addresses current political tensions in the Canadian forestry industry, where the jobs of unionized workers are pitted against the struggles of environmentalists to preserve natural resources. While not downplaying the environmental importance of issues such as clear-cutting and acid rain, Condé and Beveridge counter the negative media image of forestry workers as rednecks hostile to the environment by tracing the ways in which the pulp and paper union has attempted to work, both historically and in a contemporary context, to protect the environment. Like *Class Work* and *No Power Greater*, *Pulp Fiction* examines the paradoxical position of class as a site of resistance to global capitalism, in which labour, as a locus of collective organizing, is increasingly fragmented and associated with an anachronistic world-view.

The political and cultural stakes of a labour-based art practice have increased considerably since Condé and Beveridge first started making collaborative work with the trade unions in the early 1980s. In a corporate culture where unionized workers have come to embody a paradigm of organization that is politically and economically redundant, Condé and Beveridge are battling for image recognition in an increasingly hostile field of representation. In response to the obstacles they face as activist artists producing class-identified narratives, Condé and Beveridge have not succumbed to the malaise of a postmodern syndrome that equates the end of history with the end of social activism. On the contrary, with one foot in the union hall and the other in the art world, Condé and Beveridge counter an aggressive corporate takeover of culture with a persuasive reminder of the importance of collectivized resistance and a collaborative cultural practice. Their works, easily reproducible, easy to transport, and easily transformable into educational pamphlets and books, become conceptual counterpoints to a global capitalism that slips across borders with ease and infiltrates consciousness. Taking the union local as their immediate site of cultural representation, and the social and economic effects of globalization as their subject, they not only record union history and culture, but also become advocates for cultural

opposition and political consciousness-raising. In so doing, the question Condé and Beveridge posed almost twenty years ago of whether "it's still privileged art" remains a pressing one. In the context of the fault lines of a globalizing economy and homogenizing ideology, the community-based representations they produce erect an image barricade against the onslaught of a cultural corporatism that seeks nothing less than the eradication of class consciousness.

Notes

1. Carol Condé and Karl Beveridge, *It's Still Privileged Art* (Toronto: Art Gallery of Ontario, 1976), unpaginated.

2. Walter Klepac, "Carole Condé and Karl Beveridge," *Artscanada* (April/May 1976).

3. Peter Benchley, "The Lumpen-Headache," *The Fox*, 3 (1976), 1-39.

4. Carol Condé, interview with the author, May 1994.

5. Condé and Beveridge, *It's Still Privileged Art*.

6. For further analysis see "The Art of Nation-Building: Constructing a Cultural Identity for Post-War Canada" in this volume.

7. Bryan D. Palmer, *Working Class Experience: Rethinking the History of Canadian Labour, 1800-1991* (Toronto: McClelland & Stewart, 1992), 405.

8. Condé and Beveridge, *First Contract: Women and the Fight to Unionize* (Toronto: Between the Lines, 1986), 13.

9. This leeway extends to the dimensions of the images themselves. Although the size of an individual panel in one of the photo-narrative series is typically sixteen by twenty inches, the scale of the work may be larger or smaller according to the project for which it is being produced.

10. Condé and Beveridge, *First Contract*, 15.

11. LAMWG's membership was constituted with equal representation from labour organizations (CUPE, CLC, ACTRA, CAMERA, LCMT, OFL, and USWA) and the artistic community (Karl Beveridge, Steven Bush, Tish Carnat, Carole Condé, Rosemary Donegan, Catherine MacLeod, Richard McKenna, Simon Malbogat, and Kim Tomczak). For more information see Susan Crean, "Labour Working with Art," *Fuse Magazine* 10:5 (April 1987), 24–35.

12. Condé and Beveridge, *First Contract*, 15.

13. Condé and Beveridge, *It's Still Privileged Art*.

14. Scott Lash and John Urry, *The End of Organized Capitalism* (Madison, WI: University of Wisconsin Press, 1987), 2–7.

15. Carole Condé and Karl Beveridge, "In the Corporate Shadows: Community Arts Practice and Technology," *Leonardo* 26:5 (1993), 451.

This essay first appeared in *But Is It Art? The Spirit of Art as Activism*, edited by Nina Felshin. Seattle: Bay Press, 1994.

TESTIMONY

CULTURES OF CONQUEST/
CULTURE IN CONTEXT

The journey was to the Beyond and not to the Museum
 but in the glass case of the Museum
the Mummy still squeezes her pouch of grain
 in her dry hand.
—Ernesto Cardenal, *The Economy of Tahuantinsuyu*

The difficulty of knowing history (one's history) provokes
the deepest isolation.
—Edouard Glissant, *Caribbean Discourse*

Freedom. It isn't once, to walk out
under the Milky Way, feeling the rivers
of light, the fields of dark—
freedom is daily, prose-bound, routine
remembering. Putting together, inch by inch
the starry worlds. From all the lost collections.
—Adrienne Rich, *For Memory*

Preamble

Exile…expulsion…deportation…dispersion…acculturation…assimi-
lation: these are words that dislodge identity, utterances formed by the
vast deterritorializations of a colonial enterprise; these are the legacies
of a modernist paradigm, the ruptures of a once linear march towards a
future perfect progress. Like the return of the repressed, voices emerge
from the naming of these words that speak to a history of dispossession
and profound disorientation. They describe a contemporary global
condition of barriers and borders, of subterfuge migrations and forced
immigrations. From their whispers materialize the aftershocks of a
technological will to power. Memory intervenes, no longer Proustian,
soft and entangled, but sharp with indignation, uprooting the burial
grounds of culture. Born of dust and carried on the wind, this memory

becomes a key to the puzzle of postmodernist fragmentation, a phantom companion sifting through the ruins of representation to uncover other stories, other imaginations.

The emergence of memory as a mirror of history's instability rather than of its certainties has seeped into my writing over the last years. It has provoked me to interrogate my cultural assumptions and inherited ideas, and shaped the direction of the talk transcribed below, which I gave as part of YYZ Artists' Outlet's *Towards the Slaughterhouse of History* lecture series held in May of 1991. In preparation for the talk, I decided to trace the history of conquest through a mapping of European thought upon the "uncharted" space of the Americas, and by extension the banishment of indigenous histories from the world stage. The results of the process, I speculated, would reveal some of the implications that the invention of the New World would have for a writer or artist seeking to interrogate dominant culture. The talk that emerged, however, was less a record of a mapping than an exploration of the difficulties encountered during the process itself. As spoken act, it expressed the hesitancy of an "I" who had uncovered in the intersections of colonialism and memory issues of identity and of location.

"The spoken narrative," writes Edouard Glissant, "is not concerned with the dead. We stand our mouths open under the sun like bagasse, silenced from elsewhere."[1] As conversation or storytelling, gossip or mythmaking, speech is alive, circular, dreaming, remembered. When written down, it is transformed by the act of preservation, finalized like the engraving on a tombstone. This tension between spoken narrative and written text finds a parallel in the tension between oral and written history. To rifle through history is to discover narratives of resistance ripped from their cultural roots, pressed into ideological gridlocks, silenced by the recorded past. To hear the cadence of the colonized, to defuse the authority of the conqueror's story, becomes the struggle underlying any attempt to comprehend the legacies of colonialism. It is, in Glissant's words, "a struggle against a single History for the cross-fertilization of histories" that "means repossessing both a true sense of one's time and identity."[2] And it is a struggle that I sought to engage that evening at YYZ.

Speaking

In speaking here tonight, I would like to explore with you an attempt I have made in the last months to understand where my location is, here, in this city; what my relationship is to both a local and global culture; and how I perceive my past and future as a writer. The impetus for this investigation and self-examination arose from a decision I made in 1989

to go to Nicaragua, a country in which a revolutionary process had been unfolding since the Sandinista National Liberation Front (FSLN) came to power in 1979. I went for a number of reasons. For some time, I had been working towards an understanding of what it might mean to live in the Americas; not to live solely in Canada, nor to live beside the United States, but to live within a context framed by a north/south axis: looking towards Latin America and a post-colonial future rather than backwards to Europe and an imperial past. Within this broad framework, I was specifically interested in exploring issues of media representation and the interrelationship of culture and ideology. Thus when the opportunity arose to extend the range of this research through an affiliation with the *Agencia Nueva Nicaragua*, an independent but pro-Sandinista news agency in the capital city of Managua, I decided to travel there to analyze the role of media in the Nicaraguan election of February 1990.

My arrival in Nicaragua in October of 1989 was timed to coincide with the official opening of the election campaign. It was also in sync with a sharp escalation in counter-revolutionary activity. Almost immediately following the triumph of the Nicaraguan Revolution on July 19, 1979, the United States of America initiated a covert war against the left-wing Sandinista government through the illicit funding and training of counter-revolutionaries (Contras) in adjacent Honduras. In 1987, the Esquipulas II peace accord was signed by the leaders of the five Central American countries in an attempt to broker an end to this illegal proxy war, which had brought political instability to the region, wrought economic ruin in Nicaragua, and resulted in countless deaths of innocent civilians and Sandinista soldiers alike. As part of the peace accord, the Sandinista government agreed to a ceasefire and to a national election monitored by the United Nations. The week after I arrived, however, the Sandinista government lifted the ceasefire in response to an increase in Contra aggression. The election campaign I had come to observe would now be conducted under the pallor of war, conducted under enemy fire.[3]

A month after I arrived, the Berlin Wall fell, and a global order based on the bipolar ideology of the Cold War began to unravel. By Christmas, when the United States invaded Panama and tanks encircled the streets of Managua in fear that Nicaragua would be next, it was clear that a political process intended to bring stability to Central America had been engulfed in an atmosphere of global destabilization and uncertainty. Just the same, no one predicted that the Sandinistas would lose the election. Everyone was convinced that they would win. The election was to be the last battle of the revolution: a triumph on the electoral front that would politically sanction a guerrilla war that had toppled the corrupt American-backed regime of the Somoza family and

brought land reform and literacy to an impoverished countryside. I suppose the day that the Sandinistas lost the election was the day that my ideological and political paradigms started to fall apart. A lot of illusions, and ideals, were called into question with the result of that election on February 19, 1990. Since that day, I have been engaged, like many other intellectuals in the Americas, in a process of reconceptualizing my place in the world.

Let me contextualize this further in terms of my experience of Nicaragua. To live in Nicaragua during the election process of 1989 and 1990 was to live in one of the hot spots of the Cold War at a time when the Eastern block was crumbling. The Nicaraguans I met were very cognizant of their position within this global structure and what the implications of the dissolution and reformation of the Eastern block might be for their local context. A taxi driver in Managua explained it like this. "If you are living in a Third World country," he told me, "you only have a couple of choices of allies to help your country survive: the Soviets or the Americans. It looks like the Eastern block is going down so basically we don't have much of an option of whom we can vote for. If the Sandinistas win, who is going to help them anyways?"

Months after this conversation with the taxi driver, I am still wondering what the Sandinistas would have done if they had won the election. What could they have offered the people as a "socialist" government with the entire infrastructure of the country falling to pieces and international aid solely dependent on the Americans? When I went to Nicaragua, I believed that the socialist experiment the Sandinistas had undertaken—with its emphasis on a mixed economy, state funding for basic social needs, and an electoral process—was a viable alternative to late capitalism. In the context of the north/south divide, I believed that the Sandinista model of political self-determination and opposition to American dominance in the hemisphere would be victorious. History proved me wrong. In many ways, this talk is a response to the electoral defeat of the Nicaraguan Revolution and the present impossibility of envisioning socialism as an alternative to capitalism. It is about reconceiving a culture of opposition as a culture of resistance. In so doing, it is predicated on the belief that such a reorientation has a lot to offer for the understanding of culture in a paradoxical place at the periphery and at the heart of the American empire: that place called Canada.

When I returned to Canada from Nicaragua, I imagined I would return to an environment of relative calm. I thought, it's falling apart in Managua, but Canada will be less volatile. I arrived back in time to watch the Meech Lake proceedings unfold. I sat glued to the television for a whole week. I thought I had just landed on another planet, watch-

ing men in suits behind closed doors decide the "democratic" future of a country. Then I became a prime-time television witness to the Oka crisis. For a brief moment, the anger and frustration created by a collective memory of colonial oppression was catapulted into the media spotlight. On the six o'clock news, First Nations history and issues of self-determination were at the heart of a Canadian debate over identity. Then, just as quickly as the media window opened, it closed, and First Nations memories and voices disappeared from the news. They were swept away by the Canadian army and by the military build-up to the Gulf War. When the Gulf War began one year after the Sandinista election defeat, it seemed not only as if my paradigms of opposition had collapsed, but that the possibility of conceiving a culture of resistance was in jeopardy.

The Gulf War meant many things to me. It meant that history could be video-programmed in advance. It meant that watching a war on television in which nothing happened except missile traces that looked like fireworks and simulated bombing raids had become a form of popular culture. Operation Desert Storm, as a carefully crafted media event, had no need of a litany of facts and figures and dates; no need to register civilian casualties or mounting death counts. The script had already been written in vague and reassuring tones, the confrontation signed and sealed with American technology. In the Gulf War, the ghost of hegemony materialized. The neutralization of experience became a theme repeated across the body politic, across continents, across the body's skin. There were now a hundred ways to describe poverty without human misery, one thousand ways to image war without a hint of human suffering. Signalling an ideological and military victory for the American empire, the war also signalled a triumph for a global simulacrum in which war had been pre-scripted, narratives of resistance preempted, and all we did in Canada was watch it unfold on television.

In late January 1991, I attended a forum on the Gulf War at the University of Toronto, hoping to escape for a few brief hours from the media web of images that extinguishes dissent and forecloses critique. I learned from the panelists that I would glean little information from the media, or from Pentagon sources, or from the panelists themselves. They could speculate that two to five percent of all information we receive through formal channels of communication is accurate, but they had no more access than I to a privileged site of power. It is my belief that this manifestation of a technological paradox, in which a myriad of communication structures reveals a lack of information, will become one of the contested sites of history in the 1990s. American imperialism trumpets its technological superiority through the mass media, but also hides behind this seamless ideological screen its geopo-

litical weaknesses. The absence of information can mask the human costs of the Gulf War, but it cannot conceal indefinitely the social and economic consequences of global restructuring.

In other words, the triumph of the American Empire is propped up and artificially inflated by the ascendance of two universalizing languages: the language of mass entertainment, of CNN news and Hollywood movies; and the language of elite economics, of neo-liberal market reforms and structural adjustments. It is the simultaneity of these two languages, superficially unrelated but deeply intertwined, that constructs a new world order from the ideology of popular culture and its economic disarticulation. It is the coexistence of these two languages that means roses are grown in Zaire to meet balance-of-debt payment schedules and buy consumer goods while people in the countryside starve. It means that a corpulent president conducts a hunger strike on national television in Panama in order to pressure the United States to lend it the three hundred million dollars promised in the wake of the invasion. It means that in Ethiopia, tobacco is growing in lush, irrigated fields about half an hour's drive from the scenes of famine we view on television.

As far as I can ascertain, the effects of structural deprivation and media opulence construct a culture of conquest no more civilized or humane than that of the Spanish conquistadors, long relegated to a distant barbarous past. In this light, the quincentennial of Columbus's "discovery" of the Americas would seem to offer an opportunity to cross-examine the trajectory of conquest: to ask how the legacies of colonialism inform the present. In the shadow of global capitalism, with its intricate mesh of margins and centres, of ethnicities and class antagonisms, the answers would seem to lie in the origins of the European imperial enterprise. Answers, however, are not forthcoming in any of the commemorative events organized by European and American governments for the next year.

Let me offer you a sneak preview. In 1992, the United States is planning to spend eighty million dollars celebrating the historic significance of 1492. Spain is spending eight hundred million dollars to honour its glorious role as the "discoverer" of the Americas. IBM is sponsoring an exhibition called *Encountering the New World*, which features European artefacts, European documents, European maps, and European woodblocks. One of the more original contributions is a private initiative to marry the Statue of Liberty and the Columbus Monument in Barcelona. The engagement party for this "Marriage of Two Cultures" has already taken place, with the display of a hundred-foot dress made of 2,500 yards of shiny turquoise polyester. The honeymoon is planned for Japan.[4]

Faced with this absurd contrast, in which the First World throws lavish parties at the centre of the empire while imposing restraint packages

upon countries in the periphery, I thought I should undertake what the Caribbean writer Edouard Glissant calls "an inventory of reality," take stock of contemporary conquest through a re-examination of its historical underpinnings. When I first began to piece together this inventory, I thought the "discovery" of the Americas would provide the logical point of departure. I imagined the conquest to be the narrow entrance of a vast estuary of history, in which five hundred years of colonialism and conflict fanned outwards from its mouth like rich alluvial silt, settling into sedimentary deposits over time. In conceiving of history as layered rather than linear, I imagined I only needed to unearth the buried fragments of the past in order to construct an alternative to a narrative of Western supremacy. Yet as I began to retrace the "discovery" of the New World through the literature written on the subject, a nagging sensation of circularity, a familiar Eurocentrism, began to permeate my investigation.

From Antonello Gerbi's project to chart the "assimilation of America in the European conscience"[5] to John Elliott's claim that "by 1600, having conquered America and brought it within the confines of his intellectual world, the European could survey the earth with pride, confident in his own spiritual and technical superiority, his military capacity and his economic power,"[6] America and its indigenous populations are held captive to a European world-view. From Edmundo O'Gorman's *The Invention of America* to Tzvetan Todorov's *The Conquest of America*, the ascendancy of an Enlightenment project rather than a confrontation with "difference" is central to the interpretation of America's "discovery." For these writers, European events and European philosophies—from the Renaissance to positivism and from the Reformation to Darwinism —have mapped a "new" world from uncharted space.[7]

My attempts to circumvent this Eurocentrism by turning to a postmodernist critique of Western thought met with a similar elision of the cultural "other." Michel Foucault, for example, names the French Revolution as the site of the ideological rupture moulding modern historical consciousness, banishing the issue of colonialism to the margins of his genealogical project.[8] Fredric Jameson's theorization of a "political unconscious" turns a deaf ear upon the discourse of the subaltern, constructing instead a critique of dominant ideology from a close textual and post-Althusserian reading of "bourgeois" literature.[9] Postmodernist theory, it appears, offers the tools to deconstruct the European imagination while leaving the underlying structures of imperialism intact. Far from the rupture I had initially envisioned the conquest would represent within contemporary philosophical discourse, I discovered that the Eurocentric bias of history is not easily dislodged by deconstructing Western thought.

For Edouard Glissant, shaking the foundations of Eurocentrism and an imperialist past becomes an issue of asking the right question. And it is this very question, he suggests, that we cannot afford to ask: the question of "why—that is, for what 'valid' reason—the whites exterminated the Indians and reduced the blacks to slavery, and whether they will be held accountable?"[10] It is a question I have been trying to ask myself in the last months. It is a question that leads to the recognition of how Eurocentric our thinking, our education, and our culture have been. It is a question that this lecture series entitled *Towards the Slaughterhouse of History* appears intent upon addressing. I do not have the answers to this question. But I will try to lead you a little further into the process of reflection that Glissant's question has provoked for me.

One of the ways I tried to reflect upon this question was by studying the colonial history of Peru. I was particularly interested in Peru as a site of conquest because of the past and present militancy of its indigenous peoples, who have engaged various strategies of resistance over the centuries. In researching the historical documentation of subversion and active rebellion undertaken by the indigenous peoples of Peru, however, I found myself unable to locate a perspective outside of my own position within a global system. In some way I was always the colonizer imagining their resistance, inventing their narratives, forever playing tug-of-war with context. I began to consider history, history as it is written in a liberal Western tradition, with its roots in Hegelian philosophy, as something that may have to be discarded altogether. For Hegel, history is a linear trajectory that begins and ends with Europe, with Amerindian culture classified as prehistoric and African culture as primitive and ahistorical. History, in this context, becomes, as Edward Said has pointed out, a fantasy of the West, a reordering of imagination.[11] It harbours the creation of a racial other and constructs a concept of difference through the assimilation of other cultures within a European perspective.

In order to explode the prejudices of a Eurocentric history, to question its parameters of chronology and consciousness, it seems to me that we must learn how to decolonize both the past and the future: to envision a culture of resistance that links an anti-racist project to an anti-imperialist one. Glissant writes of the Caribbean that "our historical consciousness could not be deposited gradually and continuously like sediment, as it were, as has happened with those peoples who have frequently produced a totalitarian philosophy of history, for instance European peoples, but came together in the context of shock, contradiction, painful negation, and explosive forces."[12] In turning to the local context in which I am speaking tonight, I want to propose that in

Canada, as in the Caribbean, our history has been formed by a process of shock and negation. The difference between the two lies in the lack of consciousness, in Canada, of this being a territory born of colonialism and of displacements, a meeting place of cultures where race and history clash and conflict. In Canada, the collective remembrances of enslavement and genocide, of expulsion and dispossession, have no place in the present to emerge as an articulation of the past.

Recent events such as the controversy over the *Into the Heart of Africa* exhibition at the Royal Ontario Museum offer a glimpse of just how deep and volatile the repression of these collective memories have become.[13] Organized by a staff curator, Jeanne Cannizzo, the exhibition sought to critique imperial culture and museum collecting practices by juxtaposing a display of African artifacts with photographic documentation of missionary activity in Africa. Growing opposition to the premise of the exhibition during the curatorial process culminated in the organization of a coalition that mounted a boycott and picket of the Royal Ontario Museum for the duration of the exhibition. The coalition's accusations that Cannizzo's misuse of irony, lack of sensitivity to African history, and lack of community consultation were tantamount to racism resulted in a large amount of negative publicity and the eventual cancellation of the exhibition's planned circulation to other museums in North America. Well-intentioned but ill-conceived, the exhibition and the outcry of protest that greeted it point to a schizophrenic relationship to imperialism that infects the Canadian cultural milieu.

On one hand, Canada prides itself on its racial tolerance and its ethnic diversity. On the other hand, cultural institutions such as the ROM are the repositories of deeply entrenched colonial attitudes. The spoils of conquest that the museum has accumulated over time are immense. Its record of cultural pillage extends across the globe. A history of the ROM commissioned by the museum describes the glorious adventures of collectors and curators who travelled the world in search of treasures to bring back to Canada and place under the thoughtful guardianship of enlightened scholarship. Take, for example, Bishop White, whose activities as a missionary in China in the 1920s resembled the behaviour of a man on a credit-card spending spree. Buying everything from royal tombs to entire libraries for the ROM's collection, he shipped boatloads of illegally procured Chinese antiquities back home. In turn, the museum's curator at the time, Charles Currelly, worried that a growing nationalist sentiment in China might hinder this wholesale exportation of Chinese culture, urged Bishop White "to make hay while the sun shines."[14]

This cultural plundering, sanctioned and encouraged by the ROM, is but one reflection of Canada's perception of itself as an equal-opportunity player within the imperial system. As Cannizzo notes in her catalogue essay for the *Into the Heart of Africa* exhibition, "Canada as part of an empire had horizons that were much broader than those defined by its own political boundaries. Nor were Canadians marginal participants in the empire's triumphs and defeats. As British subjects, they took an active part in all opportunities that imperial power had to offer individuals in the Dominion."[15] And lest we imagine that Canadians today are removed from Cannizzo's description of an imperialist sensibility or from James Morris's argument in his book *Pax Britannica* that "hundreds of thousands of British Canadians regarded the Imperialist saga as part of their own international heritage,"[16] one only has to look to the public outcry over the Ontario government's decision to cease requiring police officers to swear allegiance to Queen Elizabeth II. That this decision could generate controversy and outrage suggests there is still an imperialist undercurrent to Canadian politics: a longing to be part of an empire, of belonging to a great Dominion.

So here we are today, trying to manufacture culture in a country that has repressed a history of conquest, suppressed a history of opposition, and glossed over its imperialist ambitions. In this context, it is not a self-evident process to understand the intersection of global oppressions and local marginalization, or to envision models of artistic practice that speak to this intersection. A recent exhibition held at YYZ and Wynick/Tuck Gallery suggests the contradictions and difficulties inherent in seeking to place culture at the crossroads of a post-colonial project. Entitled *The Salvage Paradigm*, the exhibition featured artists who were asked to consider how their artistic practice, specifically in its use of references to cultures other than a dominant Western one, related to the idea of the "salvage paradigm" (an anthropological model used to describe the belief that "primitive" peoples will disappear through their contact with European civilization). In response to the premise of the exhibition, the artists produced statements that exposed a colonial legacy of conflict and disorientation. By way of example, I would like to quote from two of the artists' statements.

Carl Beam, a First Nations artist whose large-scale silkscreen works represent a history of conquest and oppression, writes that:

> We have this arbitrary place called Canada, inhabited by people willing to call themselves Canadians, who are withering from inertia because they refuse to find themselves.... We need a fresh definition of who we

are, made by people who know about us as human beings living in this geographical space, knowing something of our geography; knowing the forces at play that make this person do the kind of artwork that they do.[17]

Liz Magor addresses a series of photographs that she made twenty years ago, in which she appropriated Edward Curtis's late nineteenth-century photographic portraits of First Nations people posed in traditional outfits. In her reworking of his images, Magor mimics the staged elements of his documentary practice by replacing his subjects with herself and her friends dressed up as "Indians." By reproducing in her artwork models of imperial culture, Magor occupies a controversial site of representation, but perhaps not one that we can afford to eliminate or repress. She writes:

> In the twenty years since these photographs were taken, a significant change in how I can regard them has occurred. Something like an ungluing of the constituent parts of the image has taken place, making them embarrassing to consider. And certainly my first impulse is to deny or forget them. However since disavowal of my own history is equally uncomfortable, I have to proceed to salvage what I can.[18]

It would seem to me that the struggle to articulate a culture of diversity, from whatever identity and location we may speak from, finds resonance in these two positions. We need to speak to a memory of conquest, to insist this memory forms part of the historical consciousness of our country, and we need to acknowledge the suppression of a colonial history and to try to come to terms with past imperialisms. In this process of repositioning the interrelationship of memory and history, of consciousness and place, hopefully I, and others, can begin to understand where one is, here, in this city, and what one's relationship is to both local and global culture.

In engaging with this process of repositioning, the "I" that speaks here tonight has more questions than answers. It is an "I" that is struggling to articulate a relationship between past oppressions and the potential of resistance in the present, who believes the projection of the future must be an anti-colonial one, without which we will never come to a point where we can understand one another's differences without acrimony. This "I" stands before you insisting that history is a slaughterhouse, but that history is essential nevertheless. For without an understanding of history, we will never have the opportunity to cross-examine our imperial inheritance, or to conceive of the power of memory to embody resistance.

Notes

The first epigraph is taken from *Homage to the American Indians*, trans. Monique and Carlos Altschul (Baltimore: John Hopkins University Press, 1973), 37-38. The second, from *Caribbean Discourse: Selected Essays*, trans. J. Michael Dash (Charlottesville: University of Virginia Press, 1989), 82. The third, from *The Fact of a Doorframe: Poems Selected and New 1950-1984* (New York: W.W. Norton & Co., 1984), 285.

1. Glissant, *Caribbean Discourse*, 237.

2. Ibid., 93.

3. For an analysis of the Nicaraguan electoral process see Dot Tuer, "Fearful Symmetry: Nicaraguan Self-Determination and American Rhetoric in the 1990 Nicaraguan Election," *Fuse Magazine* 12:5 (1990).

4. Information on the celebrations planned for 1992 was compiled and analyzed by Blaine Chiasson in "Goodbye Columbus" (unpublished paper), 1991.

5. Antonello Gerbi, *Nature in the New World*, trans. Jeremy Molye (Pittsburgh: University of Pittsburgh Press, 1985), 9.

6. John Elliott, *The Old World and the New 1492-1650* (Cambridge: Cambridge University Press, 1970), 53.

7. Edmundo O'Gorman, *The Invention of America* (Westport, CT: Greenwood Press, 1972) and Tzvetan Todorov, *The Conquest of America: The Question of the Other*, trans. Richard Howard (New York: Harper & Row, 1984).

8. Michel Foucault, *The Archaeology of Knowledge*, trans. A.M. Sheridan Smith (New York: Pantheon Books, 1972) and *The Order of Things: An Archaeology of the Human Sciences* (New York: Vintage Books, 1973).

9. Fredric Jameson, *The Political Unconscious: Narrative as a Socially Symbolic Act* (Ithaca: Cornell University Press, 1981).

10. Glissant, 81.

11. Edward Said, *Orientalism* (New York: Vintage Books, 1979).

12. Glissant, 62.

13. For background information on the exhibition see Hazel A. Da Breo, "Royal Spoils," *Fuse Magazine* 13:3 (1989-90). For a critique of the exhibition see M. Nourbese Philip, "The White Soul of Canada," *Third Text* 14 (Spring 1991).

14. Lovat Dickson, *The Museum Makers: The Story of the Royal Ontario Museum* (Toronto: Royal Ontario Museum, 1986), 77.

15. Jeanne Cannizzo, *Into the Heart of Africa* (Toronto: Royal Ontario Museum, 1990), 14.

16. Cited in Cannizzo, 14.

17. *The Salvage Paradigm* (pamphlet) (Toronto: YYZ Books, 1990), unpaginated.

18. Ibid.

This essay first appeared in *Towards the Slaughterhouse of History: Working Papers on Culture*. Toronto: YYZ Books, 1992.

PARABLES OF COMMUNITY
AND CULTURE FOR A
NEW WORLD (ORDER)

Parameters of the New World Order

On March 21, 1994, the right-wing coalition party of El Salvador, ARENA, won a majority victory in the first national election to be held in this mountainous Central American country since the outbreak of a bloody civil war in the early 1980s that claimed more than 75,000 lives. During the election, Joaquín Villalobos, a leader of one of the main guerrilla factions of the left-wing Farabundí-Martí Liberation Front (FMLN), donned a business suit and a cellular phone in his bid for electoral success. Trading camouflage fatigues and armed struggle for the market signs of a neo-liberalism, Villalobos desperately sought a place in the new era of free-trade capitalism and free-flow capital. His abandonment of the collectivist ideals of revolution for the *realpolitik* of a post-Berlin Wall global reordering, however, failed to secure him an electoral seat. According to Rodolfo Cardinal, vice-rector at the Jesuit-run Universidad Centroamericano in San Salvador, his failure can be seen as a symptom of a much larger loss than a military or political one. The role reversals embraced by prominent ex-guerillas of the FMLN such as Villalobos, Cardinal argues, reveal the mark of an historical moment in which the left "is losing its militancy because it has lost its utopia. It no longer has a proper alternative."[1]

Meanwhile, in southern Mexico, an uprising by the indigenous people of the Chiapas region began on January 1, 1994. Taking as their namesake Emiliano Zapata—the radical agrarian leader of the 1910 Mexican Revolution—the Zapatista National Liberation Army briefly occupied the town of San Cristobal de las Casas, dramatically announcing to the world their opposition to the Mexican government's decades of neglect and abuse of indigenous rights.[2] In response, the Mexican army strafe-bombed the outlying *barrios* of San Cristobal de las Casas and isolated hamlets, rounded up and tortured civilians, and shot captured rebels in the back of the head. This swift military retribution was followed by a hurried move to the negotiation table by the Mexican government to assure jittery global markets of the country's financial and political stability. The government sat down with the Zapatista rebels to negotiate concessions for the indigenous people of Chiapas that included land reform, access to electricity and potable water, bilingual education, electoral reform, and community radio. In return, the rebels agreed to contain their demands to a strictly regional and practical platform.

Seemingly worlds away from the Canadian landscape of liberal democracy and state-brokered culture, these two examples of social and economic self-determination cast into sharp relief the political parameters framing progressive ideals of resistance and culture in the 1990s. With national liberation abandoned as an achievable goal, the negotiated resolution accepted by the FMLN mirrors the containment, some would argue dismemberment, of traditional left-wing movements in the Americas based upon broad economic and social reforms. The strategies of the Zapatistas, on the other hand, signal the emergence of specific identity-based movements demanding access to entrenched systems of privilege and resources. Together, these reconfigurations of negotiation and resistance reflect the conditions of global restructuring: the erosion of nation-state sovereignty, the embrace of fiscal conservatism, rising ethnic and racial tensions, and increasingly vast disparities between the haves and the have-nots within a post-industrial world order.

As a writer living out the amorphous (and concrete) effects of this global restructuring in the context of Canadian culture, it feels at times as if an inexorable fragmentation is occurring, unravelling coalitions and best intentions, long standing infrastructures and political commitments. Where once a cultural politic was anchored in the conceptual arena of a modernist avant-garde and an oppositional stance to capitalist hegemony, it is now entangled in a postmodernist collapse of territories and definitions and universalities. Where once cultural workers sought to align their practice with the "isms" and "movements" of revolutionary change, they now find their constituencies forming through

the specificity of experience and collective memories of oppression. Caught between the shattered idealisms of the past and increasingly complex struggles over issues of class, race, and gender, artists confront a shifting terrain of power and representation in which a new cultural politics of difference, to borrow Cornel West's description, is emerging. With a commitment to "diversity, multiplicity and heterogeneity,"[3] this reconceptualization of culture and resistance offers the potential to transform the political and social landscape. Conversely, it also runs the risk of devolving into sectarian defenses of cultural specificity based upon reactive and generalized, rather than proactive and contingent, stances.

145

PARABLES
OF COMMUNITY
AND CULTURE
FOR A NEW
WORLD (ORDER)

Perhaps nowhere are the constraints and possibilities of this new politics of cultural difference more evident than in the use and abuse of the overdetermined cultural catchphrase of the 1990s: community. The evocation of "community" to displace and replace the "movements" and "isms" of twentieth-century modernism conjures up the fraught terrain of state multiculturalism and the disputed terms of ethnicity and citizenship. Awakening prescient sentiments of identity and oppression, community becomes a conceptual and organizational space where the past and the present overlap and left and right blur. In appealing to a notion of organic collectivity and essentialist identity, it can end up sweeping away history in the name of solidarity, collapsing differences in the name of difference.

Through an exploration of the genealogy of "community" as a signifier of cultural identification, this essay seeks to analyze what lies below the surface of this appeal to collectivity, to unravel some of the myths and preconceptions that encircle the idea of community in its present forms. In invoking a historical framework of analysis, I am interested in questioning how a colonial legacy has come to haunt contemporary invocations of community as a site of collectivity and belonging. In so doing, it is neither my claim nor my intention to construct a history of community. Rather, through the juxtaposition of stories and historical fragments, I want to anchor the abstraction of community in a historical materiality that can give form to the unconscious narratives and repressed memories of conquest and colonization. By examining how the contemporary parameters of culture and resistance are rooted in the history of the Americas, and in First Nations struggles for local autonomy and self-determination, I hope to delineate some of the tensions around issues of identity and difference that emerge from projections of community as a site of art and activism. For it is by rethinking the past in order to reimagine the future, I would argue, that the usefulness and limitations of community as a site in which current cultural politics unfold and are contested can be illuminated.

Words of Caution

> All communities larger than primordial villages of face-to-face contact (and perhaps even these) are imagined. Communities are to be distinguished, not by their falsity/genuineness, but by the style in which they are imagined.[4]

> Note the critically important feature of the war of silencing is its geographical, epistemological, and military-strategic decenteredness.[5]

A History Lesson

In 1569, thirty-six years after Francisco Pizarro landed on the shores of Peru and launched the Spanish conquest of the vast Incan empire of the Andes, Viceroy Francisco de Toledo, recently appointed by the Spanish Crown as the region's colonial overlord, set about restructuring the administrative and psychic landscape of the conquered territories. Deciding to personally oversee the process, he travelled by horseback along ancient Incan routes, retracing the memories of other conquests. However, the logic of this conquest would be inescapably different from that of its predecessors. Silver, not grain; tin, not chilies; and slaves, not tribute would drive the conqueror to organize his colonial subject. Upon surveying the indigenous use of land as both economic and spiritual ground, Toledo decided to forcibly relocate and combine local settlements, known as *allyus*, into communities clustered along Spanish trade routes and within easy reach of Spanish military supervision. Thus was born a time-honoured tradition of *campo modelos*, or model communities (most recently employed by the Americans in Vietnam and the military dictatorship of Guatemala) intended to subdue the resistance of local populations.[6]

As the centuries passed, the silver mines were exhausted and the opening of ports on the Argentinian coast shifted colonial lines of communication. Previously populous trade routes were no longer viable, and the "communities" created by the Spanish were forsaken in the creation of the nineteenth-century nation-state.[7] Twentieth-century anthropologists who studied these now isolated, rural communities described the "closed" structures of indigenous peoples, which had shut out modernity. In the anthropologists' minds, these local communities were inflexible and uncivilized; such collectivities were breeding grounds of superstition and backwardness, impediments to individualism and the initiatives of burgeoning capitalism. By their very existence, they formed

an oppositional barrier to the metropolis, to progress, to democracy, and to nationhood.[8] In the classifications and evaluations embraced by the anthropologists, however, what went unacknowledged was the legacy of conquest. Closure was not an internal condition initiated by the communities themselves, but one imposed by exterior interventions and repressions of colonialism. Ironically, the indigenous peoples of Peru and elsewhere were very open to the ideas and influences of the colonizers in the early years of conquest, and it was this very openness, this adaptability, that led to their defeat at the hands of the conquistadors.

147

PARABLES
OF COMMUNITY
AND CULTURE
FOR A NEW
WORLD (ORDER)

Sacred Projections

The military and administrative strategists of the Spanish colonial order were not the only ones with visions of how community should and could be imposed upon the *tabula rasa* of the Americas. The Franciscans and Jesuits who followed in the conquistadors' footsteps sought a New Jerusalem in the New World, finding in the Indians innocents untouched by the venal corruptions and decay of Europe. Seeking to reinvent the sacred space of a medieval cosmos, and to reinforce the imaginary of a lost paradise, they founded model Christian communities where Indians, isolated from the Spanish colonizers and from their own people, would live in a state of grace close to God. Such an evangelical reconfiguration of community, however, could only be achieved through the fragmentation and destruction of another world-view. The new converts were forced to abandon their language and culture, and were set to work building churches and cultivating fields for their spiritual masters.[9]

From that first spiritual conquest of the New World, the Americas figured in the European imagination as a conceptual space of refuge and salvation. With the religious schism of the Reformation and the emergence of the nation-state threatening traditional community formations, Europeans fled to the Americas in search of a place to construct an ideal of community existence based on shared religious or social beliefs. Pilgrims followed upon Catholic friars. Dissenters followed upon the pilgrims. Religious minorities fled persecution. Utopian socialists sought to institute communitarian ideals as lived experiences. In the New World, communities were formed from a complex entanglement of new and old oppressions, of future hopes and remembered injustices. On one hand, the model communities imposed by the colonizers functioned as covert operations for the genocide of indigenous peoples and cultures. On the other, the formation of communities by Europeans seeking to live by religious and communitarian ideals elided

the histories of conflict and conquest that preceded them, creating the paradox of community as a new beginning founded upon the (blind) projections of a *tabula rasa* landscape.

A Dictionary Definition

> **Community: 1 a** all the people living in a specific locality. **b** a specific locality, including its inhabitants. **2** a body of people having a religion, a profession, etc., in common (*the immigrant community*). **3** fellowship of interests etc.; similarity (*community of intellect*). **4** a monastic, socialistic, etc. body practising common ownership. **5** joint ownership or liability (*community of goods*). **6** the public. **7** a body of nations unified by common interests.
> — *The Concise Oxford Dictionary*

> The contrast, increasingly expressed in the nineteenth century, between the more direct, more total, and therefore more significant relationships of **community**, and the more formal, abstract and more instrumental relationships of *state*, or of *society* in its modern sense, was formalized by Tönnies (1887) as *Gemeinschaft* and *Gesellschaft*. A comparable distinction is evident in mid-twentieth century uses of **community**. In some uses this has been given a polemical edge, as in **community politics**, which is distinct not only from *national politics* but from formal *local politics*, and normally involves various kinds of direct action and local organization, 'working with the people', as which it is distinct from 'service to the community', which has an older sense of voluntary work supplementary to official provision or paid service.
> —Raymond Williams: *Keywords*

148

A Civilizing Mission

In 1857, the Assembly of the United Canadas (present-day Quebec and Ontario) passed the Gradual Civilization Act, setting into motion the first of a number of bills designed to destroy the framework of First Nations treaty rights established by Britain's Royal Proclamation of 1763. Under the terms of this new act, any Indian who was educated, free of debt, and judged to be of good character by a judicial committee could apply for twenty hectares of reserve land to cultivate as his own property and thereby become enfranchised. Linking "civilization" to individuated property rights, the act was intended to dismantle the

collective rights of tribal councils on reserves, diminish their land-based power, and to destroy community-based values. Few First Nations people stepped forward to be individuated as property-owning farmers, and First Nations chiefs were outspoken in their assessment of the Gradual Civilization Act as an attempt to destroy their collective identity and their economic power base. The objective of dismantling indigenous self-government, however, would become a cornerstone of subsequent legislation. By the time of the passage of the Indian Act of 1876, which made First Nations people wards of the state, the federal government was actively pursuing a policy of assimilation, and assuming extensive administrative and economic power over First Nations reservations and lives.[10]

149

PARABLES
OF COMMUNITY
AND CULTURE
FOR A NEW
WORLD (ORDER)

From the Royal Proclamation of 1763, in which Britain entered into nation-to-nation negotiations with First Nations peoples and guaranteed autonomy on reservations, to the Indian Act of 1876, a complete turnabout had taken place. Self-government was replaced by paternal coercion, and with it the status of indigenous communities shifted. As nations, Native Canadians were entitled to the shared ideas and definitions of sovereignty. As wards of the state, they were subject to territorial displacement, no longer part of a shared idea but separate from civilization. As a now legally defined "other," they became the objects of an ethnographic gaze, defined by cultural specificity rather than sovereign rights. Collectivity as a form of self-government became subsumed under a liberal laissez-faire discourse on economic "primitivism." The discipline of anthropology removed First Nations culture from a historical dimension and recast it as a timeless tradition without the possibility of technical innovation or conceptual creativity.

The underlying economic logic of this two-pronged drive towards assimilation and differentiation (in which the importance of individual property rights and individual capital accumulation was held in opposition to collective and community-based systems of distribution) played itself out in Canada as a series of coercive state interventions into the lives of First Nations peoples. Cultural expressions of collective identity and community values were scrutinized for their subversion of the universalizing, civilizing mission of European modernity. On April 19, 1884, a law was passed banning the celebration of the potlatch, an elaborate ceremony in which goods exchanged hands without monetary transactions. Protests from First Nations leaders astutely pointed to the ideological and economic factors at play in its prohibition. Maquinna, a Nootka chief, noted that "once I was in Victoria, and I saw a very large house; they told me it was a bank and that the white men place their money there to take care of, and that by-and-by they got it back with

interest.... When we have plenty of money or blankets, we give them away to other chiefs and people, and by-and-by they return them, with interest, and our heart feels good. Our potlatch is our bank."[11] Despite his analogy, however, those who participated in the potlatch were jailed for up to six months for their transgression of the economic (and cultural) boundaries of the nation-state.

While ceremonial and ritual culture associated with community identity was suppressed, craft production that could be subject to commercialization and to non-Native market-distribution mechanisms was encouraged. Elizabeth McLuhan and Tom Hill, in their catalogue *Norval Morrisseau and the Emergence of the Image Makers*, note that many of the artistic forms now associated with First Nations traditions, such as Haida argillite carving or Inuit sculpture and prints, were produced specifically for a white market. Northern Canadian co-ops, which subsequently became synonymous with indigenous community art production, were established at the instigation of white, middle-class women's auxiliary groups, who saw in craft production a cultural civilizing mission. Ironically, given that ceremonial art was banned by the state, items produced by the co-op artists that were not deemed to have an appropriate "primitiveness" by appearing magical or ritual in purpose were destroyed.[12] Such a repositioning of culture and community in this context only served to reinforce the canonical division between craft, as that which is made in a timeless, collective environment and is "primitive" in conceptualization; and art, as that which is produced by individuals within a Western historical succession of distinctive artistic movements, and is "modern" in its conceptualization.[13]

At its most rhetorical, then, community is steeped in the murky dialectics of the conqueror and the vanquished, the modern and the primitive, enlightenment and superstition, individuality and collectivization. At its most concrete, community in the New World signifies a history of diaspora, cloaked in layers of oppression, idealism, external restraints, and internal reconfigurations. Communities of the New World are communities of immigration, displacement, exile, emigration, and forcible relocation. The conceptualization of community in the Americas as a locus of social change and cultural expression struggles against inherited vocabularies of anthropology and modernism. It carries with it (consciously or unconsciously) a history that encrusts and constrains its contemporary usage. As a form of social, cultural, and political organization, community is both a site of self-determination and subject to definition by exterior grids of representation and power, mass media and the state.

When One Becomes the Other

The pages of the chronicles of the conquest and discovery depict that
crucial, bloody moment, full of phantasmagoria, when—disguised as a
handful of invading treasure hunters, killing and destroying—the
Judeo-Christian tradition, the Spanish language, Greece, Rome, the
Renaissance, the notion of individual sovereignty, and the chance of liv-
ing in freedom reached the shores of the Empire of the Sun. So it was
that we as Peruvians were born.[14]

151

PARABLES
OF COMMUNITY
AND CULTURE
FOR A NEW
WORLD (ORDER)

No country can remain frozen in its traditions and customs. These
must serve to shape its cultural identity, to develop valid, lasting con-
cepts of its own culture. But when development is unequal and survival
means retreating into isolation, to repeat over and over again the con-
stants of one's identity and thereby proclaim to be invincible, it is by
the same token understood that the force of revolution will let loose a
new current enriched by the memory of a culture teeming with
humanity and love, that will set in unstoppable motion a people who
possess an extraordinary ability to act collectively.[15]

A Story of Conflict

On January 26, 1983, eight journalists attempting to reach
Huaychao, a remote indigenous community in the Andean *altiplano*
near Ayacucho, Peru, were massacred. The reporters, unarmed and on
foot, were seeking to verify the military's claim that the villagers of
Huaychao had killed seven members of the *Sendero Luminoso* (Shining
Path), a Maoist-inspired guerrilla group whose operations in the coun-
tryside of Ayacucho during the late 1970s had recently expanded
beyond a regional base. The *Sendero Luminoso*'s blackout of Lima on
December 31, 1982, accompanied by a flaming hammer and sickle
burning on a mountaintop above the darkened city, fuelled fears of the
potential for an alliance between the white intellectual leadership of the
Sendero Luminoso and the Indian population of the sierra to engulf
Peru in ethnic and class-based civil war. The military's announcement
of the murder of the *Sendero* cadre by the indigenous inhabitants of a
remote mountain village appeared custom-designed to assuage these
fears. By producing evidence of peasant hostility to the *Senderistas*, the
military could reaffirm traditional divisions between Indian and white,

rural and urbanized, savage and civilized that the guerrilla activities of the *Sendero Luminoso* threatened to overturn.

While rumours of widespread military abuses in the region cast into doubt the sincerity of the military's unsubstantiated claims, the murder of the journalists eliminated any possibility of eyewitness accounts to counter the military's version of events. Instead, the Peruvian government appointed a commission to conduct an inquest into the massacre of the journalists. Amid widespread accusations by the Peruvian Left that the military, rather than the villagers, had killed the reporters, and in all probability the *Sendero* cadre as well, the commission concluded that the poverty, isolation, hatred of outsiders, religious superstition, mob mentality, and general backwardness characterizing the 20,000 Iquichano inhabitants of this highland region had led to a tragic, but comprehensible, confrontation.[16] Among the prominent anthropologists and lawyers who were appointed to the commission to offer Peruvians this socio-anthropological interpretation of the violence engulfing their country, the presence on the commission of the country's most famous novelist, Mario Vargas Llosa, lent a literary flair to the inquest. In turn, Vargas Llosa's dramatic reconstruction of the massacre and its aftermath, published in the *New York Times Magazine*, added an international political dimension to the incident.

Combining narrative conventions and ethnographic descriptions, Vargas Llosa tells a gripping story of eight journalists with names and personalities, families, dreams, and desires, who become subject to the terror of an anonymous and destitute horde of irrational peasants. In contrast, he assigns neither names nor individual motives to the inhabitants of the sierra. Instead, the indigenous peoples of the Peruvian highlands figure *en masse* in Vargas Llosa's story as an incomprehensible other, a collectivity understood only through references to their bizarre rituals and strange beliefs. Vargas Llosa attributes their worship of mountain-gods, or *apus*—the most famous, Rasuwilca, holds in his belly "a horseman with fair skin and a white horse [who] lives in a palace full of fruit and gold"[17]—to the inability of Catholicism to displace traditional beliefs. He interprets the mutilation of the journalists' eyes and mouths and their broken ankles as ritual markings designed to protect the community against strangers in league with the devil. Isolation and suspicion are seen by Vargas Llosa to saturate the lives of the Iquichanos, their centuries-old hostility to outsider influences reinforcing their poverty and ignorance. Outbreaks of violence and rebellion among these mostly illiterate, monolingual Quecha speakers are linked to a "fear that their way of life will be disturbed, that their ethnic survival is being threatened."[18] Political analysis is forsaken for an evocation of

difference, with Vargas Llosa's observation of an old woman, dancing barefoot with swollen lips and scarred cheeks, leading him to ask:

> Was she saying goodbye to us in an ancient ritual? Was she cursing us because we belonged to the strangers—*Senderistas*, "reporters," *sinchis* —who had brought new reasons for anguish and fear to their lives? Was she exorcising us? [19]

153

PARABLES
OF COMMUNITY
AND CULTURE
FOR A NEW
WORLD (ORDER)

A Lesson from Goya

In Goya's later years as a painter, he produced several small works on the theme of cannibalism. Breaking ranks with the European tradition of portraying the indigenous peoples of the Americas as cannibals, Goya painted Europeans ravishing their own flesh. Severing a representational legacy of demarcating the other as cannibal and thus juxtaposing civilized mores against a savage sublime, Goya grounded the devouring monster of the other in the self. In Goya's macabre works, the displacement from self to other that upholds Western hegemony is ruptured: the same displacement that enables Vargas Llosa to maintain a distance from the subjects of his investigation. For it is the evocation of the other as the pure space of alterity, deterritorialized through representational violence, that informs the construction of not only imaginary cannibals, but imagined communities.

A Story of Communities

In February 1993, I attended a symposium on community, art, and social change that was held at the Banff Centre for the Arts in conjunction with an artist residency program. The institution had called "community" into being as the theme of the residency, and with its naming conjured the ghosts of history and ideology—an entangled skein of colonialism and memory that cast long shadows over a dialogue that wanted to will the past away and will the future into the present. Another kind of ghost also appeared in this act of naming, one more elusive than that formed by the sediments of oppression. This ghost was shaped from primordial longings and desires, utopian evocations of wholeness, and mythic stories of unity. It called forth a projection of community, which untouched by the messy hands of history promises a holistic space of purity. Mingling with the ghosts of history and ideology, it also came to haunt the proceedings of the symposium. Its full

force, however, was not unleashed until it was summoned to the table through a story told to the participants by Rhoda Karetak, an Inuit elder from Rankin Inlet in the Northwest Territories.

Karetak spoke to the symposium on the second day of the proceedings, after the four artist groups invited to participate in the residency presented their perspectives on the theme. Bryce Kanbara, the project consultant for a group of Japanese-Canadian ceramists, read poems and fragments written by the residency artists. Collectively, their writings traced memories related to their experiences as Nisei and Sansei, second and third-generation Japanese-Canadians whose loss of language and traditions had been shaped by the historical legacies of Japanese incarceration during the Second World War, assimilation, and *shikataga-nai* (fatalistic resignation).[20] Mekarôn, a collective from Montreal who had produced mural projects supporting the struggles of James Bay Cree against hydroelectric development and the fight of the Inuit to stop low-level NATO flights over their traditional hunting grounds, spoke to a utopian vision of working across cultures and across languages. Michael Balser, the project consultant for a group of video artists making public service announcements about AIDS, talked of the difficulties of representing this issue in the mass media, and of the lack of access to television for the dissemination of their message. Ruby Arngna'naaq, representing the pan-Arctic Inuit women's collective Pauktuutit, addressed a broad range of social issues that affect women in the North from suicide to self-government, explaining the concerns and the processes involved in bringing Inuit artists to Banff.

When Rhoda Karetak rose to speak the next morning, issues of pain, survival, fear, and longing had already surfaced in the discussions held the previous day. It was her testimony, however, that encapsulated the depth of emotions evoked by the theme of community. With an interpreter at her side, Karetak told her story, a very personal narrative about growing up in a northern Arctic region of Canada. She spoke to her experience of conquest as a living memory of forced relocations and colonial interventions, civilizing missions and Western arrogance. When she was young, she told the symposium participants, she lived according to the traditional ways of her ancestors. More than anything else, she remembered the dogs that pulled the sleds, beautiful dogs with thick fur running free on the frozen tundra. Then the government came, moving her community to unfamiliar terrain in the southern Arctic. The RCMP gave the people numbers and they shot on sight dogs that were not tied up. Skidoos destroyed the dog teams, and confinement destroyed the dogs. The dogs became vicious and unpredictable, and the childhood companions she loved so much could no longer be petted. Government-

imposed education destroyed traditional knowledge of the land, and with the loss of knowledge the Inuit lost their power over their lives and their environment. Traditional clothing was no longer made, and many people froze to death. Then there were many suicides.[21]

A testimony of survival and healing, Karetak's talk that morning became a catalyst and a touchstone for the discussions that unfolded over the day and a half remaining in the symposium. For some, her words produced an outpouring of pain and anger, fracturing the utopian space of community as a place where culture could be reclaimed and acted upon. For others, the projections of community as an organic collectivity remained intact, but became another space of belonging distant from their lived experiences. Where identities and memories had been formed by territorial displacement and forced relocation, community was a home one could no longer locate. Where identities and memories had been formed by dominant Canadian culture, community was a fiction only those marked as other by the nation-state had the potential to realize. As sharp emotions of loss and alienation swirled around the room, the search for a community that could heal these schisms was never realized. In the words spoken during the symposium, however, there were as many steps forward as backward. Silences of the past were broken, and a process of listening and questioning began. Community, as an abstraction, had become a place to begin speaking from, where the sharing of histories and of memories could re-envision community as an "open" rather than "closed" site of cultural affirmation and dialogue.

155

PARABLES
OF COMMUNITY
AND CULTURE
FOR A NEW
WORLD (ORDER)

Speaking from the Heart

How can we use the "imaginary" community to go home?[22]

Through art we can preserve the knowledge of the past. We can remember what things were originally called in Inuktitut—naming things is important. Art is a way of preserving knowledge.[23]

Putting One's Foot Down

In the early part of the twentieth century, the Brazilian artist Tarsila do Amaral appropriated a long trajectory of idealized European images of the indigenous Tupinamba as cannibals to forge another vision of the Americas. In her 1928 painting *Abaporu*, she reclaimed the image of the Sciapod, a one-legged giant of the European imagination whose foot,

flailing in the air above its head, shaded the creature from the sun in hot and unknown lands. Turning the foot right-side up, so it no longer flailed haplessly in the air but was firmly planted on Brazilian soil, do Amaral metaphorically stamped out a European legacy of representing the other. The title of the work, *Abaporu*, a Tupí-Guaraní word that literally means "one who eats," referenced European fantasies of Brazilians as cannibals gnawing upon arms and feet. In so naming the painting, do Amaral alluded to her role as a collaborator in the conceptualization of the *Cannibal Manifesto*. Written by Oswaldo de Andrade in 1929, the *Cannibal Manifesto* proposed that the way forward to a national culture was not to ignore colonialism but to devour it and produce something new. Supplanting the displacement of self and other that constructs the colonial order with the specificity of location and history, do Amaral sought a vision of Brazilian art that resisted the logic of the colonizer.[24]

Stepping Towards a Community Politic

In the 1990s, putting one's foot down is not an easy step forward. The ground beneath one's feet is slippery. The realignment of economics and politics that has taken place since the 1960s has made the ground inhospitable for progressive community initiatives. Philosophically, the destabilization of self and other through post-structural theory has led as much to the affirmation of an essentialist other as to a new territory of imagination where identities are not fixed but shift through dialogue. History, as much as contemporary pressures, informs the configuration and reconfigurations of community, and conditions how individual and collective experience is negotiated through experiences of community participation. The present forces of globalization condition how communities can be envisioned as sites of cultural intervention. Community itself is a fractious term, evoked by conservative politicians and theorists when insisting upon a return to "family" values as well as by social and political activists seeking to challenge inherited structures of oppression.

In such a context, the potential to negotiate heterogeneity within a conceptualization of community is as important as achieving consensus. Part of being able to put one's foot down is understanding how history and consciousness intersect and clash, how every individual occupies and functions within a number of communities simultaneously. As borders fragment and traditional boundaries between nations and ideological positions dissolve, the conceptualization of community

as localized and dynamic is increasingly important. In this context, sustaining community as an agent for progressive change and cultural activism requires a commitment to diversity and historical contestation. For it is in the enactment of community, in all its complexity, that a site emerges from which to ground resistance to past oppressions, and thus imagine a collective future.

Notes

1. Rudolfo Cardinal cited in "Ex-Rebel Prefers Pragmatism to Guns in Achieving Goals," *Globe and Mail* (March 18, 1994), A23.

2. The Zapatista National Liberation Army (EZLN) also timed their uprising to coincide with the implementation of the North American Free Trade Agreement (NAFTA), which they denounced as threatening the collective rights of their communities. The Zapatistas have used the Internet to great effect and their books, manifestos, discussion, and support groups, etc. are posted on line.

3. Cornel West, "The New Cultural Politics of Difference," in *Out There: Marginalization and Contemporary Cultures*, eds. Russell Ferguson, Martha Gever, Trinh T. Minh-ha, and Cornell West (New York and Cambridge, MA: The New Museum of Contemporary Art and MIT Press, 1990), 19–39.

4. Benedict Anderson, *Imagined Communities: Reflections on the Origin and Spread of Nationalism* (New York: Verso, 1991), 6.

5. Michael Taussig, *The Nervous System* (New York: Routledge, 1992), 21.

6. For an overview of the Peruvian colonial period see Steve J. Stern, *Peru's Indian Peoples and the Challenge of Spanish Conquest* (Madison, WI: University of Wisconsin Press, 1982).

7. For an overview of colonialism in Latin America see Eduardo Galeano, *Open Veins of Latin America: Five Centuries of the Pillage of a Continent*, trans. Cedric Belfrage (New York: Monthly Review Press, 1973). Galeano has also written a trilogy on the history of the Americas, *Memory of Fire*, trans. Cedric Belfrage (New York: Pantheon Books, 1985).

8. For an overview of the anthropological debates on "closed" and "open" communities see Steve J. Stern, "New Approaches to the Study of Peasant Rebellion," in *Resistance, Rebellion, and Consciousness in the Andean Peasant World, 18th to 20th Centuries* (Madison, WI: University of Wisconsin Press, 1987).

9. For a description of the spiritual conquest of Spanish America see Robert Ricard, *The Spiritual Conquest of Mexico* (Berkeley: University of California Press, 1966).

10. For a historical overview of government policy towards First Nations peoples in Canada see John L. Tobias, "Protection, Civilization, Assimilation: An Outline History of Canada's Indian Policy," *Western Canadian Journal of Anthropology* 6 (1976).

11. Quoted in ed. Penny Petrone, *First People, First Voices* (Toronto: University of Toronto Press, 1983), 70.

12. Elizabeth McLuhan and Tom Hill, *Norval Morrisseau and the Emergence of the Image Makers* (Toronto: Art Gallery of Ontario, 1984).

13. For an analysis of how the primitive and the modern are constructions of Western art history see Sally Price, *Primitive Art in Civilized Places* (Chicago: University of Chicago Press, 1989).

14. Mario Vargas Llosa, "Questions of Conquest: What Columbus Wrought and What He Did Not," *Harper's* (December 1990), 51. Vargas Llosa is a Peruvian intellectual and writer whose novels and presidential candidacy as the leader of the conservative Democratic Front have brought him world attention. His articles interpreting Latin America for a North American public appear regularly in the *New York Times Magazine* and *Harper's*. In this article he calls for the assimilation of indigenous peoples as the only solution to the legacies of colonization.

15. Jorge Sanjínes, (and the Ukamau Group), *Theory and Practice of a Cinema with the People*, trans. Richard Schaaf (Willimantic, CT: Curbstone Press, 1989), 81. Sanjínes is a Bolivian filmmaker and cultural activist who has worked communally with the Bolivian peasantry for more than twenty years, producing videos and films.

16. I am summarizing here arguments forwarded by Vargas Llosa on behalf of the 1983 *Comisión Investigadora de los Sucesos de Uchuraccay* in his article "Inquest in the Andes: A Latin American Writer Explores the Political Lessons of a Peruvian Massacre," *New York Times Magazine* (May 31, 1983).

17. Vargas Llosa, "Inquest in the Andes," 33.

18. Ibid., 36.

19. Ibid., 51.

20. For a history of Japanese internment and the redress movement see Maryka Omatsu, *Bittersweet Passage: Redress and the Japanese Canadian Experience* (Toronto: Between the Lines, 1992).

21. A transcription and translation of Rhoda Karetak's testimony is published in *Questions of Community: Artists, Audiences, Coalitions*, eds. Diana Augaitis, Lorne Falk, Sylvie Gilbert, and Mary Anne Moser (Banff: Walter Phillips Gallery, 1995), 23-31.

22. Haruko Okano, a Japanese-Canadian artist and poet, contributed this question during the symposium proceedings.

23. These were the closing words of Rhoda Karetak's presentation. See *Questions of Community: Artists, Audiences, Coalitions*, 31.

24. For a brief description of Tarsila do Amaral's work and life see Oriana Baddeley and Valerie Fraser, *Drawing the Line: Art and Cultural Identity in Contemporary Latin America* (London: Verso, 1989). The *Cannibal Manifesto*, written by the Brazilian poet Oswaldo de Andrade in 1929, and illustrated by do Amaral, is translated and reprinted in Dawn Ades, *Art in Latin America* (New Haven and London: Yale University Press, 1989).

This essay first appeared in *Questions of Community: Artists, Audiences, Coalitions*, edited by Diana Augaitis, Lorne Falk, Sylvie Gilbert, and Mary Anne Moser. Banff: Walter Phillips Gallery, 1995.

IMAGING THE BORDERLANDS

The other night on television, there was a news story about economic refugees from Honduras fleeing northwards from the wrath of Hurricane Mitch. A *campesino*, crouched in the shadows of dense jungle foliage and staring pensively across the murky brown river that divides Guatemala from Mexico, tells the reporter of his plans to reach the United States. Speaking in colloquial Central American Spanish, he explains that "*en los Estados Unidos, es verdad, hay trabajo, ocho dolares por hora, diez tal vez*" (in the United States, it's true, there's work for eight dollars an hour, maybe even ten). Embedded in the expression "*es verdad*" is a double-edged inflection of doubt and conviction. The *campesino* probably suspects there is no promised land of work and dollars, yet he needs to believe in the great American Dream. How else is he able to risk his life, running a gauntlet of the Mexican army, armed robbers, unscrupulous police, United States border patrols, and immigration officers? His journey from south to north is driven not only by hunger and lack, but also by projections of plenitude.

In the colonial era of the Americas—when Texas, New Mexico, and California were the borderlands of the Viceroyalty of New Spain—the Promised Land did not lie to the north but to the south. Tales of El Dorado and the Fountain of Youth lured the Spanish inland through steamy tropical landscapes. The discovery of veins of silver as large as the anaconda snakes that slithered through the lowland jungle led them to the windswept mountain plateaus of Peru and Mexico. To the north was barren space, devoid of precious metals and fresh-flowing water. These were desert lands, inhabited by fierce nomadic tribes. From here, long before the Europeans arrived, the Mexicans began their great migration southward to found Tenochtitlán (Mexico City) and the imperial state of the Aztecs. Henceforth, the north became for them a

mythic homeland called Aztlán and the place where the symbolic ordering of their universe originated.

When the Spanish conquered Tenochtitlán, they built Christian churches from the ruins of pyramids and their colonial infrastructure from the remnants of the Aztec empire. The northern borderlands remained as they had been during the Aztec reign: the site of military confrontation between sedentary and nomadic cultures. Psychically and spatially, the frontier was nebulous and undefined. The overlay of indigenous and European cosmologies formed shifting and contested boundaries. Scattered mission settlements and army outposts created a fragile line of defense against nomadic horseback warriors who would swoop down from the north in lightning raids. After Mexican independence in 1820, government neglect left the borderlands increasingly vulnerable to the westward push of North American colonists. The threat was no longer from northern nomadic tribes but from caravans of covered wagons filled with settlers. In 1846, tensions escalated into a war between Mexico and the United States. Two years later, Mexico negotiated the terms of her defeat by ceding California, New Mexico, and Texas to the United States in exchange for fifteen million dollars. The border shed its nebulous character and became a symbol of American territorial expansion. As Mexicans flowed northward, ancient patterns of migration were reversed. After many centuries, the return to Aztlán signalled that a new ordering of the universe had begun.

When the United States began to build a fence along the border between San Diego and Tijuana in 1994, they erected a physical barrier that sliced through space and time. As the fence grew to fourteen miles in length, snaking inland from Playas Tijuana to Otay Mountain, it altered irrevocably the cosmological dimensions of the landscape. Where once Coatlicue, the serpent-skirted mother goddess of the Aztecs, had given birth to the moon and stars, now an infertile reptile hugs the earth. In a land marked by movement and myth, a stillborn monster devours people and memory. As a symbol of empire, the fence is a monument to imperial arrogance and an admission of territorial instability. Like the Great Wall of China, it divides the civilized from the marauding hordes, yet by its very presence warns of imminent barbarian incursions. In ancient Greece, Herodotus wrote of the barbarian Scythians who eluded Greek soldiers by continually moving away from and around their standing army. At the border between Tijuana and San Diego, the northward flow of migrants repeats this archaic confrontation, evading the empire's defenses by slipping through and around and over the fence.

To train a camera viewfinder on the border fence is to reproduce the struggle between stasis and motion within the realm of images. The camera, like the fence, cuts through a continuum of space and time. With the rapid click of the shutter, a fusion of light and emulsion fixes moments of flux, organizes a spatial framework of grids and lines. The photographic image holds out the lure of amplifying seeing, of rendering evident that which goes unnoticed. Yet the borderlands upon which the fence is built yield little in the way of evidence. What is visible—the imperial monument of the fence—tells a very partial story. Just as people slip through, over, and around the fence, so the metaphysical dimensions of the landscape elude the camera's gaze. How then to represent that which cannot be seen? How to convey through the static image the flow of myth and memory that swirls in the brittle desert wind? How does one photograph nomad space?

The tensions that proliferate between what is visible and what evades the camera lens lead to a compelling desire to distill the experience of the borderlands through images of people rather than landscape. Perhaps there is a moment when the *campesino* from Honduras, on reaching the final stage of his journey and waiting to cross the border, communicates in the furrowed lines of his sunburnt face the emotions that have driven him northward. Or there is a split second of terror when a group of Mexicans sprinting across the borderlands towards a standing army of American police are caught in a sweeping floodlight that rips apart the cover of night. Calling on humanist traditions of portraiture and photojournalism, such highly charged images are theatrical, emotional, and accessible. Yet obliquely, and inexorably, they vanquish the nomad space they seek to represent. The migrant as alien other is pinned down by the ethnographic gaze of the camera. The viewer is positioned outside of the image, aligned with the omnipotent eye of the camera that reduces motion to stasis. Both migrant and viewer are caught within a binary structure of looking and being seen, of us and them.

In Geoffrey James's 1998 documentary series of photographs on the Tijuana/San Diego border fence, our desire to "see" the migrant is thwarted. In the forty-eight photographs of *Running Fence*, there is a striking, almost startling, absence of people; the fence, however, is relentlessly, almost overbearingly, present. With a cartographer's precision and a metaphysician's eye, James traces the fence's winding path from its origin at Playas Tijuana to its abrupt end in the foothills of the Otay Mountain. In almost every image, the corrugated sheet metal of the fence is an omnipresent force, dividing a bleak desert landscape of sky and earth into horizontal grids. The photographic framing of the

fence echoes its military and political function; it is a barrier that arrests the viewer's gaze. There is no easy point of access or identification here. Instead, the work's singular fixation on the fence heightens tensions between migrant and imperial space. In their austerity, and haunting emptiness, his photographs become a repository for the fissures of history.

In the nineteenth-century conquest of the desert borderlands, photographers followed the tracks of settlers' wagons to map the frontier territories. As part of surveying expeditions, photographers such as Timothy O'Sullivan and Carleton Watkins produced vast, sublime images: panoramic landscapes that captured the expansiveness of empire. Through the camera, they asserted control over nomad space, in which sky and earth and signs of colonization—such as railway lines or footprints in the desert sand—were integral elements in a unified and harmonious field of vision. *Running Fence* shares affinities in form and content with the historical tradition of frontier photography. The difference lies in the way James's framing of sky and earth and fence fractures the spatial qualities of the landscape. In James's photographs, the fence rises from the earth as a monstrous aberration, rupturing a transcendental unity sanctioned by manifest destiny and imposed by the force of empire.

Until the fence was built in 1994, Playas Tijuana was a meeting place for Mexicans whose families lived on both sides of the border. On hot Sunday afternoons, crowds would gather for impromptu fiestas, spilling over from the Mexican side of the border, with its jumble of taco stands, to America's Pacific Gateway Park, with its orderly array of picnic tables. The construction of the fence sealed off this point of fluid contact, although there still remains a chain-link section of the fence through which Mexicans can greet each other like prisoners with visiting privileges. In James's photographs, the beach is deserted; a feeling of loss is palpable. The fence stretches out into the ocean and up a rocky incline like a strange amphibian creature. The graffiti on it declaring "*el mundo dividido*" announces that a symbolic reordering of the universe has occurred again, this time dividing the world in two.

As James follows the course of the fence inland, the desolation conveyed in the images increases. In his photographs of Colonia Libertad, the Tijuana shantytown that once was the convergence point for Latin Americans illegally crossing the border, an eerie solitude reigns. The fence looms over the ramshackle shacks and vacant streets, hemming in movement and space. The crowds that used to gather here in preparation for their exodus northward have been dispersed further east. Now the way to the Promised Land is a more surreptitious and dangerous two-to-three-day trek that begins where the fence ends in the San Isidro

Mountains. This stretch of territory is literally a no-man's land, a hostile terrain that harbours stories of migrants dying in the cold desert night, abandoned by the "coyote" guides hired to lead them. In James's photograph of this foreboding place, a twisting dirt road leads up a rocky outcrop. At the top, a patrol car, barely visible in the distance, lies in wait: a sentinel on guard for signs of movement.

The opening photograph of the series eloquently synthesizes the brutal and dehumanizing dimensions of this deadly game of hide and seek. A patrol car, sinister and immobile, is parked on the shoulder of a highway leading away from the Tijuana border towards San Diego. Behind it, a large caution sign picturing running figures in black silhouette warns motorists of migrants crossing, as if they might appear out of nowhere like wild deer darting in front of car headlights. The juxtaposition of the two iconic elements of the border—one signifying fleeing fugitives and the other surveillance and policing—establishes the terms of engagement for an unofficial war of attrition. Like the ancient Scythians—who the Greeks pursued in vain, only ever encountering the smouldering embers and the trodden grass of their abandoned encampments—the migrants never materialize. Only the residue of their presence is visible. Tread marks in the dirt, a hut bound and gagged in tarpaulin selling supplies for border crossings, three white crosses marking the memory of the dead: all are traces of unseen confrontations between illegal aliens and the shock troops of empire.

In answer to the question of how to photograph nomad space, James points his camera at the borderlands and mirrors back a barren landscape resonant with conflict. Whether one's eye is drawn to the patrol cars lying in wait or to the phantom signs of migrants in flight, there is no comfortable position from which to see or be seen. The photographer and viewer alike are implicated in a struggle over stasis and movement that stretches back in time to the mythic origins of Aztlán. The fence becomes a potent cipher of an imperial will to contain a flow of migrants, the desert that surrounds it a fluid continuum of time. Together these discordant elements coalesce to convey the sense of a liminal and contested territory: one that harbours secrets of life and death, undocumented histories, and ancient cosmologies. *Running Fence* excavates what the landscape withholds: dimensions of movement and memory that the camera can neither see nor record.

This essay first appeared in *Running Fence: Geoffrey James*. Vancouver: Presentation House, 1999.

PERFORMING MEMORY

THE ART OF STORYTELLING IN THE WORK OF REBECCA BELMORE

R ebecca Belmore is a sculptor and performer, a creator of installa-
tions and actions. She is an Anishinabe artist, an interpreter of
history. Above all she is a storyteller. In the early 1990s there was a
moment when, as a storyteller, Belmore felt she was being asked to tell
all: to spill forth words that tore open the wounds of colonial oppres-
sion and racism. She wondered if she was telling too much, and decided
to gather stories around her through gestures and objects rather than
through words. In her performances, her body became a cipher for the
way in which the scars of history are remembered; in her installations,
objects became offerings to a landscape that harbours the residue of
ancestral memory. Through her conceptual embodiment of story-
telling, Belmore has produced over the past ten years a powerful testi-
mony to art as a process of concretizing acts of remembering and
resistance, dreaming and mourning. Long after the exhibition closes or
the performance ends, the material traces of her artistic process live on
through their continual retelling. What follows here is my own retelling
of an exhibition held at the Blackwood Gallery in Mississauga in Febru-
ary of 2001, and of the insights Belmore has shared with me about her
artmaking.

On a bitterly cold winter day, with brilliant sunshine a fool's gold in
a harsh north wind, I drive out to the Blackwood Gallery to meet
Rebecca Belmore. Her exhibition, a performative work in progress, is
almost complete. Belmore has spent a month as an artist-in-residence,
creating a series of individual works that will form the component
whole at the closing of the show, rather than at its beginning. When I
arrive on the grounds of the University of Toronto at Mississauga,
where the gallery is located, Belmore has just returned from lighting a
fire and charring a log, ducking behind trees when the security car
drives around. The log, which she will subsequently pound with nails

and suspend above a bed of salt, is resonant with stories that reach back from the visceral moment of the work's creation to the ephemeral recesses of the artist's memory. Embedded in this work in progress are many allusions: to drums beating in the pounding of nails; to salt as an instrument of colonial trade and a simile for snow; to trees as natural monuments in a culture of spiritual clear-cutting; to shorn limbs as metaphors for our bodily existence. Like all the pieces in the exhibition, the log is alive with stories woven into its making, stories that fill the gallery with murmurs of poetry and affirmation, past injustices and present struggles for self-determination.

During our meeting we sit at a country kitchen table in one corner of the exhibition space, where tea can be sipped and recorded tapes of several of Belmore's performances watched. On the wall behind us Belmore has placed a single rose and a picture of her mother standing in front of a log cabin; on a small shelf on an adjacent wall, a tea service sits on a tray bearing the portrait of Queen Elizabeth II. Nearby, subtly embedded in drywall, a pair of glass eyes watches us. The picture of the artist's mother and the tea service form a collective memorial to the meeting of indigenous and imperial histories. The glass eyes are uncanny reminders that objects can see you as well as you see them, that landscape is not inert but acts upon one. Belmore tells me that her mother, whose name was Rose, used to stay alone in the trapper's cabin shown in the picture. Isolated deep in the Ontario woods, Rose kept company with a transistor radio. One evening as darkness descended, the batteries in the radio began to die, and the crackling noises of other people's words slowly faded away into an eerie silence. Belmore tells me that when she was a child her mother took her by canoe to the island where she was born. Years later, after her mother died, she decided to canoe to the island again; but although she recognized the shoreline and the landmarks, she couldn't find the place her mother had shown her. Silence, Belmore seems to be telling me, can be more powerful than words; the land harbours memories that we cannot always locate.

In 1991, Belmore travelled to Cuba to perform during the Havana Biennial. She chose as her site a historic colonial building, Castillo de la Fuerza (Castle of Strength), in which a staircase wound up the sides of an internal courtyard. With a long red rope binding her ankles and wrists together and gaging her mouth, she struggled up the staircase, scooping up and sweeping away the sand that lay across each worn step. Viewers gathered in the courtyard and at the top of the stairs could hear her exertion and panting, see the strain of her movements. Occasionally, she let a scream escape from her mouth. With these primal actions, stripped of words and props, she conjured the ghosts of slavery, the

silenced looks of oppression, the sweat of Cuba's sugar fields. In 2000, Belmore travelled to Grand Falls, Montana to perform *Bury My Heart*, a work whose title honours the dead of Wounded Knee, a massacre of the Lakota First Nation by the United States Army that took place in South Dakota in 1890. For the duration of the performance, a violinist played at the perimeter of a plot of land that had been transformed into a field of mud by a water sprinkler. Inside the perimeter, Belmore dug in the wet earth with her bare hands. She uncovered a hole filled with blood, and in the hole she placed a pioneer chair as well as a bouquet of carnations, which she subsequently pulled out, bloodied and bedraggled. As her feet sank into the oozing earth, her hands awash in blood and her white dress splattered with mud, her body and the remembering of history became intertwined. Through sparse and silent gestures Belmore had excavated the spirits of the dead.

In Canada, the dominant culture, born of English colonialism, has denuded the landscape of its sacred elements, repressed the spirits of the dead. The Group of Seven's paintings, as symbols of a nationalist heritage, empty the northern woods of human traces. Nature and culture, land and body, indigenous and imperial histories are not conjoined but severed. This severing finds its discursive echoes in the narratives of thinkers who have shaped our social imagination. Northrop Frye, an esteemed literary critic who searched for an answer to the question "where is here?", constructed an embattled vision of Canadian civilization as a bulwark against a hostile wilderness. For Frye, the overwhelming emptiness of untamed nature and the ways in which settlement despoiled the landscape were doubly alienating to the artist. "Canada," writes Frye, "is a country in which nature makes a direct impression on the artist's mind, an impression of its primeval lawlessness and moral nihilism, its indifference to the supreme value placed on life within human society. Its faceless, mindless unconsciousness fosters life without benevolence and destroys it without malice."[1]

In Frye's fixation on nature as a cultural void, the Canadian landscape (whether the craggy rocks and lonely pines portrayed by the Group of Seven or the inhospitable regions of the imagination mapped by Margaret Atwood in her book on Canadian literature, *Survival*) serves as the backdrop for Canada's historical narrative of an orderly progression from settler colony to modern nation. Memories of conquest and resistance are vanquished from representation, their absence papered over by mythologies of pristine wilderness or technological progress. Yet although they are excised and disavowed, these memories still linger, still trouble, still disturb, whether in the collective uprising of the Mohawk Nation to protect their burial grounds at Oka or in a quiet

moment walking in the northern bush when suddenly the trees begin to whisper and stare. The condition of historical amnesia in which landscape has been de-peopled is a traumatic one. It is this condition, this trauma, that Belmore addresses in her performances and installations.

As we sit talking in the gallery this winter afternoon, Belmore tells me that she has transformed the gallery into a landscape, one in which objects speak to memories of historical conflict. Across the room from where we sit, a pile of wood shavings forms beneath a pencil sharpener; near it lies a shredded-paper figure curled up into a fetal position on the floor. In the corner hang rags dipped in plaster and beside them a stiffened white shirt. Between the rags and the shirt, stencilled onto a patch of white plaster, are the names of sites of confrontation between First Nations people and government authorities: Oka, Burnt Church, Ipperwash, and Saskatoon. On the far wall tiny souvenir Canadian flags are arranged to resemble the profile of the American Indian from the United States nickel. Fluttering in a fan-propelled wind, the diminutive flags shed their national identity. They look more like dancing feathers, their shadows like clouds passing overhead, their profile like a mountain. Together, these pieces form the backbone of Belmore's narrative, retelling stories that we may have heard before in another guise, through the mass media or through history books. Each piece also references elements used by Belmore in previous performances, linking questions of who tells stories to a conjoining of body and memory.

The pencil-sharpener and shredded-paper figure are the material traces of a performance work in which Belmore sat in a storefront window and wrote by hand in pencil from sunrise to sunset. As she wrote she spoke her words aloud and viewers heard her voice through loudspeakers on the street. Time was marked by the movement of the sun and the repetitive action of sharpening the pencil. Through her use of a pencil and paper, Belmore transformed European instruments for recording history into gestures that preserved the past as oral culture. The significance of the manuscript Belmore produced during this day-long action did not lie in the meaning of the written words, but in the labour embodied by the reams of paper she used and in the disembodiment of language that viewers witnessed as they watched Belmore's silent, glassed-in body mouth the words they heard. By tearing up the manuscript and shaping from its remnants a bodily form in the gallery, Belmore creates a memorial to experience that the written documents of history excise or misrepresent. The shredded-paper figure also has an immediate historical resonance with the stiff white shirt that hangs on the wall. Both these objects render visible the legacies of a racist history, alluding to the frozen bodies of two First Nations men in Saskatoon,

who in the winter of 2000 were taken by police to the outskirts of the city and left there to die in the snow without shoes or coats. The plaster rags are visual echoes of the stiffened white shirt, suggesting the repetitive actions of washing, scrubbing, and cleaning away negative stereotypes. As part of a landscape in which the spirits of the dead are remembered and mourned, the rags become the guardians of memory: clouds, dreams, and ghosts.

In 1991, as the mass-media coverage of the 1990 Oka confrontation began to solidify into a historical narrative that silenced First Nations voices and their stories of the uprising, Belmore created an enormous megaphone that she used in a series of performance actions titled *Ayumee-aawach Oomama-mowan: Speaking to Their Mother.* The megaphone served as a flashpoint of protest and storytelling in different locations across Canada from Banff National Park to the prime minister's Sussex Drive residence to a northern Saskatchewan logging blockade. In each performance, Belmore would approach the megaphone and speak first, addressing her words to the earth. Then others who were gathered around would take their turn. As they spoke into the megaphone, an echo could be heard. As the earth returned words scattered in the wind back to the speaker, stories were embedded in the landscape. Ten years later, as we sit and talk within another kind of landscape, one filled with traces of Belmore's performative actions, she tells me that she does not have beginnings in her work, only endings. Yet through her artistic process of fusing body and earth, her endings are always the beginnings of other stories, her stories are gifts of memory, and her memory becomes a repository of history.

Note

1. Northrop Frye, "The Narrative Tradition in English Language Poetry," in *The Bush Garden: Essays on the Canadian Imagination* (Toronto: House of Anansi, 1971), 146.

This essay first appeared in *Rebecca Belmore: 33 Pieces.* Toronto: Blackwood Gallery, 2001.

CARTOGRAPHIES OF MEMORY

TRACING THE REPRESENTATIONAL LEGACY OF ARGENTINA'S DIRTY WAR IN THE WORK OF GUILLERMO KUITCA

In Buenos Aires, where Sarmiento, an Argentinian president during the 1800s, imported sparrows so the city would seem more like Paris, the elaborate edifices of European culture are in disrepair. The old colonial streets that sheltered the mysterious Aleph of Jorge Luis Borges's literary imagination and Ernesto Sabato's paranoiac encounters with the blind have become collages of uneven development: a jumble of modern concrete and boarded-up façades.[1] Despite the massive privatization schemes and harsh austerity measures of the Menem regime in the 1990s, there are no gleaming pastel towers of postmodernism and *villas miserias* (shantytowns) arrayed in stark contrast to signal the advance shock troops of foreign capital. A relentless urban conformity stretches from the city centre to the suburbs, a vast industrial dreamscape pockmarked by decay. Heterogeneity in Buenos Aires is not mapped upon a visible grid of stone and mortar, but located in the hidden recesses of its interiors, where the shadows of the dead haunt the living, and the flickering lights of the television set illuminate the present.

In the late 1970s, at the height of the military repression that followed the *coup d'état* on March 24, 1976, soldiers systematically cordoned off city blocks of Buenos Aires, and house-to-house searches for left-wing "subversives" took place. Those caught in the dragnet without the proper documents were hauled off to unspecified locations. Some would never return or be heard from again. At night, an eerie, paralyzing silence descended upon the city. Green Ford Falcons, the favoured unmarked vehicle of the security forces, patrolled the deserted streets. Their targets were specific: particular apartment buildings or houses under surveillance, from which people were dragged from their beds to a state-sanctioned fate of torture and disappearance. Neither television nor the print media acknowledged the sinister terror that stalked the city. The day after the *coup d'état*, it was as if the struggle for political

power in Argentina—with attendant reports of urban guerrilla activity, union conflict, unbridled corruption, and hyperinflation—had fallen into a black hole. "Quietly, effortlessly—with no upheaval, no cataclysm, not even a ripple of resistance,"² writes historian Eduardo Crawley, images of tension and turmoil abruptly vanished from the media. Yet in each neighbourhood, everybody knew of someone who had disappeared.

In terms of military strategy, the explicit objective of this dirty war and the fear it bred was two-pronged: to eliminate the populist legacy of Peronism, which had given Argentinian workers social, economic, and political rights; and to excise the spectre of Marxism spreading throughout Latin America and threatening the future of patrimony, order, and economic neoliberalism. At the heart of the "disappearances," however, argues anthropologist Michael Taussig, was an attempt by the military to control something far more ephemeral than political power: that of collective memory. "As I see it," writes Taussig, "in assassinating and disappearing people, and then denying and enshrouding the disappearances in a cloud of confusion, the State (or rather its armed and policing forces) does not aim at destroying memory. Far from it. What is aimed at is the *relocation and refunctioning of collective memory*."³ Implicit in the disappearing of bodies was the military's objective to fracture the possibility of mapping a history of repression, to transpose resistance as an act of remembrance from the public sphere to the private realm of the individual and the family. In the middle of the night, the souls of the dead did not belong to the people, but to the faceless men in the unmarked cars who hunted their prey.

On December 6, 1995—twelve years after the end of military rule—the Mothers of the Plaza de Mayo hold an anniversary vigil for *los desaparecidos* (the disappeared). The Avenida de Mayo leading to the historic plaza is lined with thousands of photocopied faces that flutter in the wind, bodiless testimonies to the annihilation of a generation of Argentinian youth. In 1977, when the Mothers of the Plaza de Mayo first began their weekly vigils, they clutched photographs of these faces to claim a public space for the memory of "disappearances" the military regime claimed had never happened. They entreated the reporters, who had gathered at the plaza to record their presence, to denounce the unspoken atrocities of the military regime; they spoke into the cameras about their futile search for official information of their children's whereabouts. You are, they told the reporters, our last hope in breaking the silent collusion that prevents the living from claiming their dead. In response, the media publicized the military's denunciation of the women as *las locas* (the crazy ones). Yet by the early 1980s, images of the

desaparecidos began to appear at random on walls in downtown Buenos Aires. Some were facsimiles of family photographs, accompanied by a name and the date of the person's disappearance; many more were blank, white silhouettes. Visible traces of the repression the military had disavowed, they signified the re-emergence of collective memory in the public sphere.

A few blocks away from the Plaza de Mayo, located in the headquarters of the CGT (Confederation of Unions) is the private office of Eva Perón. It was from this office that Evita rallied the support of the *descamisados* (shirtless workers) for her husband, President Juan Perón, in the 1940s, and dispensed social aid ranging from the building of hospitals to individual handouts. When Evita died, on July 26, 1952, a massive public surge of mourning occurred. Perón summoned a doctor to embalm her body, which thereafter lay, like Lenin's corpse in Moscow, on display in the antechamber of her office at the CGT. A union filed a formal request with the Vatican for her canonization, and images of "Santa Evita" with a halo began to circulate around the country. In 1955, after the military overthrew Perón's government and forced him into exile, they stole Evita's perfectly preserved corpse from the CGT and spirited it away to a secret location in Europe. To hide the trail of the body's disappearance, the military had three wax copies of her body made and hidden in different European cities.[4] References and images of Evita were purged from the public sphere, yet dedication to her memory did not falter. When Perón returned from exile in 1973, hundreds of thousands of youths lined the streets of Buenos Aires chanting "*Si Evita vivería, sería montonera*,"[5] claiming Evita as the patron saint of left-wing militancy.

In 1976, Evita's body was finally buried in La Recoleta cemetery. The military had secretly returned it to Argentina from a hiding place in Italy and laid it to rest in a crypt designed to withstand saboteurs, grave robbers, and nuclear bombs. Yet as the Mothers of the Plaza de Mayo hold their vigils for bodies that are still missing, it is not Evita's grave that is most venerated. Rather, it is her private office—untouched and closed to the public since the kidnapping of her body by the military in 1955—that has become the focal site of commemoration. On the anniversary of her death, the faithful gather outside the CGT to offer flowers and mementos to her phantom presence, who the building custodians say they can hear laughing in the middle of the night. At the Plaza de Mayo that sombre December day in 1995, Evita is also in attendance. Large banners bearing her image are interspersed among the photocopied faces of the *desaparecidos*. Prominently displayed beside her is the photographic icon of Che Guevara, the revolutionary hero

who also pervades the collective memory of resistance and repression in the turbulent post-war history of Argentina history.

While the Mothers gather at the Plaza de Mayo, another search for a missing body is underway. At a rural airstrip in Bolivia, an international team of archaeologists and security agents has arrived to attempt to recover the remains of Che Guevara, assassinated by the Bolivian army in collusion with the CIA in 1967. According to CNN, one of the fifty-odd television signals that flood the living rooms of Buenos Aires, local *campesinos* claim to know where the body lies, and Cuba and Argentina are already arguing over where it should be reburied. The team, however, is unsuccessful in their quest to find it. What CNN does not report is the rumour circulating in Bolivia that the peasants are reluctant to reveal the body's whereabouts, as they believe its removal will disturb the messianic power and solace it imparts to local inhabitants.

On local broadcasts the same evening, coverage of the search for Che's body and the anniversary vigil at the Plaza de Mayo is overshadowed by the controversy that has erupted over the imminent arrival of Madonna in Buenos Aires. She is to star in Alan Parker's film version of the rock-opera *Evita*, in which she plays Eva Perón and Antonio Banderas Che Guevara. President Menem has announced that he will not permit the film to be shot on government property, including the Casa Rosada (Argentina's pink equivalent of the White House, which borders the Plaza de Mayo), in front of which the workers gathered to hear Evita's speeches. A proliferation of graffiti has sprouted along the highway leading from the international airport to the city centre, denouncing the travesty of Madonna's casting as Evita in a Hollywood-financed remake of Argentinian history. Yet several months later, when Madonna enters a downtown restaurant dressed the part, with contact lenses that turn her brown eyes green, patrons gasp in astonishment at the resemblance, and the reappearance of an embodied Evita in their midst.

*

In this surface chaos of missing bodies and phantom icons, local vigils and global transmissions, it is not physical evidence that constitutes a history of repression and resistance, but ephemeral images. Over 30,000 Argentinians were killed by the military during the dirty war; most of their bodies have never been recovered. Since the process of "redemocratization" began in 1983, the concentration camps and torture centres that held them captive have been destroyed, and records of their final destinations secreted away. The torturers have been granted amnesty by the Menem government and military bases are being converted into shopping centres. In the absence of a recognizable cartography of graves

and documents, it is the process of remembering that marks the dislo-
cation of bodies and history.

Like the nomad sentinels of a past that cannot be codified or forgot-
ten, the photocopied faces of the *desaparecidos* link the deterritorializa-
tion of history to a deterritorialization of bodies, attesting to the power
of mimesis to conjure the memory of their (absent) presence. On the
other hand, the phantom icons of Evita and Che link a deterritorializa-
tion of history to a deterritorialization of images. Appropriated and
refashioned by the narratives of the mass media, Evita and Che become
the transnational commodities of the imagination. Yet the mysticism that
they inspire attests to the power of images to invoke popular veneration
and local resistance. In this confluence of disappearances, official denials,
and populist remembering, the struggle over the relocation of collective
memory surfaces in unexpected configurations and significations.

*

In stark contrast to the image profusion of the *desaparecidos* and pop-
ulist heroes, Argentinian artist Guillermo Kuitca has produced, since the
late 1980s, paintings that are emptied of people. Working first with
maps of European cities found in tourist guides, then with generic blue-
prints of stadiums, hospitals, and theatres, Kuitca traces facsimiles onto
canvas with faint, draftsman-like gestures. In the process, he transforms
the original referents into opaque labyrinths. There is something arrest-
ing, almost uncanny, in the severity and fragility of these paintings. In
conjuring sensations of disorientation and displacement, they appear to
uphold Jean Baudrillard's dictum that the map now precedes the territo-
ry, offering a visual analogy for his claim that the overproduction of
information has produced a simulacrum—a hyperreal—disassociated
from lived experience.[6] Yet when placed within the representational
legacy of Argentina's dirty war, Kuitca's paintings generate meanings
that sharply diverge from Baudrillard's vision of the hyperreal and
attendant loss of signification.

During the dirty war, a lack rather than an excess of information
engendered the simulacrum; fear and silence severed signs from their
material referents. Viewed through the veil of state terror, Baudrillard's
hyperreal finds a sinister and unsettling alterity in the coercive dismem-
berment of collective memory by the Argentinian military. This alterity
finds its visceral symbol in the image of the *desaparecido*. It finds an
imaginary counterpart in Kuitca's reconfigurations of city streets and
building blueprints. Rather than appropriating and rendering static the
dynamic circulation of phantom icons, Kuitca charts the absence of
their resting places. The claustrophobic and tightly wrought circularity

of his paintings conjures the web of fear produced during the dirty war. The intersecting planes and architectural grids of his canvases visually transcribe the paralysis of silence that descended upon the deserted city streets of Buenos Aires, and the sinister disappearances of people in the middle of the night. Abstracted representations of state terror, Kuitca's paintings deterritorialize spatial order to chart the interiority of remembrance.

Kuitca's use of European city maps also evokes the historical particularity of Buenos Aires's nineteenth-century quest to copy Paris. By retracing the city streets of Prague or Barcelona, Kuitca transforms Old World cartography into a template for New World disorientation, revealing the impossibility of fixing into place bodies that disappear without a physical trace. Transposing his facsimiles of city maps onto mattresses in a 1993 installation in Valencia, Spain, Kuitca unveils the gap between the intimacy of terror (the beds from which subversives were dragged in the middle of the night) and the impenetrability of the exterior façades that house the memories of the event (the undisclosed centres of torture, the secret concentration camps).

Kuitca's series of paintings of architectural blueprints, entitled *La Tablada*, alludes to the residual traces of history that emerge from this gap between state repression and its public denial. While the blueprints of the hospitals and stadiums he retraces onto canvas are generic, the title of the series evokes the memory of a specific event in Argentinian politics: a guerrilla attack on the La Tablada army base near Buenos Aires in January 1989. Taking place six years after the fall of the military junta, this attack seemed to erupt out of nowhere. The brutal military repression that ensued when the base was retaken—with many of the guerrillas murdered after they had surrendered inside the compound—resonated with the horror of a past that had not been forgotten or forgiven. Occurring in the context of repeated attempts by the military to overthrow the democratic government, La Tablada served as a tragic reminder of the legacy of militancy and repression that simmered below the surface of civilian society.

In this context, Kuitca's canvases become enigmatic signifiers for the legacy of violence in Latin America that haunts the present. In 1973, following the military's overthrow of Salvador Allende's Popular Unity government in Chile, the stadium in Santiago harboured the bodies of "subversives," the first casualties in a continental military strategy of disappearing adversaries. Like a blueprint for future repression, the brutality enacted in this stadium radiated outwards from Chile (by way of an American training camp in Panama) to Argentina and then across the continent, the tentacles of terror penetrating the infrastructures of civilian society. Even hospitals became recruiting grounds for doctors

willing to use their medical expertise to refine the torture techniques carried out upon the *desaparecidos*. In his paintings, Kuitca retraces the grid lines of these "invisible" repressions to create abstract memorials to a history of terror.

Juxtaposing Kuitca's cartographies and the iconography of Evita, Che, and the *desaparecidos*, there emerges an interplay of (absent) presence and missing bodies, deterritorializations and conceptual mappings that challenges the cynicism and passivity of Baudrillard's simulacrum. Although the triumph of consumerism and the ascendancy of a hyperreal is as easily observed in the shopping malls and on the television screen in Buenos Aires as in Toronto or Los Angeles, it is not the fluidity of capital and images that maps the past in Argentina but the alterity of collective memory. Extending from a surface chaos of icons to the austerity of Kuitca's paintings, this alterity offers a (dis)location from which to envisage the simulacrum as site of resistance rather than of capitulation, and to imagine the heterogeneity of local memory as an antidote to the homogeneity of global culture.

Notes

1. Jorge Luis Borges, "The Aleph," in *The Aleph and Other Stories 1939–1969*, ed. and trans. Norman Thomas di Giovanni (New York: Bantam Books, 1970); and Ernesto Sabato, *On Heroes and Tombs*, trans. Helen R. Lane (New York: Ballantine Books, 1981). "The Aleph" is the story of a mysterious sphere in which one can see the infinity of consciousness and the eternity of the universe. *On Heroes and Tombs* tells the story of a sect of blind men who entrap the narrator in an underground labyrinth in which visions of infinity and eternity become a terrifying nightmare.

2. Eduardo Crawley, *A House Divided: Argentina 1880-1980* (London: C. Hurst & Company, 1984), 421.

3. Michael Taussig, "Violence and Resistance in the Americas: The Legacy of Conquest," in *The Nervous System* (New York: Routledge, 1992), 48. Emphasis in original.

4. For an account of Evita's life and after-life see Tomás Eloy Martínez, *Santa Evita*, trans. Helen Lane (New York: Knopf, 1996).

5. This slogan translates as "If Evita would have lived, she would be Montonero." Montonero refers to a leftist movement of urban guerrillas that emerged from the Peronist resistance during the military dictatorship of the late 1960s. The movement attracted the support of many Argentinian young people, and when Juan Perón returned to Argentina in 1973, it pressed for radical social and economic reforms. With the military coup of 1976, the Montoneros went underground and became a target of military repression.

6. Jean Baudrillard, "The Precession of Simulacra," in *Simulations*, trans. Paul Foss, Paul Patton, and Philip Beitchman (New York: Semiotext(e), 1983), 2.

This article first appeared in *Parachute* 83 (1996).

ANATOMY OF AN INSURRECTION

To articulate the past historically does not mean to recognize it "the way it really was" (Ranke). It means to seize hold of a memory as it flashes up at a moment of danger.
— Walter Benjamin, *Theses on the Philosophy of History*

In the 1990s, I was travelling with friends in northern Argentina when we came upon a makeshift memorial to the *desaparecidos*: those murdered by the military dictatorship in the late 1970s and their bodies disappeared. It was early morning on a desolate stretch of highway near Jujuy; greeting us were the remnants of an all-night vigil: the embers of a fire smouldering, roses wilting. On the ground lay life-size paper cutouts of human figures, each with a name written across the torso for each of the political prisoners assassinated in this remote place twenty years before. My friends had known these paper cutouts as breathing, dreaming bodies, upon which the Argentinian military had enacted an unspeakable violence. In response to the military's intent to "disappear" all evidence of their remains, those who survived had placed silhouettes in their stead. Since that early-morning chance encounter, the scene of the paper bodies scattered on the ground has lingered in my mind. As a witness to this fragile memorial, I keep thinking about how a fleeting act of remembering keeps alive a history that many want buried, how material gestures create a collective archive for the recording of utopian dreams and brutal endings.

Toronto, with its intimate downtown neighbourhoods and relentless suburban sprawl, is where I was born, yet sometimes I feel as if my body is suspended above the clouds somewhere in between the grey sheen of Lake Ontario and the muddy waters of the Río Paraná in Argentina. Perhaps it is because I am in the process of moving back and forth between Canada and Argentina that my search for a historical fabric of memory has a sudden urgency and elusiveness. Memory is so unreliable,

selective, subject to unconscious slips and repression. Why is it that we can never remember pain? Why does pleasure come enveloped in the gauze of nostalgia? Memory is the raw material of our lives, a repository in which the past resides and emerges in unexpected ways, erupting in dreams, in images, in words. How, then, do we gather its traces into a form that is no longer personal but collective in its dimensions?

In December of 1999, I am once again travelling in Argentina. On my way to Corrientes, a colonial city in northern Argentina founded in 1588 at the junction of the Paraná and Paraguay rivers, I stop at a café in Buenos Aires. I sit, pen in hand and writing little, overcome by the strange, intense exhaustion that comes from an all-night journey, think-ing about the stark contrast between Canada's orderly progress and the historical turbulence of Argentina. When I arrive in Corrientes the next day, I find the city engulfed in chaos. Six months earlier, protestors erected a tent city in the central plaza to demonstrate against corrup-tion and unpaid wages. Still protesting, still unpaid, they have occupied the bridge that traverses the grand Paraná river. The bridge, a two-kilo-metre-long causeway joining Corrientes to the neighbouring province of Chaco, symbolically links the past and the present. It is a crossing place between the vast wilderness of Chaco—until the late nineteenth-century fiercely defended against colonization by indigenous peoples—and Corrientes, the birthplace of a mixing between the Guaraní Indians and the Spanish conquistadors that dates back to the 1500s. Today, the bridge forms an integral part of an international trucking route linking Argentina to Brazil and Bolivia.

It has been three days since the protestors first occupied the bridge, a graceful arch of girders and suspension wires that has rendered obso-lete the once bustling port of Corrientes, now a naval graveyard of rusting cranes and half-sunken ferryboats. The only way to cross the bridge—piled high at the centre with old car parts doused in gasoline and burning tires—is by foot. People walk slowly in the searing mid-day sun, picking their way through the debris of the barricades, weav-ing around family encampments, communal kitchens, and open-air assemblies. On the highways leading to the bridge, trucks filled with rotting vegetables and cows parched from a lack of water form long lines. Drivers set up lawn chairs near their vehicles, drinking beer while their wives hang clothes out to dry on improvised lines. At the foot of the bridge in Chaco, the National Guard amasses, lean, taut men dressed in combat fatigues and visor helmets carrying Plexiglas shields and large black guns.

On the fourth day of the occupation, the chorus of opinions about politics and protest that fill the local talk-radio shows is abruptly inter-

rupted. A blaring warning resounds across the airwaves: the National Guard is advancing, tanks and troops are bearing down upon the protestors. Journalists stationed at satellite units on the bridge make urgent calls for reinforcements; the hysteria in their voices engulfs the city in mass revolt. I leave the house, swept up in a rushing current of people running from downtown businesses and shantytowns, clutching briefcases and knapsacks, running towards the bridge. There are middle-aged businessmen with large bellies and tough-looking hoods with their shirts stripped off and elegant middle-class señoras with high heels and painted nails and dangling earrings. They grab rocks from the streets as noise crescendoes, hundreds of people pounding sticks and stones against the guardrails of the bridge. Black smoke rises from burning tires and the acrid fumes of tear gas waft against a red sun setting. The army and the people are fighting for possession of the bridge, advancing and retreating, regrouping and advancing once more. A siren wails and the crowd gives way for an ambulance to carry out the wounded. Then, as suddenly as it began, the fighting ends. A cheer goes up as the National Guard withdraws its troops back across the bridge to Chaco. Spontaneous dancing breaks out in the streets. In the heat of insurrection, the people have won a momentary victory.

As I watch the battle unfold from the foot of the bridge, my partner turns to me and asks, "Why didn't you bring the video camera from Canada?" But how could a video camera capture the emotions that grip the crowds, convey the sheer rage at the army's invasion of their city? How could the narrow viewfinder record the panorama of the confrontation, miniature gladiators moving back and forth across the bridge in the distance, locked in hand-to-hand combat like actors in a cinematic scene with a cast of thousands? As the tear-gas fumes fill my stinging eyes with tears, he gives me a blue handkerchief to dunk in water and cover my face. I still have that handkerchief, stained with black ink and spotted with the lint that gathers at the bottom of my purse. It is a talisman of the day I became a witness to the inchoate forces of history.

Years ago, I had dinner with an Argentinian woman who was living in Winnipeg. She had been part of the student movement of the 1970s and had fled Argentina after the military coup in 1976, travelling through Bolivia and Peru to end her journey on the cold winter plains of Alberta, a hothouse plant brutally transplanted. She described a childhood memory of the uprising of the *descamisados*—the shirtless ones—in 1955. Perón had been overthrown by the military and the workers had taken to the streets, thousands of men pouring out of the poor *barrios* on the outskirts of Buenos Aires towards the city centre. It

was terrifying, she told me, to peer out from behind white lace curtains into the black night, watching people surge past her window like an unstoppable hemorrhage of blood pouring from an open wound. I had never been able to imagine what she saw that starless night, to sense the panic that gripped her as the crowd moved past her, brandishing sticks and rocks, until that moment at the bridge in Corrientes. Caught in the swirling anger of the crowd, I watch as the *descamisados*, stripped to the waist, bodies blackened by the soot of the burning tires, muscles in their arms glistening from the sweat of battle, walk out of the pages of a history book and into my field of vision. Something stirs deep inside me, a visceral sensation of time in convulsion, of emotion overtaking reason, of Goya's sleeping monsters awakening.

Since the National Guard's failed attempt to take the bridge, a restless people's army has formed. They come by the hundreds, with baskets of bread and rocks to feed the protestors and the barricades. Around the city, *campesinos* take to the highways, erecting spontaneous roadblocks to prevent any movement in or out of the city. The truckers grow more impatient; the line of trucks grows still longer. Shortages of gasoline and milk begin. The siege of the city tightens. On the bridge, the atmosphere is tense. During the day, the temperature climbs to 50 degrees Celsius. At night, hot breezes from the river spell slight relief. The pavement is slick with gasoline, and burning tires illuminate the all-night vigils. Groups of young men from the poor *barrios* mill about, waiting for the next confrontation, as families cook over makeshift stoves. On the sixth night of the occupation, a priest arrives in flowing white robes to mediate the conflict. He preaches absolution and plots behind the scenes to rob the people of their pride, the way the politicians robbed them of their salaries. He promises to save their souls but has no money to fill their stomachs. The response from the people on the bridge is swift and resolute. They will not leave until all their back wages are paid in full. Carnival has turned to war.

I have come to Corrientes for neither carnival nor war, but to work in the provincial archives, a collection of moth-eaten documents housed in an old colonial mansion in the city centre. The archive is run by Doctor Bos, a chain-smoking, patrician member of the local oligarchy, who has rescued the decaying documents from the dank basement of a government building at his own expense. The archive holds out the allure of an unexplored history. There are town-hall proceedings and land grants from the 1600s; there are judicial records and Jesuit mission inventories from the 1700s. All are languishing here, unread and neglected. Every day I go to the archive, ring a bell to open the locked door at the entrance, and sit at a long, dark, polished-wood

table, a fan blowing hot air on my face, turning the pages of leather-bound volumes, trying to decipher the ornate calligraphy of a distant colonial past. Many of the documents, however, are so badly damaged and so full of holes that they are indecipherable. As I sit in the dimly-lit, high-ceilinged rooms of the archive, poring over yellowing parchment sheets, I cannot help but think about the paradoxes of a historical discipline dedicated to knowing the past through written sources. If the moths have eaten all the evidence, I wonder to myself, does that mean that Corrientes is bereft of history?

One afternoon, Doctor Bos calls me into his office to show me a number of prize documents he has discovered in his rummaging through the mountains of paper he has saved from oblivion. A tall, imposing man, dressed impeccably in a double-breasted suit despite the humid heat, he prides himself on an unbroken line of ancestry leading back to the first conquistadors in the region. He owns vast tracts of land granted by the king to his forefathers, and travels to Europe several times a year. Vienna is his favourite city, so civilized, so cultured. If I ever go to Spain, he tells me, I should look up his friend, La Contesa Rouge, who has in her personal library the original manuscript of Álvar Núñez Cabeza de Vaca's account of his eight-year walk across the American Southwest in the 1530s.

With his hands stained yellow and slightly trembling from too many years of cigarette smoking, Doctor Bos takes a key from his suit pocket and opens a locked bookcase with etched-glass doors. He leafs through the pile of papers stacked on the shelves and pulls out the original court proceedings relating to the criminal trial of Camila O'Gorman and Ladislao Gutiérrez. In 1848, Camila, a young aristocratic girl, became pregnant with the child of Ladislao, a priest. Together they fled from Buenos Aires to the province of Corrientes, where they were caught, brought to trial, and executed for breaking the moral code of the oligarchy. Doctor Bos pulls another document from the shelf. This, he tells me, is a private letter written by the aunt of the local hero of the independence wars Juan José Cabral, whose statue with a rearing horse and drawn sword adorns the central plaza of the city. In the letter, she reveals a family secret. My nephew, Juan José Cabral, she writes, is the son of my brother, a priest, and Josefa, our domestic slave girl. Cabral, whose Caucasian features are celebrated in monuments across the country, is an illegitimate mulatto.

I am only able to get the briefest glimpse of the documents laid before me before they are wrested away and placed back under lock and key. I am a witness to their authenticity, but prevented from verifying the evidence that counters an official history. As they disappear from

sight, I ask Doctor Bos if he might have other documents related to the Jesuit missions. Many, he assures me, and lifts a silver bell to summon one of the young men who toil in the archive. "Bring me volume six of the *Temporalidades*," he orders in an imperious voice to a boy who comes scurrying to his office, then just as quickly vanishes back into the darkened recesses of the archive. A few minutes later, the boy returns with a large dusty tome, the covers tied together with thin white laces. As Doctor Bos struggles to undo the laces, a red flush mounts across his face. "They have touched my documents," he announces in a raspy voice laced with horror. "They have touched my documents with their dirty, dirty, dirty, hands." They—the local Correntinos who have access to the archive by law—enrage Bos by their very existence, barbarians sullying the vestiges of civilization with their blackened fingers.

In the early hours of Friday morning on the eighth day of the occupation, the electrical power in the city goes out. The bridge and the neighbourhoods that surround it are plunged into darkness. At the same moment, soldiers in full riot gear storm the bridge, pinning huddled protestors in the glare of floodlights. In the confusion of tear gas and rubber bullets that follows, a journalist from Crónica TV is wounded. Behind the soldiers, a bulldozer approaches to clear the bridge of barricades, destroying in its path the mobile broadcasting units that could sound a radio alarm. At five o'clock, the National Guard retakes the bridge and the truckers begin to pass. By five-thirty, fighting has spilled onto the avenue that leads to the bridge and the sound of bullets punctures the early-morning air. At six o'clock, as dawn is breaking, the first death is reported. In the neighbourhoods around the bridge, the tear gas is so thick that families flee their houses, eyes red and swollen, children screaming in the darkness. At six-thirty, another death occurs.

By midmorning, street battles are raging and frantic voices fill the radio airwaves: women imploring for the violence to stop; *campesinos* calling to say they are coming in trucks from the countryside to fight the army. The *descamisados* stream in from the poorer *barrios*, drawn into the conflict by their inarticulate anger at the poverty they endure. On the avenue by the bridge, the National Guard lance tear-gas bombs and shoot into the crowd; protestors throw stones or simply howl their indignation at the repression unfolding in front of them. At the airport on the outskirts of Corrientes, troop reinforcements arrive in two Hercules planes: six hundred men, two tanks, and heavy artillery. In the city centre, the hospitals are overflowing with the wounded.

Across from the bridge lies the provincial jail, a medieval-looking fortress with small slits for windows and castle-like turrets. Inside its maze of hallways and cells, Hugo Perié, the acting governor of the

province, is trying to negotiate an end to the spiralling violence. He was a guerrilla leader in the 1970s, and is now an elected senator and the head of the provisional government brought to power by a people's movement that began with a tent city and has ended in street battles on the avenue. Thirty years earlier, Perié was held as a political prisoner in this very jail, which he escaped from in a guerrilla raid. Once again he is inside its walls, only this time he is not fleeing the repressive apparatus of the state but mediating its terror. The National Guard commander, Ricardo Chiappe, is an old military cadre: during the dirty war, he was in charge of a secret concentration camp named La Perla. By the early evening, Perié and Chiappe reach an accord. The local police agree to form an unarmed human shield to quell the rebellion. As the police walk hesitantly into the mêlée holding high white ceasefire flags that flutter in the wind, a hush descends upon the crowd. Arms raised to throw rocks are slowly lowered. Protestors begin to melt away into the side streets. The confrontation ends as night descends, the remnants of the barricades and the burning tires still smouldering on the now deserted avenue, their flickering light casting eerie shadows upon the debris of the all-day street battle.

The next morning, the gypsies who live on the avenue near the bridge in a huge, cavernous building—brick and mortar transformed into a stationary tent—call the radio to denounce the army, who, they say, burst into their home, took them captive as tear gas overwhelmed them, went to their roof, and began to shoot at the protestors. The radio also reports that the army approached another house on the avenue and ordered the occupants to stop playing revolutionary music. The owner of the house refused, and when the soldier told him that his refusal to comply would have serious consequences, he ripped open his shirt and yelled, "Just shoot me, then, right here and now, but I'm not turning off my music." In Buenos Aires, the national government holds a press conference to denounce the violence in Corrientes, claiming outside professional agitators have instigated the insurrection. They accuse the provincial police of giving guns to the people and cast blame for the wounded and dead on anonymous snipers. Yet despite the bravado and the denunciations, the National Guard has done its job. By Saturday night, when a silent march is held to mourn the dead, many of those who had occupied the bridge are absent, quietly dismantling their tents in the plaza or sitting at home behind closed doors, shaken and scared. Of the thousands who once marched through the streets demanding justice, there are now only a few hundred, who walk stone-faced from the plaza to black crosses erected on the avenue to mark the dead. It is only when they see the sinister green wall of soldiers posted at the

entrance to the bridge that they become agitated, raising their fists to the sky and chanting, "*Un pueblo unido nunca será vencido*," as if this were Nicaragua in 1979 and not a small provincial town in Argentina twenty years later.

In Corrientes, resistance ends in inconceivable violence: troops, tanks, ambushes in the dead of night, tear gas, live ammunition shot from guns designed to discharge rubber bullets, house-to-house searches, four dead, thirty wounded, fifty arrested. It is the week before Christmas and Corrientes is a city in mourning, an occupied territory. The national government has dissolved the parliament and sent its own officials to run the province; the National Guard replaces the local police as the enforcer of order. When the Sunday newspapers arrive from Buenos Aires, the photographs they feature of the insurrection seem at odds with the witness' memories of the Friday street battles. In the images, the National Guardsmen form a disciplined line; across the avenue, a few lone men, bandannas covering their faces, are throwing rocks. It is only after carefully examining the images that one realizes the position of the troops in relation to the avenue and the bridge is wrong. The photographs have been digitally altered to create another version of events. In the analysis accompanying the images, the press describes a day of anarchic violence fuelled by the bellicose Guaraní blood of the Correntinos. Across the city, people whisper in low voices: the papers are full of lies.

After the repression, people settle back into familiar rhythms of living. They form queues blocks long, still waiting to be paid salaries owed to them since June. They sit and sit and sit, no longer waiting in anticipation but in resignation. To sit drinking *maté* on the bridge is a form of protest; to sit drinking *maté* in front of the house, unemployed, is a known form of defeat. A friend in Canada writes to me by e-mail to tell me that he cannot find any information about what happened in Corrientes, either in the newspapers or on the Internet. The events of the last weeks have fallen into a black hole of nothingness—or perhaps it is a milky white one like José Saramago describes in *Blindness*—a white nothingness that breeds a horrifying brutality.

On the last night of the millennium, as the crescendo of fireworks and gunshots splutters and fades into the dark blue night, I am overcome with restlessness. The contrast between Toronto, with its urgency to do in order to live and be defined, and the interminable waiting in Corrientes is suddenly intolerable. At first my sense of resignation is abstract, a fact that has no substance, no earth attached to its thought. By New Year's Eve, defeat becomes palpable, its taste bitter. Sadness

pours over me like a rainfall, emotions saturate, the body disassociates. The first time I saw Corrientes, I was enraptured by the play of light and dappled shadows, the soft pinks of dawn and the red streaks of an early-evening river walk. This light had a calibration, an intensity, I had never known in Ontario; it marked a strangeness that could not reach my childhood repository of sensations. Now it is darkness, not light, that reaches out to touch me. I am bathed in black, as if I have been carried to the river and gently pushed into one of the sinister whirlpools formed by the current, which draw you down to depths where the sun cannot reach and leave you there, an offering to the river spirits.

It is December, 2000, and I have returned to Corrientes. The interim government appointed after the uprising is still in effect; the parliament is still dissolved. People still form long lines waiting to be paid, their salaries now issued in government coupons that only the grocery stores will accept at face value. In the city centre, the archive lies shuttered and empty. Doctor Bos has died, and the personal collection of documents in his office has disappeared. The letter from the aunt of Cabral, the great revolutionary hero of Corrientes, once again lies in private hands, a piece of history sequestered in one of the colonial houses of the oligarchy, behind its ornately carved doors and intricate iron grillwork windows and internal patios lined with mosaic tile. On the anniversary of the ambush, I walk to the bridge. A march is planned from the central plaza to the crosses marking the dead on the avenue. By early evening, only a few people have gathered. Across the street, a much larger group has formed around an outdoor café television. Boca is playing River and the city is transfixed with soccer, cars streaming along the avenue where once there were protestors, waving the bright yellow and blue flags of the winning team.

The week after Christmas, I awake to torrential rains beating out a staccato rhythm on the tin roof, water cascading in rivulets from the balding earth onto the red brick patio. Thunder echoes through the house; flashes of lightning illuminate a dull grey sky. Four blocks away the river is consumed in a violent turbulence: all froth and eddies. Today, there is a commemorative service being held for Carlos, a Correntino youth who disappeared during the dirty war. In 1977, when Carlos died in a volley of gunshots on a crowded street in Buenos Aires, Argentina was consumed, like the Río Paraná this morning, in furious violence. Terror crept through the streets like a malignant plague, with suspected guerrillas dragged into unmarked cars and shot on sight by army patrols. In the schools, the military held special convocations to indoctrinate the populace. Arriving in full uniform with a 16mm pro-

jector and a film of spliced-together scenes of bombs exploding and street fighting, the soldiers told the students that they were messiahs coming to save their souls from subversion.

The day that Carlos died his wife was with him. They were walking in the Once market district, where they were supposed to pass documents to someone who never arrived. Instead, soldiers began to encircle them, blocking off the two ends of the street. Carlos yelled to his wife to run in one direction; he began to run in the other. The last thing she heard was the sound of shots as she ran and ran, slipping into a store, breathless and agitated, asking for refuge from a robbery that never happened. Unlike Orpheus, she never turned back for one last glimpse of her lover as she walked from the underworld, and so she lived in the shadow of the day he disappeared. Twenty-three years later, a small wooden crate arrives at the Corrientes airport carrying the bones of Carlos, twenty-four years old when he died. The quest of the Mothers of the Plaza de Mayo to materialize the bodies of the disappeared and banish the shadows of the dead has resulted in the discovery of his remains in an unmarked mass grave on the outskirts of Buenos Aires.

The commemorative service is scheduled for ten o'clock in the morning at a private cemetery bordering the Paraná river. At nine, the rain still falls in torrents. By ten, the rain has diminished to a spluttering drizzle, and we walk through the wet grass to a small canopy; underneath it lies Carlos's open grave. Of the five hundred militants in Corrientes who went underground when the military seized power in March of 1976, only several dozen have survived. They are here today, to mourn and remember. Sylvia, the widow of Carlos, embraces other women who, like her, are living with the memory of their disappeared partners. Only they have never found the remains of their *compañeros*. There are the children whose parents were disappeared, today holding on to a moment in which death has finality and ritual. There are the men who survived torture and prison, unbroken by jail but now convulsed by sorrow. Perié, the ex-governor, speaks to a sense of touching history before he breaks down in tears. The mother of Carlos, a stately woman in her seventies who holds on to her daughter-in-law's arm, speaks in a quiet, resolute voice. She is simply grateful, she tells us, to know where her son is, to be able to walk to this resting place on the river and bring flowers to his grave. As she speaks, images of the paper cutout figures, the rough-hewn wooden crosses on the avenue and the blue handkerchief collide. History and memory have become irrevocably intertwined, creating a different kind of archive, one that seizes hold of a moment of danger in order to recognize the past.

This essay first appeared in *Alphabet City* 8 (2002).

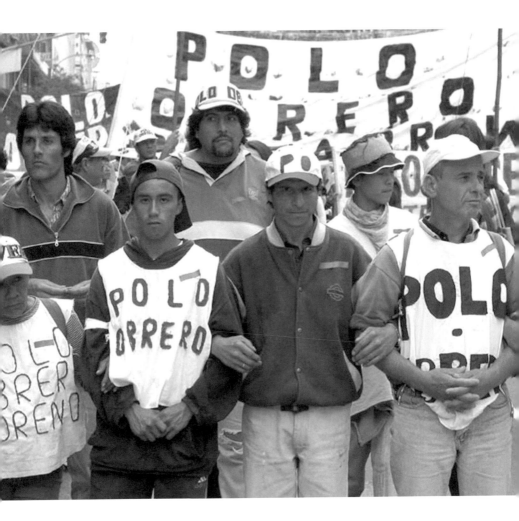

FROM THE CONCEPTUAL
TO THE POLITICAL

THE ART OF POLITICAL PROTEST IN ARGENTINA

On an overcast and chilly evening in late August 2002, 100,000 people
converged in front of the Congress in Buenos Aires, waving flags
and carrying banners, to protest against poverty, corruption, privatiza-
tion, and the global policies of the IMF. Among the demonstrators were
the *piqueteros*—organized groups of the unemployed and the poor who
have mounted increasingly intensive protests and general strikes by
blockading access to roads and bridges. They had been marching under
the pale winter sun since noon, gathering in the poorer *barrios* and
walking for miles towards the city centre. As they reached the main
avenues of the city, they were joined by political leaders of the left and
centre, university and secondary-school students, union locals, middle-
class women and men and children banging pots and pans, intellectu-
als, office workers, artists, shop owners, writers—in effect, the rich and
the poor, the educated and the marginalized, the entrepreneurs and the
workers, had formed a vast mass of people. Together, they marched
under the slogan *que se vayan todos*: a collective demand that the entire
political system be restructured and elections called to replace every
official in the country.

After the demonstrators had assembled, political and cultural leaders
mounted a podium in front of the Congress to denounce the govern-
ment's indifference to Argentina's economic and political crisis, and to
read from hundreds of notes passed hand to hand through the crowd,
sent from groups around the country who were mounting simultane-
ous protests affirming *que se vayan todos*. At the conclusion of the
demonstration, the speakers announced the screening of a video. As the
crowd fell silent, an image appeared on a huge screen behind the podi-
um of a hand waving, over and over again. This repeating image,
framed by the enormous neo-classical columns of a Congress built to
reflect a European heritage of democracy wrought from dependency

economics, foreign debt, and the concentration of capital, was simple and austere: a single gesture repudiating a political and economic system in ruins. As the hand symbolically waved away corruption and cynicism, the mass of people slowly dispersed into the winter darkness of the city. Thousands of miles away from the carefully packaged video installations of Documenta or the MOMA, in a country that has become a casualty of globalization, the conceptual minimalism of a Bruce Nauman or Bill Viola artwork was transformed into a profound political statement of resistance and indignation.

To arrive in Argentina from Canada is to pass through the looking glass of globalization. On the other side of money markets and multi-national mergers and World Trade Organization squabbles among the G8 are countries so indebted to the First World that any additional loans from the International Monetary Fund only service an already impossible debt load. Completing the vicious circle of loan repayments and soaring interest rates (fifty-seven percent in Argentina) are the austerity measures of the IMF. In return for their "pennies from heaven," the IMF insists upon the privatization of all public-sector services (water, gas, electricity) and cuts to education, social welfare, and health services. In Argentina, compliance with IMF policies has been complicated by a drastic devaluation of the peso and a frightening spiral of massive poverty.

In the period between December 20, 2001, when the country exploded in violent protests over hunger among the poor, cutbacks, rising unemployment, and the freezing of all the bank accounts in the country, until the march on the Congress on August 31, 2002, more than half the country fell below the poverty line. In the poorer provinces of the country's interior, more than seventy percent of the population is now without adequate resources to feed their families. In the shantytowns, there is not a dog or a cat to be found. Children search through garbage looking for scraps of food; small babies have bloated stomachs; in the schools, children faint from hunger. As protests against such brutal poverty escalate, so do police repression and the violation of human rights. Days before the Congress demonstration, the *piqueteros* cut access to the main highways and bridges leading to Buenos Aires to commemorate the assassination of two demonstrators by police during a protest the previous March.

The question of art's future may appear to be irrelevant in the face of the social conflict and harsh deprivation that Argentinians are experiencing. Yet one of the great paradoxes of the Argentinian crisis is that the social convulsions of the last months have been accompanied by an explosion of artistic and cultural expressions of protest. In the grand

avenues of Buenos Aires, in the dirt roads of the *barrios*, and in the city plazas, people have taken to art as they have taken to the street. In the poorer *barrios*, communities have organized *assembleas populares* (open assemblies), during which they discuss politics and culture and social change. Abandoned public buildings have been taken over to create neighbourhood cultural centres. Theatre groups travel to the outskirts of the city to perform in open-air squares. Video artists and photographers roam the streets alongside the protestors taking pictures. At La Recoleta, Buenos Aires's largest cultural centre, a major photography exhibition was organized through an open call for images documenting the months of protest. Argentinian films of the 1970s—such as Getino and Solanas's epic political manifesto, *The Hour of the Furnaces*, considered the founding work of Third Cinema—are being screened throughout the country. In response to this affirmation of art as a vehicle for historical memory and political action, Solanas has begun a sequel to *The Hour of the Furnaces*, travelling the country to film the unfolding of an unprecedented economic crisis and demand for political change.

In this convergence of art and protest, the forms of cultural expression that have emerged are distinct from a traditional conception of art in the sense of works exhibited in galleries and museums and bought and traded by wealthy patrons. For the rich of Argentina, the relevance of this type of art remains intact. In times of economic instability, the wealthy put their money in gold and land and paintings. For the poor, who are now the majority of Argentinians, this art is at best a diversion or solace, no matter what claims are made for its role as a form of social critique. The reality that Argentina is now experiencing is reflected not in the cultural heritage found in galleries or museums, but in spontaneous artistic expressions of protest that capture the urgency of the present. The inspiration for this form of art lies in a political struggle for social change; its execution is collective rather than individual in nature. On the streets of Argentina, artistic interventions transform the conceptual premises and avant-garde strategies of performance art and video installation into a popular art of the people: an art that is at times humorous, at other times deadly serious, but always imaginative and original.

Take, for example, a "performance action" that occurred during the first month of the *corralito*—a term used to describe the freezing of the Argentinians' bank accounts. A middle-class family, unable to go on vacation because they could not withdraw their money from the bank, decided instead to take their holidays inside the bank. One morning early in January, they arrived at the bank with lawn chairs, tents, tangas, sunglasses, and picnic baskets, and proceeded to set up a beach oasis. Their protest was so ingenious and so appealing to the public that the

bank could not risk the tumult that might have occurred if they had tried to remove the family. So there they sat, drinking beer and tanning under fluorescent lights, the cameras of national television trained upon them as strangers and friends alike brought them holiday treats to eat and red wine to drink.

By March, when it had become clear that there was no resolution to the crisis in sight and police repression against protests mounted, demonstrators organized an act of cultural critique in front of the residence of the Archbishop of Buenos Aires, the titular head of Argentina's extremely powerful and conservative Catholic Church. As hundreds of protesters converged upon the Archbishop's residence, and hundreds of riot police formed a line of defense between his ornate dwelling and the street, each protester held up a large piece of reflective Mylar that had been cut into the shape of glasses. As they stood there, in silent defiance, holding up a wall of mirrors, they reflected back to the police and the church their own image as the image of repression in Argentina. As eloquent and as simple as the video image of the hand waving away political corruption outside the Congress, the use of mirrors to protest the abuses of power combined the performative elements of contemporary art with a social message that reverberated throughout the society.

In Mayan mythology, a legend describes how, at the beginning of creation, humans had a mirror in which they could see the past and the future. However, as time passed, the gods dimmed this mirror, so that the past and future became opaque and indiscernible. Perhaps the moment that Argentina is now living—a moment at which their nation is considered by some in the G8 as a *país perdido*, a country lost to globalization—is one in which the ancient powers of the Mayans are returning. The view of the past and future from the other side of the looking glass in Argentina, where spontaneous acts of artistic protest reflect an ever-increasing social and economic crisis, is not a utopian one. In Argentina, people are fighting for their basic human rights, their identities, and their lives. The popular art of protest reflects this convulsive reality. The vibrancy and urgency of public artistic intervention, once the terrain of the elite and the intelligentsia, reassert a future for art as a collective expression of social conflict. What remains to be seen is whether this Maya-like mirror of projection and prediction can reach back to the other side of the looking glass—where globalization is still a dream of reason from which we have not awakened.

MINING
THE MEDIA
ARCHIVE

This essay first appeared in *Fuse Magazine* 25:4 (2002).

GATEWAYS TO THE EARTH AND SKY

At Fort York in Toronto, on a Thursday afternoon in early October, 2003, a group of First Nations artists were finishing their site-specific installations for the opening of *Earth Warriors*, a visual arts exhibition held as part of the annual Tecumseh Arts Festival. As a harsh autumn wind swept over the parapets and across the grassy plains of the fort, Maria Hupfield hauled wheelbarrows of dirt to mould a floral patterned circle out of earth; Philip Cote dug into manicured grass to plant an eagle staff; his sister, Carolyn Cote, searched the grounds for stones to form a medicine wheel. In the centre of the fort, sacks of bird-seed were piled high, waiting for Teresa Marshall to scatter them into an eight-pointed star. Inside the thick stone walls of the gunpowder deposit, Oscar De Las Flores's monumental black-and-white drawing of a world in convulsion—a visual cacophony of viperous generals and Goyaesque victims of colonial wars—was already hanging at the back of the room. In the cellar of the officers' mess, David Hannan's eyeless, skinless coyote sculptures were foraging in a vault that had become their lair. Offsite in her hotel room, Joane Cardinal-Schubert was sewing buffalo images onto white transparent flags, testimonies to the wounds of conquest that she would later place within the walls of the fort. Collectively and individually, these First Nations artists had gathered to disturb colonial narratives and to honour the memory of their ancestors and of their histories.

Fort York, a heritage site marking the British colonization of North America, was founded as an outpost garrison in 1793. The site was fortified in 1811 in anticipation of an American invasion, its cannons facing the vast boreal forests and silt-filled marshes that bordered the shores of Lake Ontario. Outside the fort's embankments lay the territories of the Ojibway and the Mississauga, whose warriors held the balance of power in the armed conflicts that beset the region. In the

intervening years between then and now, the marshes receded and the boreal forests vanished, transforming the fort into a quaint anachronism surrounded by looming financial towers and cars streaming along the Gardiner Expressway. Within its museum walls, the once dominant presence of First Nations peoples goes unacknowledged, the dialectics of history replaced by summer tourists snapping pictures of soldiers in period costume. That autumn day, however, First Nations artists were conjuring a place and time when the Anishinabe stood proud as the protectors of the spirits and the earth, while inside the fort walls a few bedraggled conscripts huddled in wooden huts, shuddering at the onset of winter and a gnawing hunger in a strange land.

Tecumseh, the great Shawnee leader, fought and died in the War of 1812 at the time Fort York was being built. Through his alliance with the British, he sought to unite First Nations peoples in resistance to the invading Americans and preserve the land-based rights of his people. While history records his death in the Battle of the Thames on October 5, 1813 as an act of valour defending the British, there are some who say that he was betrayed that day, his European allies fearing that he would realize his vision of a pan-Indian territory. There are others who say that he was carrying a medicine pouch that protected him, and that he did not perish on the battlefield. Whether or not he was betrayed, or survived the battle, what lives on in these stories is the spirit of Tecumseh as a warrior and guardian of sacred traditions. It is in this spirit that the Tecumseh Collective was founded in 1999 to create and promote community-centred First Nations art that focuses "on questions of history and territory…to unearth, redefine and honour significant local lands and spaces across Canada."[1] And it is in commemoration of Tecumseh's historical and cultural legacy that the collective organizes an arts festival each autumn at Fort York. Now in its fourth year, the Tecumseh Arts Festival features a month-long exhibition of contemporary First Nations art; a weekend celebration of First Nations traditions including professional dancing, drumming, storytelling, and craft workshops; and, for the first time in 2003, the Native Men's Residence fall solstice powwow.

On the Saturday afternoon of the festival's opening, a harsh wind still blew, but the fall solstice powwow had transformed the desolate grounds of Fort York into a blaze of colours and crowds. In the centre of the fort, a circle of dancers in ceremonial dress—replete with beading and porcupine quills, feathers and furs—wound around to the sound of the powwow drums. At the eastern wall of the fort, another circle formed as people clustered around a fire to hear storytellers weave tapestries of history and legend from words. Near the storytelling circle lay

Maria Hupfield's installation, whose floral patterns, based on traditional Woodland motifs, had grown in diameter since Thursday. Entitled *My Grandmother's Tiipii*, her circular earthwork was a personal memorial to a grandmother Hupfield never knew and a collective gesture honouring the female territory of the tiipii skirt. Layering earth on top of cultivated grass, Hupfield's installation inverted the domestication of the urban landscape to reveal the domestic roots of First Nations culture. The decorative swirls of the earth paid homage to Ojibway women's traditional arts of beadwork and basket weaving. The circular sweep of the tiipii skirt conjoined earth and moon, encompassing the natural rhythm of the seasons and the feminine lunar cycle. As the concentric energy of the dancers and storytellers radiated outwards, Hupfield's installation focused this energy back to its origin in the land, creating a conceptual meeting ground for the fusion of First Nations traditions and contemporary artistic expression.

On the other side of the fort's grounds lay Teresa Marshall's *A Scattering of Seeds*, an eight-pointed star made from seeds coloured ochre and burnt orange and spring green. Similar in its formal conception to Hupfield's tiipii skirt, Marshall's intricate design was inspired by the Mi'kmaq women's traditional handiwork and their use of fiddlehead-coloured beads. In turn, her use of seeds represented the potential of culture to travel and grow between nations, the birds and wind her intermediaries that spread the seeds through the air as she had sown them upon the ground. Journeying from Nova Scotia to Toronto to participate in the *Earth Warriors* exhibition, Marshall chose to create an eight-pointed star in honour of Tecumseh's vision of the unification of First Nations, and in so doing, to share her own people's symbol of unity. According to Mi'kmaq tradition the seven nations of the East Coast confederacy are represented by seven points of the star, while the eighth point speaks to an ancient prophecy that another people, the Europeans, would arrive to complete the harmony of the circle. That this prophecy has not yet come to pass is evident in the history of the Americas since the conquest, in which First Nations' contact with the Europeans led to epidemics and betrayals, broken treaties and stolen lands, the repression of traditional culture and the brutality of residential schools. In response to this prophecy, Marshall's scattering of seeds for the birds to feed upon was an offering of plenitude and a prayer of hope, her ephemeral gesture a story connecting sky and earth to a future vision of harmony for all the peoples of the Americas.

The role of First Nations art as a sacred source of remembrance and healing was also central to the works of Carolyn and Philip Cote.

Carolyn Cote's *Medicine Wheel–Relative Echo*, located near Marshall's eight-pointed star, drew upon sweat-lodge teachings to create a metaphorical journey for the viewer. Gathering rounded stones from across the grounds of Fort York, Cote laid them a foot apart to form a circle representing a hundred-year lifecycle. At each of the four cardinal directions, she placed a stone covered with an appliqué face of a sacred woman, her long hair braided into the earth. These four stones, symbolizing the mothers of the First Nations, were gateways to insight and reflection. The eastern gateway marked the moment of birth and death and regeneration where zero and a hundred merge into one. The southern gateway marked the age of twenty-five and entrance into adulthood. The western gateway marked the age of fifty, a time when the maturity of experience, knowledge, and spirituality converge. The northern gateway marked the age of seventy-five, when the waning of one's earthly powers, echoing the weak winter sun, leads to a descent back into childhood, and to the closing of the medicine wheel. As viewers approached Cote's installation, they were asked to walk its perimeter, and to place a stone at the point on the circle that corresponded to their age. At the end of the month-long exhibition, the accumulation of stones became a historical record, and container, for all those who had followed the medicine wheel's path and teachings.

At the western corner of the fort, Philip Cote's *Landmark*, an eagle-headed staff adorned with ribbons and a drum, stood guard over the circles that Hupfield, Marshall, and his sister Carolyn had shaped from earth and seeds and stones. Carved from cedar and painted black, the staff had served as Cote's companion in his spiritual journeys and purification quests for traditional knowledge. In the context of the *Earth Warriors* exhibition, it became a sentinel totem calling forth the intimate relation between First Nations teachings and respect for the land. At the base of the staff, a cross of exposed earth marked the four cardinal directions. At its top, a drum painted with a sun and a silhouette of a boy dangled from the eagle's mouth; around its neck coloured ribbons fluttered in the wind. As with Marshall's eight-pointed star, the various elements of the staff formed a composite whole that linked a vision of the future to stories of the past. According to Ojibway legend, the eagle flew across the flooded earth in search of those who still honoured the sacred ways of being, and so saved the earth from annihilation; the eagle brought the sacred fire to the Ojibway people, and thus renewed the gift of life. The drum that hung from the eagle's mouth symbolized the importance of a return to traditional knowledge; the silhouette of the boy represented a messenger carrying forward the teachings of the

ancestors to future generations. The ribbons fluttering in the wind were offerings to the earth and sky, connecting the land as the source of spirituality to the flight of the eagle circling above.

In contrast to the artworks located outside in the open air, each in its own way carving indigenous time out of colonial space to envision the past and future, David Hannan's and Oscar De Las Flores's interventions, located inside the thick-walled buildings erected by the invading forces of conquest, projected a darker and more ambivalent interpretation of the present. To reach David Hannan's *Officer's Quarters* the viewer had to descend a steep set of stairs to the cellar of the officers' barracks, where money vaults were built after the Rebellions of 1837 to secure government funds from rebel attacks. In one of these vaults, long since emptied of gold bullion and paper bonds, Hannan lined the floor with copper sheeting and placed on top two coyote sculptures. Cast in concrete from the plaster forms that taxidermists use to stuff the skins of hunted animals, but stripped of fur and beaded eyes, the coyotes became eerie creatures of the imagination rather than facsimiles of realism. Like phantom dogs of the night, they were both of this world and not: guardians and tricksters of the spirit realm whose natural habitat, like the boreal forests and marshes that once ringed Fort York, had vanished. In the process of adaptation to their new surroundings, one of the coyotes had retained its animal form while the other had been transformed into a mixture of predator and prey, the coyote's torso moulded to the legs of a deer. Cornered in a vault that was both their refuge and their captivity, these hybrid simulations of nature, hovering between extinction and mutation, served as metaphors for the encroachment of urbanization and a precarious survival.

Parallel to Hannan's shape-shifting representations of a natural world under siege, Oscar De Las Flores's *The Prudishly Lavish Televised History of Devastation*, a large-scale drawing hanging in the gunpowder magazine, portrayed a material world beset by avarice and aggression. Inspired by the Mexican graphic-art and mural traditions of caricature, Flores's dizzying swirl of figures, one tumbling upon the other, created a narrative chaos to depict the colonial devastation stretching from the conquest of the Americas to the invasion of Iraq. In one corner, a First Nations warrior sat slumped over in defeat; in another, tanks and exploding bombs merged with cowering civilian victims; in the centre, the pig snouts and reptilian eyes of oppressors leered over a visceral carnage of suffering. An homage to peoples, past and present, whose lands and lives have been decimated by invading armies, Flores's work was also a tribute to the famous *Tres Grandes* muralists of the Mexican

Revolution—Diego Rivera, David Alfaro Siqueiros, and José Clemente Orozco—whose vision of a political role for art encompassed the reclamation of indigenous culture. The influence of Orozco, whose murals were powerful condemnations of links between the damages of historical violence and contemporary conditions of poverty and exploitation, was particularly evident. Similar to Orozco, Flores's cataclysmic vision of imperialism in the New World—imposed first by the Spanish and then by the Americans—exposed the dehumanization and injustice experienced by all the colonized peoples of the world.

In contrast to Flores's figurative testament to the disasters of war, Joane Cardinal-Schubert's *Buffalo Jump* addressed the legacies of conquest through the conceptual transformation of a colonized landscape. Travelling from Calgary to participate in the exhibition, Cardinal-Schubert responded to the site-specific context she encountered by making transparent white flags to mark the layers of history embedded in the fort and its environs. On each flag she sewed three small red zippers that opened to reveal slits cut into the material; on four of the flags, she filled the zipper openings with words she had cut out from newspapers, creating a concrete poetry of resistance. On the others, the zipper openings were left empty to become concrete metaphors for the wounds and gaps of history. On the upper left-hand corner of each flag, she sewed a totem image of a buffalo to identify the flags as custodians of First Nations territory. Bringing the flags to the fort the day of the powwow, Cardinal-Schubert chose as her sites of intervention two small, fenced-in areas protecting archaeological excavations taking place at the fort.

At the first site, located outside the gunpowder magazine where Flores's painting hung, Cardinal-Schubert lined one side of the fence with the four flags whose zippers opened to reveal words that read in sequence: "history's" "targets" "questioned"—"poised" "renewal" "questioned"—"honour" "approval" "trapped"—"destruction" "trail" "uprooted." As the flags fluttered in the wind against a background vista of bank buildings and the CN Tower, their words formed a composite narrative that doubled back upon itself, telling a history of the earth's violation and cultural domination by subverting the language and the symbols of oppression. At the other archaeological excavation, located beside the storytelling circle, Cardinal-Schubert placed, on the four corners of the fence, the flags whose zipper openings were empty slits. At the very moment that she was planting the flags on the fence, which barred the public from the material evidence of the past, a traditional story about the white buffalo was being told around the fire of

burning cedar. In this subtle contestation between two conceptions of history, the zippers became portals through which the words of the storyteller flowed, transforming the European symbol of the white flag, signifying surrender, into an act of reclaiming First Nations lands and voices.

In naming the exhibition *Earth Warriors*, Philip Cote, a founding member of the Tecumseh Collective and a descendant of the Shawnee leader, told me that the collective wanted to emphasize the role of the artist as a warrior of peace, one who goes to battle on the field of representation, his or her weapons those of vision and interpretation. As First Nations artists, the participants in the *Earth Warriors* exhibition encountered such a battlefield at Fort York, whose preservation and restoration privileges the architecture of war and colonization. In response, the artists called upon the traditions of their ancestors and contemporary artistic practices to create other ways of remembering and interpreting a historical site of conquest. In so doing, they opened gateways, like those of Carolyn Cote's *Medicine Wheel – Relative Echo* and became, like the birds and the wind in Teresa Marshall's *A Scattering of Seeds*, the intermediaries for the potential of First Nations culture to flourish and spread.

That such a potential could materialize became evident in an inadvertent clash of traditions that occurred during the weekend festivities. On the Saturday afternoon of the powwow, a bride dressed in flowing white arrived at the gates of the fort. While she had been told there would be a First Nations arts festival taking place at the same time as her wedding, what she did not know, or perhaps could not imagine, was that this would include a powwow ceremony. When she saw the crowds clustered around the powwow circle and heard the beating of the drums, she became visibly distraught. Her distress increased further when she learned that the drumming embodies the sacred heartbeat of the powwow, and could not be halted for her wedding ceremony. In response to this unanticipated collision of cultures, Philip Cote sought to bridge the distance between them by approaching the organizers of the powwow to ask if they would hold an honour dance for the bride. After the bride and groom spoke their wedding vows, Philip Cote and Rebecca Baird—two founding members of the Tecumseh Collective and the key animators of the festival—led them to the powwow circle. As the couple, flanked by Cote and Baird, and followed by the First Nations dancers, stepped hesitantly into the circle and began to dance, the contestation of colonial space was transformed for a moment in time into a meeting place of differences. And as the visitors to the

Tecumseh Arts Festival and members of the wedding party began to join in — relatives, friends, and strangers dancing round to close the powwow circle — a gateway opened for the sharing of traditions, and created hope for future harmony between nations.

Note

1. Mission statement for the Tecumseh Arts Collective, founded in 1999 by Rebecca Baird, Rebecca Belmore, Philip Cote, Bonnie Devine, and Robert Houle. In 2003, the collective was composed of Rebecca Baird, Philip Cote, Carolyn Cote, Oscar De Las Flores, and David Hannan.

This essay was commissioned by the 2003 Tecumseh Arts Festival.

SELECTED BIBLIOGRAPHY

Critical Essays

"Gestures in the Looking Glass: Performance Art and the Body." In *Caught in the Act: An Anthology of Performance Art by Canadian Women*, edited by Tanya Mars and Johanna Householder. Toronto: YYZ Books, 2004.

"Vera Frenkel: The Secret Life of a Performance Artist." In *Caught in the Act: An Anthology of Performance Art by Canadian Women*, edited by Tanya Mars and Johanna Householder. Toronto: YYZ Books, 2004.

"Old Bones and Beautiful Words." In *Colonial Saints in the Americas 1500–1800*, edited by Allan Greer and Jodi Bilinkoff. New York: Routledge, 2003.

"From the Conceptual to the Political: The Art of Political Protest in Argentina." *Fuse Magazine* 25:4 (2002).

"What if Daily Life in Canada is Boring? Contextualizing Greg Curnoe's Regionalism." *Fuse Magazine* 24:3 (2001).

"Embodying the Virtual: Hybrid Subjectivity in Cyberspace." In *The Multiple and Mutable Subject*, edited by Vera Lemecha and Reva Stone. Winnipeg: St. Norberts Arts Centre, 2001.

"Jeff Wall." *CV Photo* 46 (1999).

"Camera Obscured." *Canadian Art* 16:1 (1999).

"At the Gates: Border Arts of Insite97." *Canadian Art* 15:1 (1998).

"Mining the Media Archive: When History Meets Simulation in the Work of Dara Birnbaum and Stan Douglas." *Fuse Magazine* 20:5 (1997).

"Blindness and Insight: The Act of Interrogating Vision in the Work of James Coleman." In *Robert Lehman Lectures on Contemporary Art*, edited by Lynne Cooke and Karen Kelly. New York: Dia Centre for the Arts, 1996.

"Utopias of Resistance/Strategies of Cultural Self-Determination." In *Video re/View: the (best) source for critical writings on Canadian Artists' Video*, edited by Peggy Gale and Lisa Steele. Toronto: Art Metropole, 1996.

"Cartographies of Memory: Tracing the Representational Legacy of Argentina's Dirty War in the Work of Guillermo Kuitca." *Parachute* 83 (1996).

"Parables of Community and Culture for a New World (Order)." In *Questions of Community: Artists, Audiences, Coalitions*, edited by Diana Augaitis, Lorne Falk, Sylvie Gilbert, and Mary Anne Moser. Banff: Walter Phillips Gallery, 1995.

"Mirroring Identities: Two Decades of Video Art in English Canada." In *Mirror Machine: Video and Identity*, edited by Janine Marchessault. Toronto: YYZ Books and CRCCII, 1995.

"Is It Still Privileged Art? The Politics of Class and Collaboration in the Art Practice of Carole Condé and Karl Beveridge." In *But Is It Art? The Spirit of Art as Activism*, edited by Nina Felshin. Seattle: Bay Press, 1994.

"Video in Drag: Tran-sexing the Feminine." In *Sightlines: Reading Contemporary Canadian Art*, edited by Jessica Bradley and Lesley Johnstone. Montreal: Artextes editions, 1994.

"All in the Family: An Examination of Community Access Cable Television in Canada." *Fuse Magazine* 17:3 (1994).

"Cultures of Conquest/Culture in Context." In *Towards the Slaughterhouse of History: Working Papers on Culture*. Toronto: YYZ Books, 1992.

"The Art of Nation-Building: Constructing a Cultural Identity for Post-War Canada." *Parallélogramme* 17:4 (1992).

"Decolonizng the Imagination: Artists' Exchanges Cuba-Canada." *C Magazine* 33 (1992).

"Columbus Re-sighted: An Analysis of Photographic Practices in the New World of Post-Modernism." In *13 Essays on Photography*. Ottawa: Canadian Museum of Contemporary Photography, 1991.

"Fragile Imprints/Mediated Resistances." *C Magazine* 26 (1990).

"Fearful Symmetry: The 1990 Nicaraguan Elections." *Fuse Magazine* 13:5 (1990).

"Radioactivating Nicaragua: Community Radio Conference." *Fuse Magazine* 12:4 (1990).

"From The Father's House: Video, Feminism and the Challenge of Difference." *Fuse Magazine* 11:4 (1988).

"'The CEAC was banned in Canada': Programme Notes for a Tragic-Comic Opera in Three Acts." *C Magazine* 11 (1986).

"To Speak of Difference." *Parachute* 43 (1986).

"Feminine Pleasure in the Politics of Seduction." *C Magazine* 4 (1985).

Creative Documentary & Fiction

"The Site of an Imaginary History." In *Archaeology Impulse*, edited by Eldon Garnet. Toronto: University of Toronto Press, 2005.

"Anatomy of an Insurrection." *Alphabet City* 8 (2002).

"Utopia." *Public* 20 (2000).

"Stolen Doubles." *Site Specific*. Toronto: A Space, 1988.

"Mary, Mary, Quite Contrary." *Impulse* 12:3 (1986).

Interviews

"The Story is always Partial; A Conversation with Vera Frenkel." *Art Journal* 57:4 (1988).

Interview with Nell Tenhaaf. In *Fit/Unfit; Apte/Inapte: Nell Tenhaaf: A Survey Exhibition*. Oshawa: Robert McLaughlin Gallery, 2003.

Catalogue Essays

"Art in the Age of Intelligence Machines." In *David Rokeby*. Vancouver: Art Gallery of Hamilton and Presentation House, 2004.

"The Heart of Matter: The Mediation of Science in the Art of Catherine Richards." In *Excitable Tissues*. Ottawa: Ottawa Art Gallery, 2003.

"The Ghost in the Machine: Translation and Otherness." In *Piano à Numéros*. Quebec City: OHM Editions, 2003.

"Performing Memory: The Art of Storytelling in the Work of Rebecca Belmore." In *Rebecca Belmore: 33 Pieces*. Toronto: Blackwood Gallery, 2001.

"Gestures Towards Desire: Exploring the Feminine Imaginary." In *Sorel Cohen's Photographs*. Toronto: Koffler Art Gallery, 2000.

"The Instability of Self in the Art of Sylvie Belanger." In *Sylvie Bélanger: De La Séduction à la Résistance*. Windsor: Windsor Art Gallery, 1999.

"Imaging the Border." In *Running Fence: Geoffrey James*. Vancouver: Presentation House, 1999.

"The Second Nature of Simulation: Mirroring the Organic in the Virtual World of Char Davies's *Ephémère*" In *Char Davies: Ephémère*. Ottawa: National Gallery of Canada, 1998.

"Threads of Memory and Exile: The Art of Storytelling in the Work of Vera Frenkel." In *Images Festival of Independent Film and Video*. Toronto, 1997.

"The art of façade in the work of Radoslaw Kudlinski and Anna Passakas." In *Blue Republic*. Oakville: Oakville Galleries, 1997.

"The Play of Mimesis and Alterity in Stan Douglas's *Der Sandmann*." In *Real Fictions: Four Canadian Artists*. Sydney: Sydney Museum of Contemporary Art, 1996.

"Spiegel und Mimesis: Eine Untersuchung der Bildaneignung und Wierderholung in den Arbeiten von Dara Birnbaum." In *Dara Birnbaum*. Vienna: Kunsthalle Wein, 1995.

"Worlds Between: The Thematics of Exile and Memory in the Work of Vera Frenkel." In *Vera Frenkel: Raincoats, Suitcases, Palms*. Toronto: Art Gallery at York University, 1993.

"Requiem for a Modern Love." In *Colin Campbell: Media Works 1972–1990*. Winnipeg: Winnipeg Art Gallery, 1991.

"The Women Men Love To Hate, or Anatomy is Not Quite Destiny." In *Tanya Mars Pure Hell*. Toronto: The Power Plant, 1990.

"BOX (Ahhareturnabout)." In *Box: James Coleman*. Toronto: Art Gallery of York University, 1990.

"Evocations of the Heroic/Mediations Upon A Site." In *Heroics: A Critical View*. Banff: Walter Phillips Gallery, 1988.

IMAGE CREDITS

Cover Pedro Quiros, *Continens Paradisi*, 1618. Map showing the exact location of paradise in the New World. In León Pinelo, *El Paraíso del Nuevo Mundo*, 1656.

viii Vera Frenkel, *…from the Transit Bar*, 1992. Detail view of multiple-channel video installation (Kassel). Reproduced courtesy of the artist.

1 David Rokeby, *The Giver of Names*, 1991–. Detail of computer-integrated video installation. Reproduced courtesy of the artist.

2 David Rokeby, *The Giver of Names*, 1991–. Installation view. Reproduced courtesy of the artist.

17 Nell Tenhaaf, *UCBM (you could be me)*, 1999. Detail of interactive video installation. Reproduced courtesy of the artist.

18 Char Davies, *Summer Landscape,* 1998. Digital frame captured in real-time through head-mounted display during live performance of immersive virtual environment *Ephémère*. Reproduced courtesy of the artist.

24 Catherine Richards, *I was scared to death; I could have died of joy*, 2000 © CARCC, 2005. Detail view of glass brain in tube. Reproduced courtesy of the artist.

34 Vera Frenkel, *Body Missing*, 1994. Installation view of multiple-channel video installation (Paris). Reproduced courtesy of the artist.

42 Dara Birnbaum, *Hostage*, 1994. Installation view of six-channel video and interactive laser installation. Reproduced courtesy of Marian Goodman Gallery, New York.

53 Carole Condé and Karl Beveridge, *Linda No. 2*, 1981. Colour photograph. Reproduced courtesy of the artists.

54 & 91 *Art Communication Edition*, 2:2 and 2:1, 1978. Covers. Thanks to Miles Collyer for sourcing the image.

92 Carole Condé and Karl Beveridge, *Free Expression*, 1989. Cibachrome colour photograph. Reproduced courtesy of the artists.

108 Carole Condé and Karl Beveridge, *Work in Progress*, 1980. Colour photograph. Reproduced courtesy of the artists.

127 Guillermo Kuitca, *Untitled*, 1996. Oil and acrylic on canvas 190 x 221 cm. Collection of Shelly Fox and Philip Aarons, New York. Reproduced courtesy of Sperone Westwater, New York.

128 Carl Beam, *Columbus and Bees*, 1990. Etching on Arches paper 109.2 x 83.3 cm. Collection of the Art Gallery of Ontario. Reproduced courtesy of Ann Beam.

141 Carl Beam, *Sitting Bull and Whale*, 1990. Etching on Arches paper 109.2 x 83.3 cm. Collection of the Art Gallery of Ontario. Reproduced courtesy of Ann Beam.

142 Oscar De Las Flores, *The Prudishly Lavish Televised History of Devastation*, 2003. Detail of drawing. Photo: Steve Frank.

160 Geoffrey James, *Road Sign on Highway 905, two miles north of the border*, 1997. Black-and-white photograph. Reproduced courtesy of the artist.

166 Rebecca Belmore, *Manifesto*. Detail of *33 Pieces*, 2001. Photo: Michael Beynon. Reproduced courtesy of Blackwood Gallery, UTM.

172 Guillermo Kuitca, *The Tablada Suite V*, 1992. Acrylic and graphite on canvas 181 x 126 cm. Collection Brondsbury Holdings Ltd. Reproduced courtesy of Sperone Westwater, New York.

180 Photocopied images of the disappeared, Plaza de Mayo, Buenos Aires, December 1996. Photo: Dot Tuer.

191 Shrine for the disappeared near Jujuy, July 1997. Photo: Dot Tuer.

192 Piqueteros' demonstration, Buenos Aires, October 2002. Photo: David McIntosh.

197 Graffiti Graphic, "The Solution: Self-Management, Peoples' Assemblies," Buenos Aires, November 2002. Photo: David McIntosh.

198 View of Tecumseh Arts Festival site and Teresa Marshall, *A Scattering of Seeds*, Fort York, Toronto, 2003. Photo: David Hannan.

207 Joane Cardinal-Schubert, *Buffalo Jump*, 2003. Detail of installation in Tecumseh Arts Festival. Photo: David Hannan.